Painting with Markers

Painting with Markers

by Emile Troisé and Otis Port

WATSON-GUPTILL PUBLICATIONS, NEW YORK

To all the children whom I enjoyed painting

Published 1972 in New York by Watson-Guptill Publications,
a division of Billboard Publications, Inc.,
165 West 46 Street, New York, N. Y.

Manufactured in Japan

ISBN 0-8230-3563-8

Library of Congress Catalog Card Number: 76-165936

First Printing, 1972

ACKNOWLEDGMENTS

The authors owe debts of gratitude to many persons and companies who rendered valuable assistance in researching this book. The help of Eagle Pencil Company and Eberhard Faber Pen & Pencil Company was especially valuable. And for his persevering encouragement during the book's gestation Watson-Guptill editor Donald Holden deserves a note of sincere thanks. To the many others who must because of space limitations remain unnamed — but definitely not un-remembered — we raise a brush in smart salute.

PREFACE

News of this book on how to adapt markers as a painting medium has already generated a great deal of excitement among amateur and professional artists. Traveling to various artist communities — from New York and New England to California and the Southwest — to look for different painting styles, I have discussed Emile Troisé's discoveries and pioneering efforts in marker techniques with scores of enthusiastic artists. When I returned for a second visit to some places, I was inundated with questions from artists whom I hadn't met during the first visit.

As you might suspect, though, felt-tip markers haven't been used much as a fine-art medium. But my trips were productive in turning up a few examples of marker paintings for this book. On one trip to New Hampshire's White Mountain region, I described Emile's work to a local artist at his roadside gallery. His medium was watercolor. Not long afterwards, I received a package of marker paintings from him. He had merely substituted turpentine for water and markers for watercolors, and produced some stunning effects, several of which are featured.

And here is the best example to support our contention that markers may be the easiest medium to master as well as the most versatile. Recently, Emile tutored several students in New York in the techniques presented here, and one — Mrs. Evelyn Kagel — won first prize in a community art competition with her marker painting *Chrysanthemums*, illustrated on p. 21. Another work of hers is also featured here.

Although Emile and I have spent more than two years in the preparation of this book, our investigations may not encompass all the possibilities of handling, technique, and mediums. This volume, then, is an invitation to join in the exploration of a new painting medium. We recognize that Robert Fawcett, Henry C. Pitz, and other artists have long used markers as a drawing and sketching medium, and we acknowledge that debt. If marker paintings do become common and customary, however, it is my personal opinion that the art world can look to Emile Troisé for the inspiration that propelled markers into the fine-arts arena.

Otis Port
Scottsdale, Arizona

CONTENTS

COLOR PLATES

Unless otherwise indicated, all figures and black and white illustrations are done by Emile Troisé.

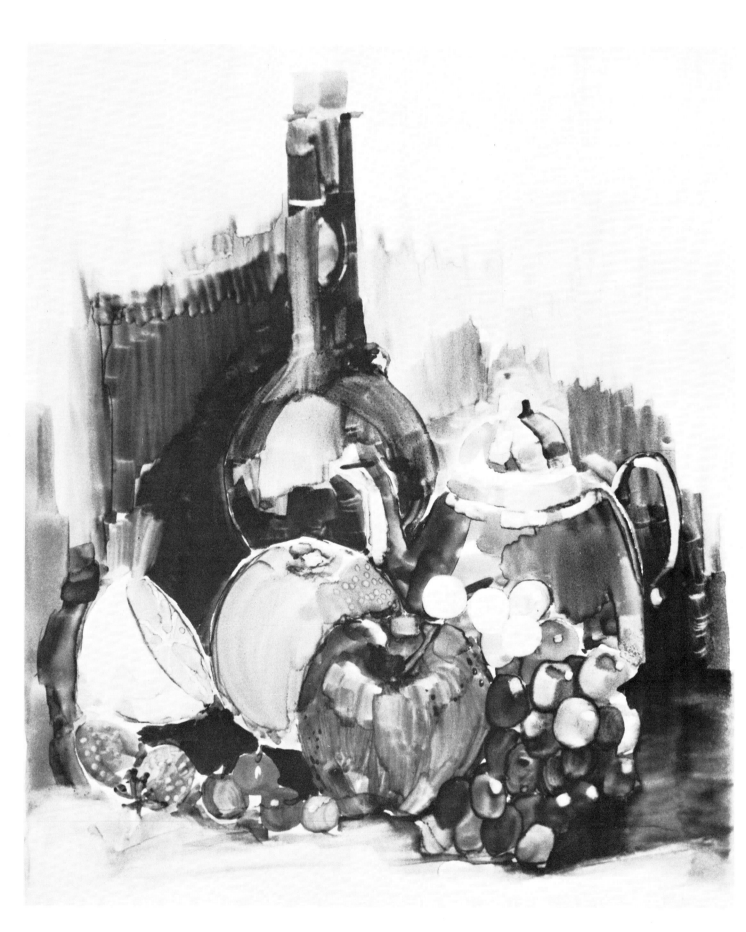

Still Life With Fruits. This painting, done with markers on a sheet of 10″ x 12″ vellum, demonstrates several unusual attributes of painting with markers on an impermeable surface: overpainting erases prior strokes of felt-tip markers; blending gives hard and soft effects; stippling or washing with a Q-Tip and turpentine helps to lighten or blend colors.

THE MAGIC
OF MARKERS

It began with Flo-Master in the late 1940s. A short time later, during the height of Flo-Master's early popularity, along came Magic Markers. That was nearly twenty years ago. In the interim, several very famous artists became converts of the new medium — at least for drawing. Most notable, perhaps, are Henry C. Pitz and the late Robert Fawcett — who's said to have made a one-time purchase of two million Flo-Master felt tips.

Markers as a Medium

Yet the full potential of porous-tip markers (hereafter called simply "markers") as a *painting medium* has never been truly realized. Until now. There are two obvious reasons why. First, marker colors are formulated with dyes, not pigments, and dyes are generally light-fugitive (that is, they fade in strong light). And second, not until recently have marker manufacturers offered the extensive palettes now available (some one hundred colors from two manufacturers, more than fifty from two others). A not so obvious reason is the fact that, historically, artists have tended to resist technological changes of the sort represented by the development of markers.

Today, three factors have come together to create a climate in which markers may come to be accepted widely as a painter's medium. First, this is "the Age of Aquarius," a time of adventuresome nonconformity and youthful experimentation, when traditional values are challenged by individuals seeking personal and total relevance to a world that ought to be. These conditions, reflected on the artistic front, have produced a new breed of artists and "happenings." The latter are works of art created only to be destroyed in an era when artistic merit is perceived in the most commonplace of objects, when works of art are created outdoors from natural elements (for instance, ditches and mounds of soil) which nature will inevitably modify. In other words, this is an age when permanence may be a less important consideration.

Solution to Fading

The second contributing factor in the acceptance of markers is permanence. If you're concerned about the tendency of marker colors to fade, a solution may be at hand, thanks to the recent explosion of plastics in almost every conceivable industrial area. Most plastics are quite sensitive to the ultraviolet (UV) segment of the spectrum, and, consequently, a sizable number of UV screening agents have been developed within the past five to ten years. Although we know of no such product that absolutely will prevent marker fading in direct sunlight, we believe marker paintings treated with a UV absorber will block enough of the damaging light rays so that, with proper caution, marker paintings can be conventionally hung and last practically as long as a watercolor. Nevertheless, it should be noted that this opinion is based on rather superficial, backyard-type tests. Scientific testing is needed before our opinion can be stated as fact. (Product recommendations appear in the next chapter.)

And the third factor, of course, is the current availability of almost any marker color an artist could ask for.

The Ultimate in Versatility?

Markers, especially the venerable Flo-Master, are so versatile that it's hard to fault them on esthetic grounds. By carefully selecting your painting surface, you can achieve effects remarkably similar to pen and ink, wash, watercolor, Conté crayon, scratchboard — even oils. And all this capability comes prepackaged in a variety of sizes and shapes which can be conveniently carried into the field or tucked into pocket or purse for spur-of-the-moment renderings. Moreover, markers often offer the advantages of more traditional media without the usual disadvantages. For example, a marker "watercolor" can be reworked at will — even erased totally for a fresh start — if it's executed on certain impermeable papers (described in the next chapter). Nor do you have to bother with cleaning brushes; a simple wipe of the marker's tip with a paper towel or absorbent cloth will suffice.

Furthermore, markers are surprisingly easy to handle. By following the instructions, examples, and suggestions presented in this book, you should be able to master the technical side within a gratifyingly short period of time. David C. Baker, the New Hampshire watercolorist, was able to adapt his unusual style to markers after merely hearing a verbal description of the fundamentals — to wit, use turpentine instead of water and, naturally, substitute markers for watercolor paints. In a year he became a prolific marker painter and has sold many of his works.

We hope this rather terse introduction to marker painting has piqued your interest, for the only way you'll be in a real position to evaluate marker painting is to try it.

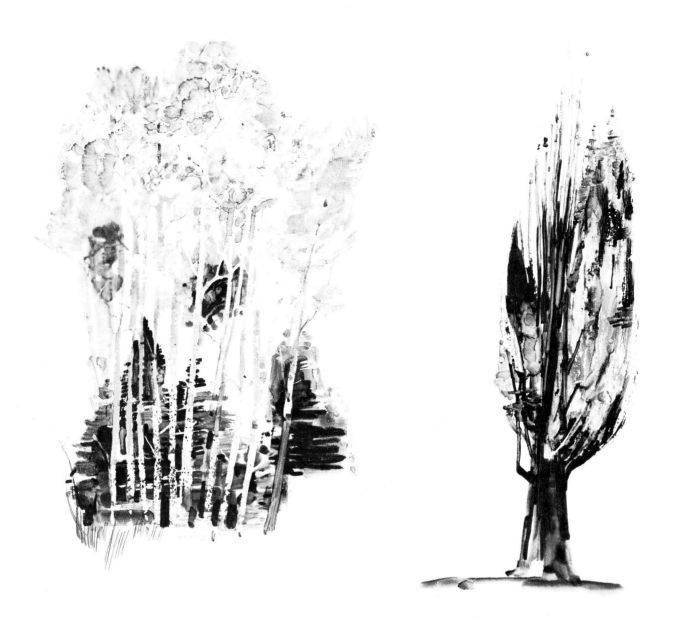

White Birch Trees. This study was produced by various shortcut techniques. The trunks were masked out with liquid frisket which allowed the pines to be painted in the background without touching the trunk areas. Foliage was rendered partly by the "stamp pad" technique. This painting was done on a permeable surface.

Poplar. This sketch was done on dull-coated paper with black markers. No. 1 gray was used to push aside the darker inks to create a textured effect between the branches of the trees.

Marine Basin. (Right) On absorbent surfaces such as the medium-toothed watercolor board used here, marker paintings take on some qualities of watercolor paintings.

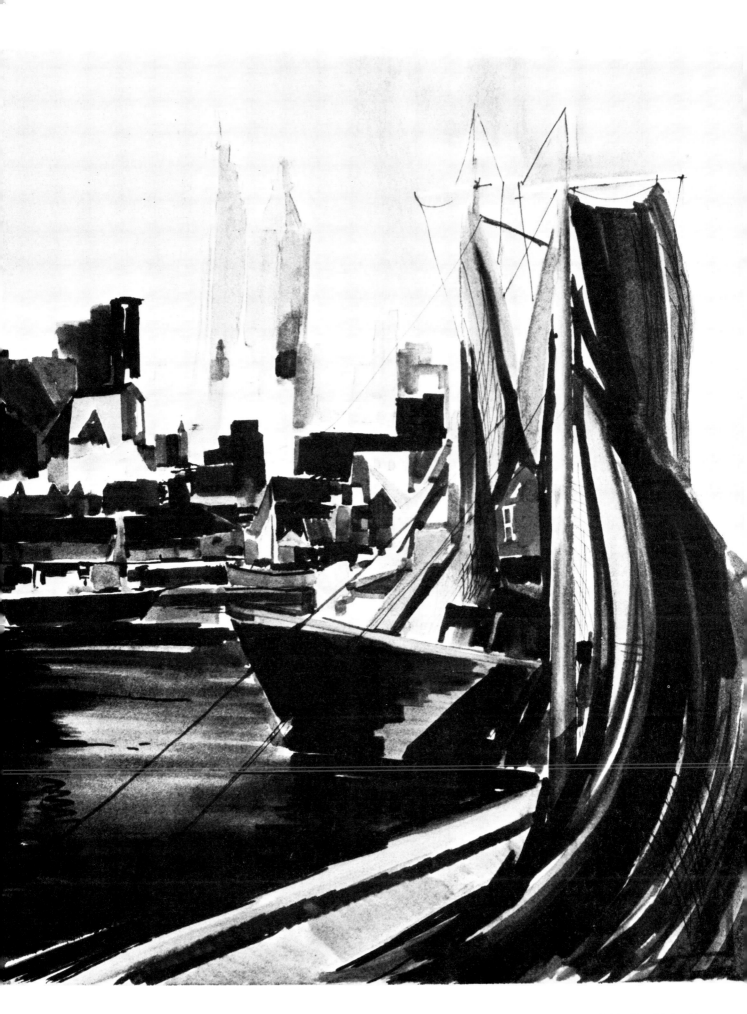

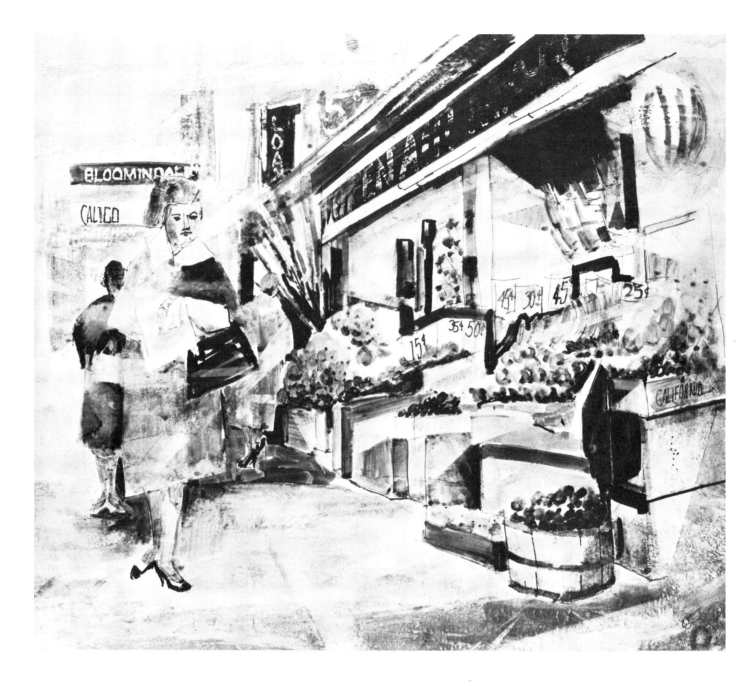

East Fifty-ninth Street. The interesting surface texture of this New York City scene was obtained with oil-paint impasto on illustration board. This type of impermeable surface is ideal for painting with markers.

BASIC EQUIPMENT AND MATERIALS

If you're interested in painting with markers, the foremost question is: What do I need to get started? And: Can I use any of the materials and equipment I already have?

To answer the last question first — yes, but a limited yes. Some of the painting surfaces that are most compatible with markers are commonly used with other media. But many aren't. A few may be difficult to find in a local art supply store; you may have to write to the manufacturer. For one type of surface, you'll have to patronize a lumberyard or building materials supplier. You'll probably find that painting with markers requires a whole new set of equipment and materials. And it can become rather expensive, but we'll have some suggestions for limited budgets later on. Also, the book is organized so that the number of colors you need is small at the outset, allowing you to obtain additional markers as you progress through the exercises and painting projects.

The tools you'll need can be classified into three categories: markers and other painting instruments, papers and other painting surfaces, and miscellaneous items. Let's take them in order.

Markers and Painting Instruments

Markers come in a multitude of sizes, shapes, and colors — from little glass containers and pencil-like plastic and metal units to oversize markers available for the artist who "thinks big." Tips come in an assortment of sizes and shapes, too — fine, chisel, round, square, or T-shaped. They're made from such porous materials as felt and nylon "foam." More than fifty different colors and hues are made by at least four manufacturers: Cooper Color (Ad markers), Eagle Pencil (Prismacolor markers), Eberhard Faber (Design Markette), and Magic Marker (Magic Markers). Less opulent color selections are made by several more companies, including Carter's Ink and Sanford Ink. (See Suppliers List in the back of the book.)

As far as performance is concerned, markers from various manufacturers are interchangeable. There are detectable differences, probably the result of varying formulations, but these aren't generally significant enough to affect your choice of one brand over another. Aside from your personal tastes in shape, the other factors liable to influence your choice of markers are such features as an interchangeable fine-line adapter for chisel-tip Ad markers; the organization of twenty-four of the Design Markette colors into highlight, middle-tone, and shadow hues; color-coded tops on Prismacolor markers which simplify selection from a revolving carousel; and specialized sets from Magic Marker for outdoor and stone colors (twelve units) and skin tones (twelve units).

Oil-Based and Water-Based Markers

The point to bear in mind when purchasing markers is whether the ink is formulated with an "oil" solvent (xylene or similar chemical) or with water. Oil-based markers are normally designated "permanent" or "waterproof," while water-based units will often be stamped "washable" or "nontoxic." Failing such a clue, sniff the tip. An oil marker generally will have a distinctive, penetrating odor, not unlike some enamel paints or airplane glue. (The odor is also something of a warning, for the organic solvents are potentially dangerous. Do *not* use oil markers in a very small, unventilated room, and do *not* allow children to use them.) Although there are occasions when it's advantageous to mix the two types of markers, oil-based formulations will be used throughout this book, unless otherwise noted.

The Cadillac of markers is the Flo-Master by Venus Esterbrook. Introduced in the late 1940s and still without peer, Flo-Master is distinguished above all by its controlled-flow ink supply. The tip (in several interchangeable styles) is spring-loaded so that increased pressure opens a valve for increased ink flow. Thus, one Flo-Master can produce variations in tone that would require at least two or three markers without this ink-metering principle. Admittedly, the Flo-Master carries a high price tag, compared with most other markers. Yet it may well be the most economical instrument, in the long haul. It's refillable, and a small can of ink will last for a considerable length of time. (One artist has painted more than one hundred marker works, some as large as 24" x 48", and has one half or more of the ink remaining in each of eight 4-oz. cans.) Also, the felt tips are replaceable at nominal cost. Both transparent and opaque inks are available. Getting accustomed to the "touch" of the Flo-Master does take quite a bit of practice, but this is a minor drawback. For ambitious artists, there's a king-size Flo-Master with a T-shaped tip that's 5/8" wide.

Papers: Permeable and Impermeable

Approximately two hundred papers and other painting surfaces have been tested for marker painting. For convenience, these can be put into two classifications: either permeable to marker inks or impermeable. Most papers are permeable. The disadvantage of such surfaces is that colors which have penetrated into the body of the paper (below the surface) are effectively "locked in." It's next to impossible to blend colors. Instead, you merely get a hard-edged overlap of tones. On the other hand, it appears that marker inks which have penetrated below the surface are more resistant to fading.

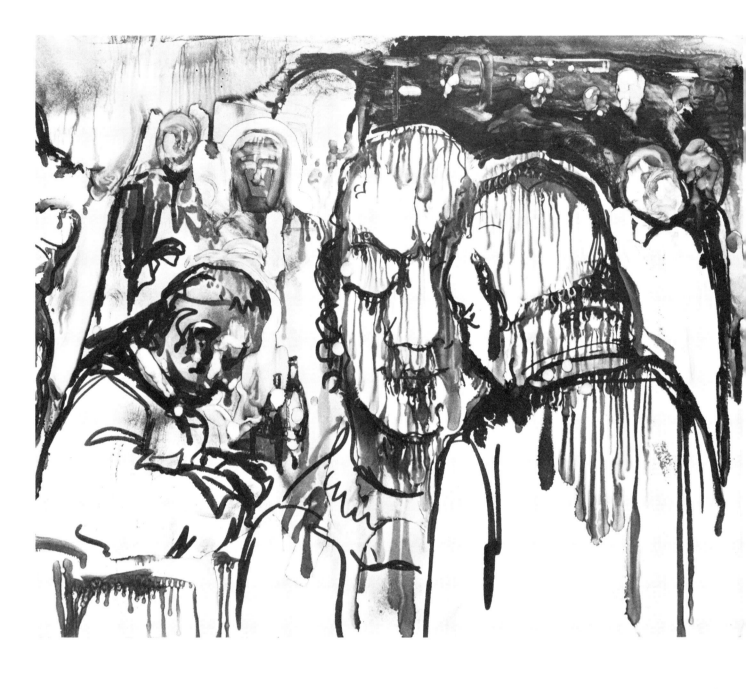

Café Scene by David C. Baker. The spontaneity of on-the-spot scenes such as this one is easy to capture with markers and any sketch paper. Action and feeling can be expressed vividly with the different kinds of marker tips available.

Nevertheless, it's our belief that the fading problem can be greatly mitigated once marker manufacturers are aware of the fine-art potentials of their products. Therefore, for most paintings, impermeable or nonabsorbent papers are preferred. Certain chemicals, known as ultraviolet or UV absorbers, are available and will effectively screen out the most harmful light rays. These screening agents will be discussed in more detail later.

Two of the more common impermeable papers that will work well with markers are vellum (use the heavyweight grade if possible) and acetate overlay sheets. Both of these are carried by most art stores. A "vellum type" paper from Bienfang Paper Company called Satin Design No. 150, is particularly good. Strangely, another Bienfang paper, Felt Marker Graphics No. 360fm, may be ideal for graphic art studios but it's permeable and colors are very difficult to blend and, therefore, is not recommended. Some, but not all, parchment-type papers are also good.

Among the less common papers that produce satisfactory results are Bienfang's Aurora dull-coated design paper and Bainbridge's high-coated showcard board.

Some other very good painting surfaces are the new "plastic papers" or "paperized plastics." Few of these are commercially available except in large quantities, but samples are usually available. (See Suppliers List for names and addresses.)

Some of the very best smooth to fine-textured papers are those which have a pyroxylin coating. However, these are used mostly by graphic artists and may be difficult to locate. A superb paper called "white pyro cover stock" (also available in colors) can be ordered. Several excellent textured papers (such as crushed calf No. 4 grain and light kid No. 2 grain) are made by Uni-Mark, Inc., under the Unicote Fab-Hyde trade name. (See Suppliers List for names and addresses in the back of the book.)

For a little more tooth, various watercolor papers can be used. Bienfang's Watchung No. 535 is one of the best watercolor papers for marker work (Watchung No. 535-EH is somewhat less satisfactory). Strathmore's Artist watercolor 140 lb. hot-pressed surface paper may also be considered.

To obtain an oil-like quality in marker paintings, Bienfang's Canvasette paper is ideal. Most primed artist's canvases also are very good. Swatches primed with acrylic-based materials, furnished by Tara Materials, Inc., were tested, and most were found to be eminently suitable.

Lacking any of the above, you can easily prepare your own painting surfaces by priming nearly anything with an oil-paint impasto. So treated, even the cardboard back from a sketchpad will prove to be as good as any commercial offering. For maximum rigidity, you can prime a Masonite panel. Masonite even has a "preprimed" panel that's ideal. It's Marlite and is simply Masonite with a plastic coating on one side. The coating is quite shiny, though this can be toned down by rubbing the surface with pumice or a nylon scouring pad. You can order Marlite from your local lumberyard.

Miscellaneous Materials

An amazing variety of materials and implements was used by the artists featured in this book. Some of the materials you'll

W. C. Fields. Quick portrait studies are easily rendered with one color of markers with different tips. This sketch was done from another portrait which was used as a model.

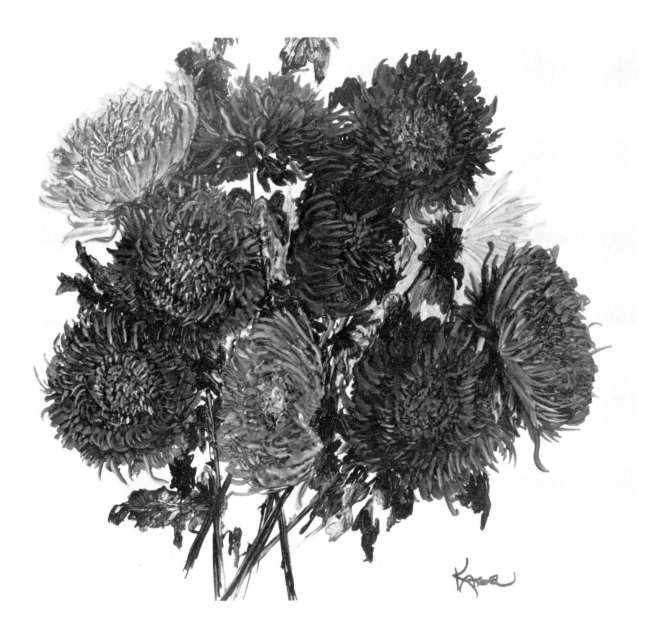

Man and Baby Llama. (Left) A turpentine-moistened Q-Tip was used to spot the llama's wool and create the delicate texture. The leaves in the foreground were overpainted through cut paper stencils.

Chrysanthemums (Above) by Evelyn Kagel. This award-winning painting was done by a student of Mr. Troisé. Large flowers were painted on a 24″ x 30″ sheet of acetate, and color was built on color to enhance the depth as well as the size of each flower.

Rock Singer by David C. Baker. In this study, marker colors were manipulated with a watercolor brush wetted with turpentine. The surface is Marlite, an impermeable plastic-coated hardwood panel.

find useful are white masking tape, gum arabic or another liquid frisket (or you might want to substitute a frisket film), a spray bottle (the sort that Windex comes in), a razor blade, a utility knife, "stamp pads" made out of paper towels and magazine covers, a bough of leaves, a rubber roller, a felt paint roller, and many, many other tools — some rather esoteric.

Time and again, however, you'll need turpentine and cotton swabs (Q-Tips). A supply of these, along with an absorbent material (such as paper towels), for frequent wiping of marker tips, is essential.

No doubt there'll be times when one and only one material or implement will do the intended job. But this isn't always true. If you recognize an opportunity to use something else, by all means do so. Use your ingenuity whenever possible. And this goes for the manner of execution, too. Deviations from the methods presented, innovation, and adaptations to suit your own personal tastes are all encouraged.

Tests on Retarding Chemicals

Last, you'll want to obtain one or more of the chemicals that will retard fading of marker dyes. This, unhappily, is an area that needs systematic investigation. Informal tests that we've conducted have mapped superficial guidelines, but much work remains to be done in identifying the best chemical or combination of chemicals for preserving marker colors. Apart from applying one or more of the following UV absorbers, the only sure way to prevent fading is never to expose a marker painting to direct sunlight or strong sources of reflected natural light. Artificial lighting may damage marker paintings over extended periods of time, but no fading has been detected thus far in several marker paintings hung conventionally as long as five years ago. On the other hand, serious fading will occur within a matter of weeks in direct sunlight.

Merix AST 1001 seems to be the best preservative tested so far. Unlike most other UV absorbers, it's a water-based solution that does not attack marker colors. Often UV absorbers must be dissolved in toluene, methanol, or other related solvents, and these solvents also will dissolve marker inks. Thus, even a fine aerosol mist tends to spot the painting. The light yellow color of Merix AST 1001 is essentially invisible, and its effect on blue colors is minimal. Some UV absorbers do screen out noticeable amounts of blue light, however.

More Fixing Agents

Another good offering is Uvinul D-50. This chemical is also slightly soluble in water. Its water solubility is so small, however, that at least five coats are necessary, and twenty would be better. Otherwise, its performance appears to be comparable to Merix AST 1001.

There appears to be a synergistic, or chemically interactive, effect when two or more screening agents are combined. For instance, the compound used to coat Polaroid prints plus a commercial aerosol spray called Crescent Matton, by Crescent Portrait & Frame Company, plus a conventional fixative spray — applied in that order — seems to be more effective than any other combination of these three products. Polaroid print coat plus Crescent plus Polaroid print coat, for example, is not quite as good. The Polaroid print coat-Crescent Matton-fixative coating method approaches Merix AST 1001 in performance.

Crescent Portrait & Frame also makes another product named Koloron, and it's nearly as effective as Crescent Matton. But it attacks marker inks even more vigorously than does the latter. Spray Mark UVA causes still more spotting. Therefore, some sort of undercoat is desirable with any of these sprays. (Suppliers of these products are listed in the back of the book.)

Further Tests Are Needed

Another half dozen chemicals have been tested, with varying degrees of fade retardance. However, only a few of the many possible combinations have been tested, and none of these combinations included the Merix compound. It's hoped, therefore, that one of the marker manufacturers with a Fade-O-Meter (a device that greatly accelerates fading under controlled conditions) will undertake a thorough research program and determine the optimum coating combinations.

In addition to using a UV absorber solution — which comes in liquid form — from one of a score of manufacturers known to make such a product, there are several transparent plastic sheets that contain effective UV screens. Rohm & Haas makes one such plastic — Korad ACV, an acrylic film. But PVC and other plastics are produced with UV absorbers in the body of the plastic. These can be obtained in thicknesses of around 1/8" or so and used as "glass" for framing. Or you can paint directly on the plastic, then turn it over in the frame.

Considering the range of options, it seems that an answer should be at hand — one effective enough to give marker paintings a life at least as long as that of watercolors. Nevertheless, the warning should be repeated before we end this discussion. Marker colors are light-sensitive, not too different from color photographs in this respect, and care must be taken to prevent exposure to sunlight. As a painting medium for professional artists, then, markers at present have limited appeal. But if properly cared for, marker paintings should endure for at least the artist's lifetime.

A Fine-tip quick diagonal strokes

B Slower up and down strokes

C Slower curved strokes

D Long edge of "giant" marker

E Slow chisel-tip strokes

F Quicker chisel-tip strokes

G Twisted diagonal chisel-tip strokes

H Twisted horizontal chisel-tip strokes

I Straight up and down chisel-tip strokes

Figure 1. To get acquainted with this new painting medium, experiment by drawing strokes with fine- and chisel-tip markers on inexpensive sketch paper. The slower the stroke, the more ink is absorbed in the paper and the heavier the line weight is.

LINE
AND
TONE

No one particularly enjoys doing simplistic exercises, so we'll try to keep them down to a minimum and get on to the painting projects, which deal with more satisfactory subject matter. But don't infer from this statement that you're encouraged to skip what follows. On the contrary. Because in the next few exercises are the foundations of the painting techniques which will be employed throughout this book. Unless you've had considerable experience with markers — in a commercial art studio, for instance — we strongly recommend a persistent, tenacious, page-by-page approach.

Materials Needed

Listed below are the markers and papers you should have on hand in order to execute the first-phase exercises in which you'll get the feel of markers (strokes with various tips, laying in flat tones over large areas, blending, etc.).

1. Black chisel-tip marker (unless otherwise specified, all markers are of the oil-based, non-water-soluble variety)

2. Medium gray (No. 5 or No. 7) chisel-tip marker

3. Light gray (No. 1) chisel-tip marker

4. Black fine-tip marker

5. Another chisel-tip marker of any color — red, for instance

6. Ordinary sketch paper

7. Heavyweight vellum

8. Turpentine (a solvent/thinner for oil-based markers)

9. Q-Tip cotton swabs

10. Facial tissue

11. Soft cotton rag or other absorbent material for wiping marker tips clean

Simple Stroke Exercises

First off, take a sheet of sketch paper and use the fine- and chisel-tip markers to produce a variety of strokes, such as those illustrated in Figure 1. The difference in line weight or boldness in the top row is merely a function of pressure on the marker tip: the harder you press, the wider the line. Speed can also contribute to line width when you apply oil markers on such absorbent surfaces as sketch paper. A slow stroke allows more ink to flow outward from the tip.

The middle row of strokes are straightforward products of a chisel-tip marker. Figure 1D is an example of the somewhat

wider line you'll get if you have one of the oversize or "giant" markers available. Figure 1E demonstrates the width of the longest side of the more common chisel-tip marker. And Figure 1F is comprised of strokes made with the thinner edge.

Now do some experimenting with the corners of your chisel-tip marker similar to the lines of the bottom row of panels in Figure 1. There are other possibilities not illustrated. Twist and rotate the marker as you stroke across the paper. Vary the pressure and/or angle of the tip against the paper. Dab the paper with various tip edges and corners. Spend the time filling a sheet or two with similar experiments. When you feel acquainted with marker possibilities, when you're relaxed and comfortable with this new medium, continue on to Figure 2.

Blended Tones

The nine progressively darker squares in Figure 2 were achieved with only three markers: No. 1 gray, No. 5 gray, and black (respectively, Figures 2A, 2E, and 2I). This can be done in two ways, depending upon whether the painting surface is permeable or impermeable. With permeable paper, each succeeding square could be produced by one, two, or three additional overpainted layers of inks. Each layer is absorbed into the paper and contributes to a progressive darkening.

However, with impermeable papers — such as vellum, which is what was used here — the situation changes. After one or at most two overpaintings, additional layers of ink result in minor, if any, darkening. This is because the existing inks don't penetrate into the paper; they merely dry on the surface. Thus, the solvent carrier in which marker dyes are dissolved tends to rewet inks previously deposited, with the result that the marker tip shoves aside existing ink layers. Consequently, while Figure 2C could be produced by three layers of No. 1 gray ink, it can also be attained by thinning No. 5 gray with No. 1 gray. The next square (Figure 2D) is created similarly; the difference is the amount of pressure exerted on the No. 1 gray marker as you overpaint No. 5 gray.

Figure 2F is No. 1 gray overpainted with No. 5 gray. Following this is a black square toned down with No. 1 gray (Figure 2G). Then comes a black square diluted with No. 5 gray (Figure 2H). You can produce equivalent tonal studies in color, using light red, red, and dark red markers, for example. Another worthwhile exercise is to use the same tack with No. 1 gray, red, and black. Or try blue, red, and green.

Figure 3 adds another dimension to blended tones. Here, you stroke in a dark, pure color — say, black or red — on a sheet of vellum. Then you overpaint that with No. 1 gray and work out onto virgin paper. (Note: Every time you do any overpainting,

A One coat of No. 1 gray

B Two coats of No. 1 gray

C Three coats of No. 1 gray or thinning No. 5 with No. 1 gray

D Different pressure No. 1 gray on No. 5 gray

E Pure No. 5 gray

F No. 1 gray overpainted with No. 5

G Black toned down with No. 1 gray

H Black diluted with No. 5 gray

I Pure black

Figure 2. These nine gray squares were produced on vellum with only three markers: No. 1 gray, No. 5 gray, and black. On permeable papers darker grays (or other colors) are achieved by overpainting.

Figure 3. On nonabsorbent papers, blending is very simple because previously applied inks are rewetted by subsequent marker strokes. First, put down a stroke of black or other color on a vellum sheet (left). Then work outward from one edge with a light gray or lighter color, and achieve the lightest possible shade. Another variation (right) is blending in the center between two parallel dark strokes.

Figure 4. Another method of blending involves turpentine. An inked-in area on vellum (left) can be transformed into the cloudlike area (right) with a Q-Tip moistened with turpentine. Be careful not to use too much turpentine, or you'll "erase" the marker inks.

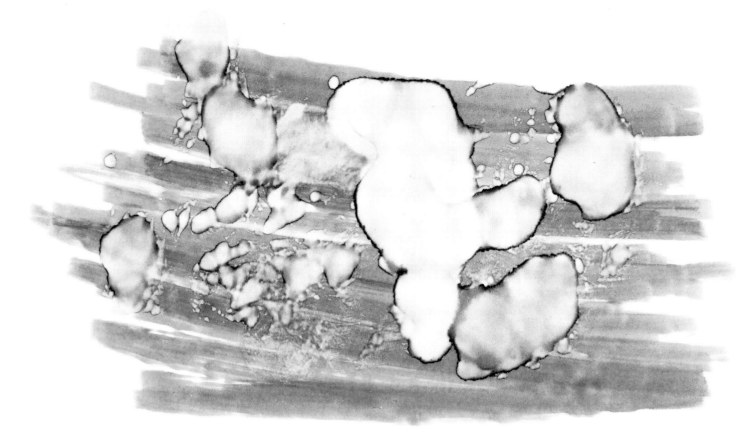

Figure 5. This effect was obtained by dotting the marker inks with turpentine from a Q-Tip, then patting the area with a wadded facial tissue. The turpentine might also be sprayed from a bottle of the Windex variety.

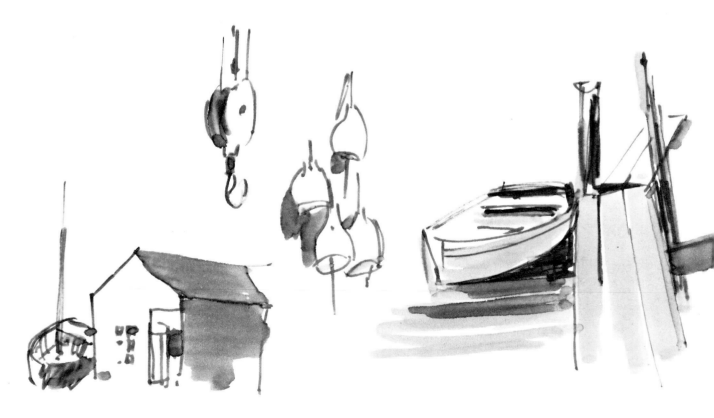

Figure 6. Here are some simple studies done on vellum. Note how the last color applied tends to rewet and obliterate existing colors and lines.

wipe the marker's tip, or the subsequent stroke will be an impure mixture, containing some of the color picked up from the area that was overpainted.) Another exercise shown in Figure 3 involves blending with No. 1 gray from two parallel dark strokes toward the center. Try this same technique with red and No. 1 gray — or with any two colors.

Blending With Turpentine

Return to Figures 2 and 3 for a moment and repeat these exercises once more, but this time substitute a turpentine-moistened Q-Tip for the No. 1 gray marker. The Q-Tip should just barely be moist; dip it, then squeeze and wipe it almost dry.

Figure 4, also executed on vellum, demonstrates what happens when a small quantity of turpentine is actually poured over a stroked-in area. Observe how this technique simulates the appearance of wash or watercolor. In all cases where a wash is mentioned, we refer to laying in a pure color, then thinning it with turpentine — unless water-soluble markers are used, in which case water is substituted for turpentine.

Figure 5 furnished another illustration of how turpentine affects marker inks. Here, a relatively wet Q-Tip was used to blend in the large central shapes. While these amorphous areas were still wet (turpentine dries much slower than marker inks), a piece of facial tissue was wadded and patted over the still wet inks, then transferred and patted down in adjacent regions. As the tissue absorbed some turpentine from the still wet region, it was transferred to other parts of the filled-in background and created interesting textural effects, not unlike clouds.

Now take a fresh sheet of vellum and render some objective subjects (see Figure 6). Remember that the last color applied has a tendency to blend or eradicate existing colors. Hence, to paint something resembling the rowboat and pier in Figure 6, the background colors should be blocked in first. Then the fine details are added with a fine-tip marker. We'll return to this concept of foreground emerging from background in later chapters.

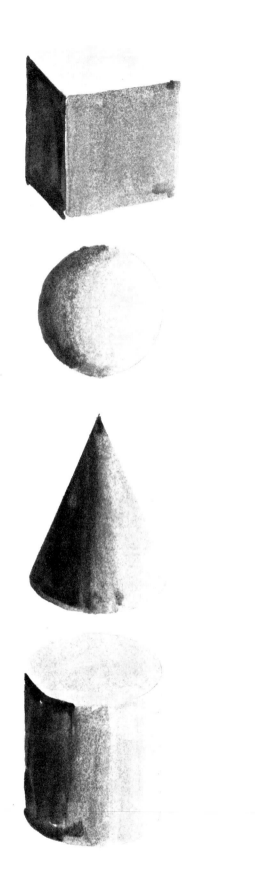

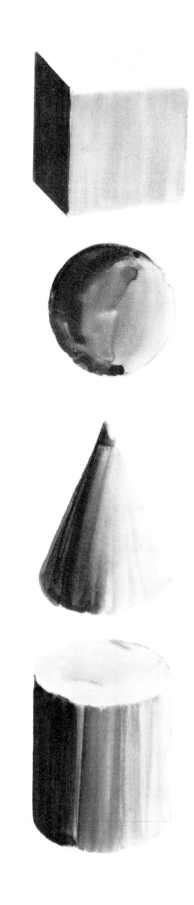

Figure 7. Here are examples of light-to-dark progression done on illustration board. The cube and the cylinder, for example, were done by applying Nos. 1, 5, and 9 grays in that order. On the other hand, the sphere and the cone were done with only No. 3 and No. 5 grays.

Figure 8. Dark-to-light progression can be done on vellum or other impermeable papers. All figures were rendered first as a dark silhouette; later lighter tones were added over the darkest ink. Tips should be wiped and tested on scrap paper to be sure that the color will be pure and not muddy.

Chapter 4
SHADOWS
AND
HIGHLIGHTS

After you put a line around a given space on a sheet of paper, the next task is to give dimension to the flat form. This, fundamentally, is a matter of judiciously using shadows and highlights. The theory and practice of simulating depth is beyond the scope of this book — but how to execute shadow and highlight with markers is something else. This is what we'll study in the next few pages.

Necessary Materials

To duplicate the work illustrated in this chapter, you'll need the following materials:

1. Black or No. 9 gray marker

2. No. 5 gray marker

3. No. 3 gray marker

4. No. 1 gray marker

5. Heavyweight vellum

6. Sketch paper or illustration board (the latter preferred)

7. Turpentine

8. Q-Tips

9. Watercolor brush, small

10. Paper towel

You might also want to try using a color or two, in which case you'll need at least two, maybe three, hues of the color — plus umber and/or burnt umber for darkening.

Two Ways of Shading

Let's look at Figure 7. The cube is merely three flat planes of tone — Nos. 1, 5, and 9 grays. The sphere takes more energy. It was executed with No. 3 and No. 5 grays, used in that order. The lighter shade was first used to completely fill in the figure, then built up in intensity with circular strokes that overlapped more and more often in the direction of the shadow. A crescent shape of No. 5 gray was added. Then, hurriedly, the No. 3 gray marker was again used to soften the border between the two shades. Considerable pressure must be used to blend out the darker color. With slight modifications, this same method produced the cone and cylinder.

On nonabsorbent surfaces, however, any subsequent laying in of marker colors exposes the previously applied inks to the solvent in which the dyes are dissolved, and the solvent again dissolves or "rewets" the underlying inks. And so, you can overpaint or rework an area for an indefinite number of times — even switching back and forth between black and white.

Highlights and Blending

In Figure 8, the order of marker use is reversed. The sphere, the cone, and the cylinder were executed by first stroking in the dark tone. The edges were rewetted and softened with very light pressure on the lighter marker. The ink picked up by the second marker's porous tip gradually is depleted during the following strokes until, near the edges of the figures, the shade returned to almost pure No. 1 (or No. 3) gray.

Figure 9 contains three of the primary geometric shapes: a cube, a cylinder, and a cone. Add a sphere to the list and you have the solid figures in Figures 7 and 8. Compare the last two illustrations carefully because they depict the two basic approaches to shadowing with markers: the first is working from light to dark, and the second is working from dark to light. Which technique you use depends largely on the painting surface. If it is absorbent, you progress from light to dark, as in Figure 9. On the other hand, if your paper is nonabsorbent (vellum, for example), you can reverse the procedure and work from dark to light. Nonabsorbent surfaces also admit light-to-dark executions, but the converse is not true: going from dark to light generally isn't satisfactory on absorbent surfaces. It's because the very quality of absorbency means the marker inks seep into the surface and thus become difficult, if not impossible, to remove. An attempt to overpaint a dark area with a lighter shade is, consequently, futile.

Now suppose you have a dense color and need to add a thin strip of lighter color. On nonabsorbent surfaces this presents no problem. Simply paint over the dark color. As shown in Figure 10, the rewetted dark ink is easily blotted up by the marker's tip. Using a No. 1 gray, you can achieve a shade so light that it appears to be virtually the shade of virgin paper — especially if the light area is completely surrounded by a darker shade. (Caution: wipe the tip frequently to avoid muddy effects. This is particularly important when two different colors, such as red and green, are involved.)

Finally, repeat the exercise illustrated in Figure 8, this time using just the darker color. Accomplish the blending and thinning with a Q-Tip which has been dipped in turpentine and squeezed almost dry in a paper towel or cloth. Also repeat Figure 10, but obtain the highlights with a Q-Tip and a small watercolor brush. If desired, you can attempt to duplicate Figure 7 on illustration board by the same procedure. You won't be able to do it, as explained above, but the attempt will be instructive.

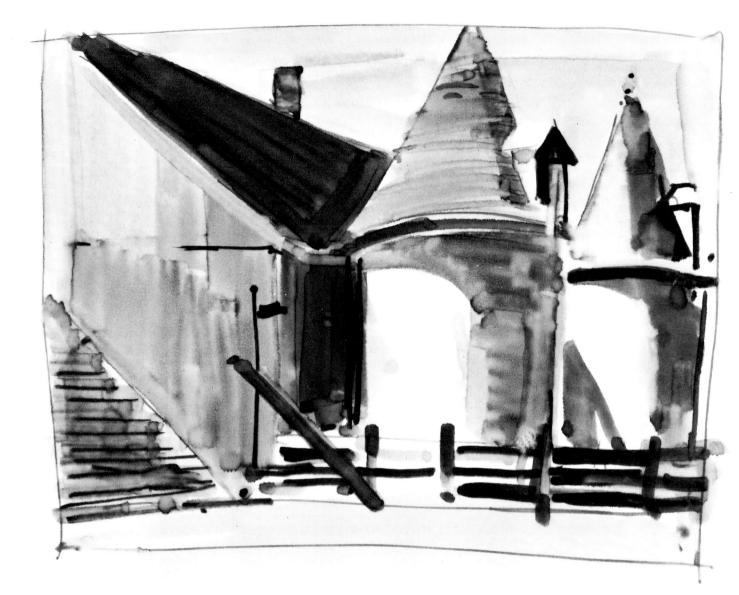

Figure 9. (Above) When you work on impermeable surfaces such as vellum, which is what the artist used here, shadows can be rendered in either of two ways. The first is adding the shadow on top of other colors. The other is the reverse — putting in the shadows and then painting lighter tones over the darker inks. Cylindrical silos were executed by the latter method. Dark-to-light progression, which can be used only on nonabsorbent surfaces, is also evident if you trace the barn's roof line from upper left down to center left.

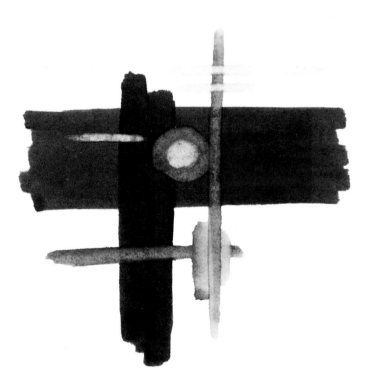

Figure 10. (Left) Lightening dark tones — and blending — can also be achieved with a Q-Tip moistened with turpentine or with a watercolor brush. A combination of markers and a Q-Tip containing turpentine was used to execute the abstract figure.

BLENDING
AND
TEXTURING

In this chapter we'll present the two basic approaches to blending colors, and then suggest a few of the multitudinous techniques for achieving texture. Our objective is merely to point out the bare essentials in order for you to comprehend what the artists are doing in the painting projects later in the book.

Materials to Have on Hand

Here are the materials you'll need for the following exercises:

1. Markers — Nos. 1, 3, 5, 7, and 9 grays, also black and fine line black

2. Vellum

3. Marlite panel (Masonite with white plastic coating)

4. Turpentine

5. Spray bottle (an old Windex dispenser, for instance)

6. Rubber cement thinner

7. Q-Tips

8. Facial tissue

9. Paint roller, small

10. Quill feather, large

11. Bough of leaves, small

12. Paper towels or rags

Adding or Subtracting Colors

Figure 11 pretty well sums up your options. Colors have been modified by mixing two or more inks, by superimposing (which can produce either a lighter or a darker shade), and by thinning. The first stem segment, for instance, was produced with three strokes. The first stroke was done with the longest side of a No. 7 gray marker's chisel tip. The second was done with the edge of a No. 5 gray tip, starting off to the left, intersecting the No. 7 gray line near its midpoint and then continuing downward over the darker gray. And the third was done with another stroke of No. 7 gray superimposed above the intersecting stroke, using the narrow edge of the tip to lay in color on color with very light pressure on the marker, resulting in a deepening of the shade.

In the middle stem example, No. 1 gray has been superimposed over No. 7 gray — but with moderate pressure on the marker. Hence, the rewetted No. 7 gray ink is largely removed, pushed aside, and blotted up by the No. 1 gray tip. (Remember to wipe the tip after each such stroke to clean out the contaminating color.) Essentially, the same effect could also be obtained by using a small watercolor brush dipped in turpentine and wiped nearly dry. A wetter brush would produce something a little different, as would a brush containing rubber cement thinner. For outdoor painting, turpentine in a refillable marker, such as Flo-Master, is convenient.

The catkins (or aments) were handled similarly. At upper right in Figure 11 are three steps for rendering one of the pussy willow's namesakes (it looks like a kitten's tail) when you start with a dark shade. The No. 7 gray ovoid was reworked with No. 3 gray, then the "husk" was added. This technique, as you can see, emphasizes the outline. Another method is to start with No. 3 gray and pick up a little of the darker ink by rotating the marker tip through the stem, which is demonstrated in Figure 11 at bottom right. Both techniques are suitable and choosing between them is probably best left to individual conditions. Lighting, for instance, or the desired effect in relation to other painting elements could induce your choice.

Thinning and Blending

How you thin or blend colors — what technique you use — can noticeably affect the outcome. You should be familiar with the differences between obtaining lighter shades by thinning and by blending — and between thinning with turpentine and with rubber cement thinner. The latter dries appreciably faster and does not "attack" marker inks with quite as much vigor as does turpentine. The three large squares in Figure 12 were executed as follows: Figure 12A — solid black washed with turpentine, using a Q-Tip; Figure 12B — solid black washed with rubber cement thinner in a Q-Tip; and Figure 12C — blended grays, Nos. 9, 7, 5, and 1.

One of the advantages of turpentine's slower drying rate is shown in Figure 12D. This interesting texture is a result of washing solid black with a fairly wet Q-Tip, then, with a crumpled facial tissue, patting the turpentine before it dries. This texturing technique is almost infinitely versatile. You can design the blotter by folding the tissue in a predetermined manner and lifting off the wet colors in such a way as to create the impression of, say, vegetation (see Figure 13). Or you can use the object you want to emulate in the painting. A feather makes a good blotter. Simply roll it down with a small paint roller, and you'll obtain the effect as in Figure 14. Try this same approach with a small bough of leaves (the ink will not be blotted up but will nevertheless take a pressure pattern), an individual maple leaf, rough-textured cloth (such as burlap), or anything else that comes to mind.

Figure 11. (Right) Three primary methods of blending colors on impermeable paper are shown here. The first stem shows *mixing*, which involves overpainting one color with another, with moderate to heavy pressure exerted on the marker tip during overpainting. The second stem demonstrates *superimposing* colors — light on dark or dark on light — wherein overpainted color is applied with light pressure so as not to completely disturb the existing color. *Thinning* produced the catkin on the last stem. A Q-Tip moistened with turpentine was rotated through the stem to pick up color.

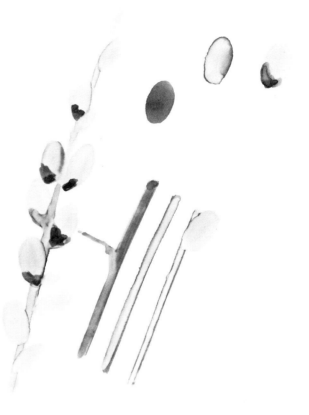

Figure 12. (Below) The choice of mixing or superimposing versus thinning can affect the finished result. All of these squares were originally solid black.

A Washed with Q-Tip and turpentine

B Thinned with rubber cement thinner

C Blended with Nos. 9, 7, 5, and 1 grays

D Washed with turpentine, patted with tissue

Second-Color Texturing

With slight modification, this technique can also produce second-color texturing. Here, instead of blotting up wet ink, allow the ink to dry and then paint the feather, leaves, cloth, or what-have-you with a marker of another color and quickly roll the feather down on the painting. A crumpled facial tissue can be employed, also. To avoid the necessity of haste, because marker colors dry so rapidly and must be immediately transferred, you can paint the feather and then spray it with turpentine which will retard the drying rate. Stiff Marlite panels are an ideal surface for this technique, especially if you work on an easel.

This "stamp pad" technique (for want of another description) may seem rather artificial, but if it isn't inappropriate for a given painting, what sense does it make to laboriously draw a feather or other texture if that appearance can be created in a fraction of the time by this technique? After all, the quality of a painting is not determined by the materials an artist uses, but by his skill in handling those materials.

Now, before you progress to the next exercise, it's suggested that, if you have a selection of colored markers other than the grays we have been using, you repeat the foregoing exercises in various colors. It isn't important what colors you use, or whether they are the "right" colors for executing a pussy willow or a feathery texture. What's important is that you gain experience with combinations of colors and learn how they interact on a painted surface.

Figure 13. (Above) These leaflike patterns or textures were blotted up by pressing facial tissue on wet marker inks. Facial tissue can be crumpled or folded in various ways to simulate a multitude of shapes and surface characteristics. Different colors of ink can be applied with the tissue.

Figure 14. (Below) Another approach is to blot up color with the object being portrayed. A feather works beautifully, as illustrated here. Also note that a rubber roller can be used to apply color as well as to take it up. Leaves are another good subject for this technique.

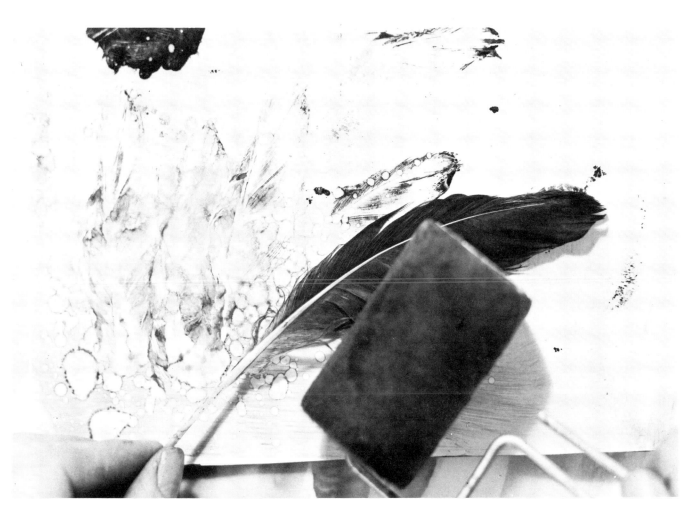

Figure 15. The entire tree was outlined with brushed-on gum water — negative stenciling. A few brushstrokes of gum water were applied in the trunk for texture — positive stenciling.

MASKING
AND
STENCILING

The "stamp pad" transfer technique isn't the only shortcut to which you have access when you paint with markers. Stenciling is another very important time-saving technique. It'll enable you to obtain effects with minimal effort — effects that would otherwise be excruciatingly difficult. As you'll discover in this chapter, and in the opening pages of the project that follows, stenciling is a work-horse technique adaptable to widely diverse purposes, including major contributions to your texturing repertoire.

Materials to Have on Hand

Here are the materials you'll need to work your way through the following exercises:

1. Nos. 1, 3, 5, 7, and 9 grays (colors may be substituted if you like)

2. Vellum

3. Coated cover stock

4. Illustration board

5. Flint paper (or other thin, smooth paper)

6. Turpentine

7. Q-Tips and cotton balls

8. Drawing board

9. Roll of 1" wide white correction tape

10. Single-edge razor or, better, utility knife

11. Gum water

12. Rubber cement

13. Ruling pen

14. Tube of opaque white gouache or watercolor

15. Inexpensive camel's hair watercolor brush

16. Cake of soap

Two Types of Stencils

Fundamentally, there are two types of stencils: the mask is "positive" or it's "negative." If positive, the mask is painted on to represent something (a tree, for instance) that you wish to preserve for subsequent execution or which you intend to leave untouched. Negative masks, on the other hand, are painted around something (such as a tree-shaped area) to protect the rest of the painting surface while you execute the exposed portion.

Figure 15, a detail from the painting project immediately following this chapter, illustrates the use of both types, positive and negative. First, the entire tree was outlined with gum water on pyroxylin-coated cover stock. Some of the small branches were added later and not included in this original design. Next, somewhat away from the outline, the remainder of the painting surface was covered with a gum-water mask, applied with a camel's hair watercolor brush, leaving the tree area exposed. Then a few more brushstrokes with gum water were added within the trunk. These are the white texture regions visible in Figure 15. When the gum water was thoroughly dry, the artist almost recklessly stroked in marker colors, knowing that the colors would "take" only where they touched unmasked paper. After he gave the colors several minutes to dry completely, the mask was removed. You can remove the mask by rubbing or — on waterproof surfaces such as vellum, acetate, or coated cover stock — you can wash off a gum-water mask under a running tap.

Advantages of Stenciling

Not only does stenciling free the artist from concern about controlling color lay-in to within the necessary parameters, depending upon what's being rendered, but it also provides a means of executing fine details that would be problematical even with some fine-tip marker tips. Also — and most important — stenciling yields crisp, sharp edges that can be handled to give a painting an appealing modernistic air.

Painted-on stencils can be produced with a variety of media. Gum water is good because it seems to dry "harder," but friskets and maskoids are marketed by several manufacturers, and you may find one of these to your liking. Lacking one of the specialty products, you can use ordinary rubber cement. Figure 16 was done with such a stencil. Note the black irregular shapes near the center and elsewhere. These are unremoved rubber cement. Marker inks produce denser tones on rubber cement than they do on certain papers, such as vellum, which is the painting surface pictured. Were the extra density desirable, part or all of the mask could be allowed to remain.

Painted-Stencil Technique

As the book progresses, several modifications of the painted-stencil technique will be introduced. There's one in particular that produces exceptional textures (Figure 17). The veined, filamentlike effect in the evergreen tree is an example. It's

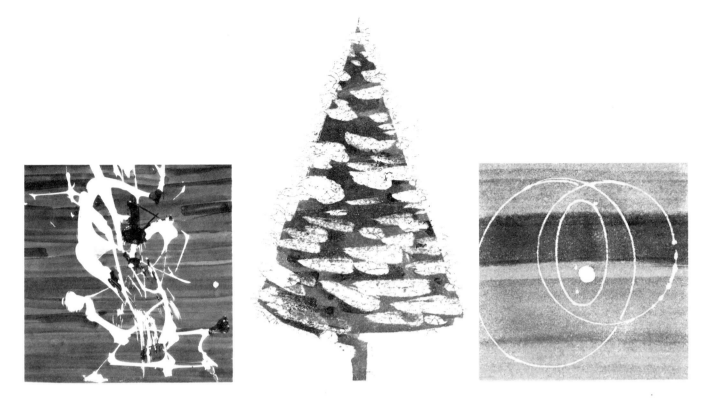

Figure 16. (Left) Brushed-on stencils can be produced with several mediums. Even rubber cement will work, as shown here. Note the clean, crisp edges which are characteristic of stenciled work.

Figure 17. (Center) The light portions of the Christmas tree were produced with a brushed-on stencil on illustration board. Note the fine, filamentlike texture. The effect was achieved by mixing gum water (liquid frisket may also be used) with soap bubbles.

Figure 18. (Right) Also done on illustration board, geometric forms are indicative of liquid stenciling applied with a ruling pen for precise effects.

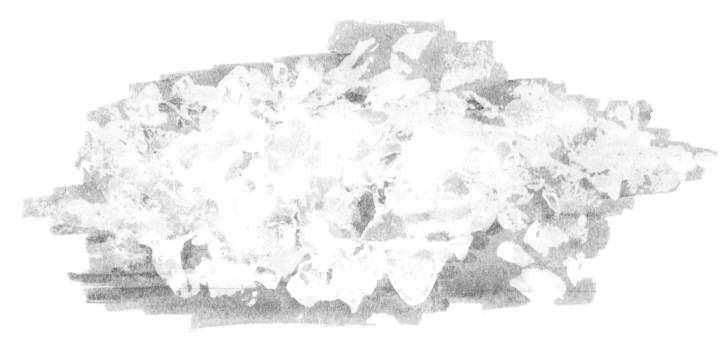

Figure 19. This painting of a horse and carriage was done with white gouache virtually squeezed from the tube and minimum use of a brush. Before the paint dried, the scene was pressed onto another illustration board and lifted off; the original painting was shifted, then again pressed onto the illustration board. This process was repeated, then the upper board was lifted off and the white paint allowed to dry. A No. 7 gray was superimposed. Last, the paper was brushed with a Q-Tip wetted with water, and then sponged, which removed most of the thickest deposits of opaque white. Thinner areas of white remained, lightening the color of the ink.

produced by mixing gum water with soap suds — the frothier the suds, the better. Combine the two ingredients in a palette cup, whipping them with your brush, then paint the bubbles on the paper (in this case, illustration board). When the mixture has dried — and it'll take quite a while — the soap bubbles will have cracked and fissured, leaving tiny crevices through which the marker inks can penetrate to the surface of the board when you overpaint. Wait a few minutes, rub off the mask, and there'll be an intriguing texture. Slight variations of the proportion of soap to gum water — the mixture's frothiness, the type of soap used (cake soap is recommended, although liquids will work), even the hardness or softness of your local water — all these factors will affect the outcome. So be prepared to do some experimenting. (The rather precise shaping of the tree's cone outline is due to another stenciling technique, to be discussed shortly.)

You can see the results of applying a gum-water mask with ruling pen and drafting template in creating geometric forms in Figure 18.

"Stamp Pad" Transfer Technique

Still another variation is shown in Figure 19. This employs a combination of "stamp pad" transfer and stenciling. The materials involved are two sheets of illustration board, opaque white paint, a brush, and one marker (No. 7 gray was used here). This is the procedure. Start by using opaque white to paint a scene of your choosing (the one in Figure 18 began with a horse and carriage, which is partially discernible at bottom center). Put the opaque white down thickly on the illustration board, squeezing the paint straight from the tube and manipulating it as little as possible with the brush. Now cover the design with another sheet of illustration board, face down. Press the two boards together. Alter their respective position. Perhaps you can rotate one and/or shift the other. Press them together again. Repeat a third time and a fourth, then lift the covering board off and let the white paint dry. Later, superimpose marker ink, wait a few minutes, then gently wash the painting with a cotton ball wet with water. This will remove all the thickest opaque white and most of the thinner areas. However, some of the thinner white will remain, tending to lighten the marker ink by a shade or two.

Cut Stencils — the Old Standby

Practically everyone is familiar with one form of stenciling which involves words, letters, and numbers painted through cut-out stencils on articles ranging from orange crates to military equipment. And the same basic technique can be used with markers. We've already seen one case in point, the evergreen tree (Figure 17). The over-all shape was cut into paper, the cutout positioned over the painting surface, and then the marker inks stroked on.

We'll return to painting through cut stencils later. Meanwhile, it should be noted that cut stencils can also be employed to *remove* marker colors from impermeable surfaces with equal ease. Example: a block of color was applied to pyroxylin-coated paper. Next, a free-form stencil was cut in a square of flint paper with a utility knife (Figure 20). Then this stencil was

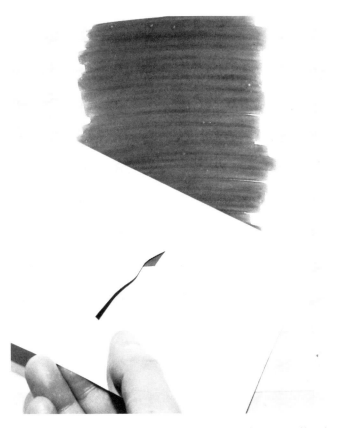

Figure 20. Stencils can also be used to remove marker colors. Here is a block of color on impermeable paper and a free-form cut paper stencil.

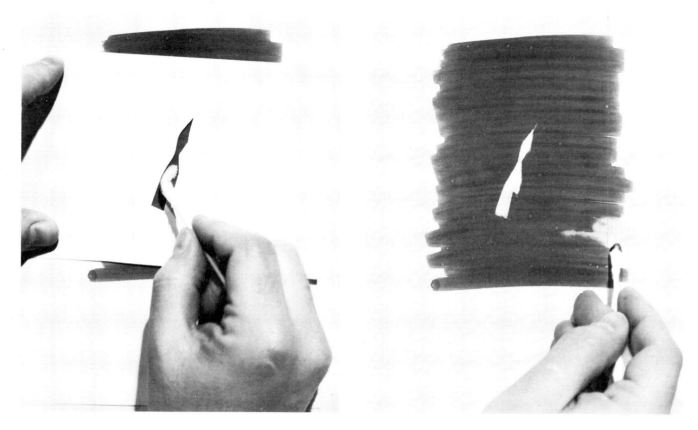

Figure 21. Place the stencil on the color block, then pick up the color through the stencil with Q-Tip and turpentine.

Figure 22. This is the result, with color removal sharply defined.

placed over the color block and a Q-Tip moistened with turpentine was used to pick up the ink through the stencil (Figure 21). In Figure 22, you see how sharply defined the "reverse stenciled" figure is. To ensure crisp edges, use the smoothest paper possible for the cut stencil; rough or textured paper may allow some turpentine to seep under the edge.

Now let's put together some of the techniques studied so far and create a design similar to the one shown in Figure 23. This begins with a square of solid color — No. 7 gray — about 3" on each side, with vellum as the painting surface. Overpaint a block letter U shape along three sides with No. 9 gray or black. Cut a nickel-size circle in a small piece of flint paper and use the cutout to stencil a circle overlapping the dark and medium grays. Pick up all the ink with turpentine and a Q-Tip. Cut an elliptical shape in another piece of flint paper and paint through it with No. 9 gray, the ellipse jutting slightly into the now white circle. Four barlike stencils then complete the design. At the top, in the center of the U, is a bar stenciled with No. 1 gray over the No. 7 gray. (Remember: wipe the lighter marker's tip to clean off the darker ink.) The narrow bar at left and the long horizontal bar are stenciled with Nos. 3 and 5 grays, respectively. Last, another vertical bar is "reverse stenciled" with turpentine and a Q-Tip. Once you have the hang of it, use the same stencils with a selection of color markers and create an original design. Exercises such as these will be quite instructive.

Cut Masking-Tape Stencils

And here we are, at the end of the beginning. You've experimented with various techniques and tools — enough so that you can continue on to the painting projects which follow and quickly grasp the significance of the new thrusts in technique, style, and materials. The last exercise, coming up, leads directly into the first project — painting trees.

One of the characteristics of cut stencils is their simplicity of line. The use of a knife or single-edge razor usually precludes too great an involvement with minute details. They're just too hard to cut accurately. Hence, if you want a feeling of starkness, a cut stencil is ideal. The trouble is, large stencils cut in paper are cumbersome; it's easy for ink to run under the edges. Moreover, this problem is complicated if two or more colors are applied.

Solution: instead of cutting the stencil in paper, cut it in tape. That way, you can affix the stencil to the painting surface and press down the cut-out edges to seal against unwanted ink flow.

Making the Masking-Tape Stencil

To make a masking-tape or cut-tape stencil, you'll need the tape. A good choice is white correction tape, a relatively smooth white masking tape. In addition, you have to cut the stencil on something: a drawing board is good; a Masonite panel is another possibility. Be sure the surface is clean. Otherwise, the tape will lift off dirt or oils that can prevent secure adhesion to the painting surface. Then, starting from one side of the cutting surface and working toward the other, lay down strips of tape about twice the length of the intended size of your subject (in this example, a tree). Each successive strip

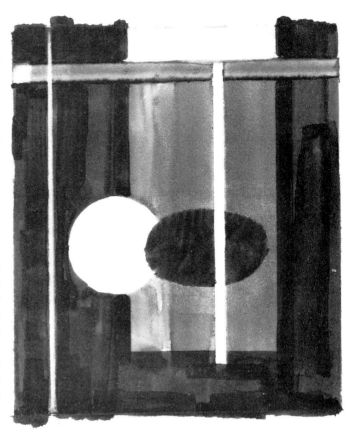

Figure 23. This abstract exercise combines most of the cut-stencil techniques. Begin with a square of solid No. 7 gray. Add an overpainted U-shaped area in black or No. 9 gray. Pick up a nickel-size circle using a cut paper stencil and Q-Tip. Cut out an ellipse and overpaint it with No. 9 gray. Stencil in a couple of bars and reverse-stencil (erase) another.

should overlap the previous one in shingle fashion. The amount of overlap is important. Not enough and the stencil will pull apart when you lift it to transfer it onto the painting surface. An overlap of about half the tape's width is adequate (Figure 24). Continue laying down tape strips until you have a margin of at least two or three strips of 1"wide tape on either side. Then draw the subject tree on the tape.

With a sharp utility knife, cut along the outline drawing (Figure 25). Don't worry if the knife refuses to follow every little variation in contour. For this painting, the motto is "the simpler, the better." When the entire outline has been cut, peel away the tree area. This is necessarily done in steps by first removing the trunk (Figure 26) and then the limbs. Use the knife to sever the limbs from the trunk.

Now, before you attempt to lift the stencil from the cutting surface, reinforce it, top and bottom, with crosswise strips of tape (Figure 27). Additional reinforcements, to prevent the stencil from pulling apart at its seams, are advisable along the sides, too.

Carefully peel the stencil off the cutting surface and lay it on the painting surface (Figure 28). In this case, the painting surface should be an impermeable surface such as pyroxylin-coated paper (also known as pyro cover stock). Affix the stencil firmly by brushing it down with your hand, working from top to bottom as if the stencil were wallpaper. Be careful to avoid wrinkles. Finally, when the stencil is flat, go back over the cut-out edges, exerting pressure with a fingernail or other hard object, to iron down these edges. You want to be sure that no ink will seep under the edges of the tape. When you've done this, the stencil is ready to use. Painting of the tree is demonstrated in the first project.

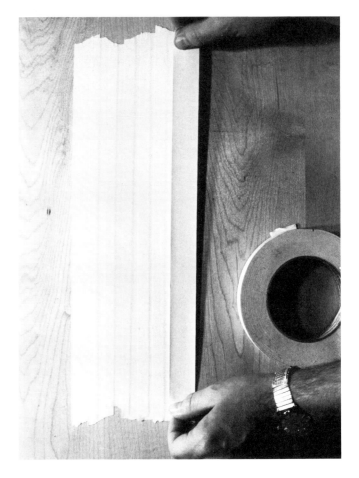

Figure 24. To make a masking-tape stencil, begin by laying down overlapping strips of white correction tape. Strips should overlap about half their width to prevent the completed stencil from pulling apart. Use an old drawing board or other surface that won't be ruined by knife cuts.

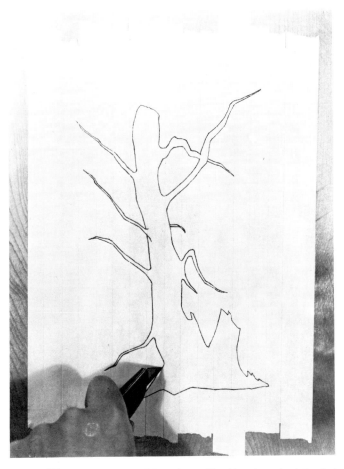

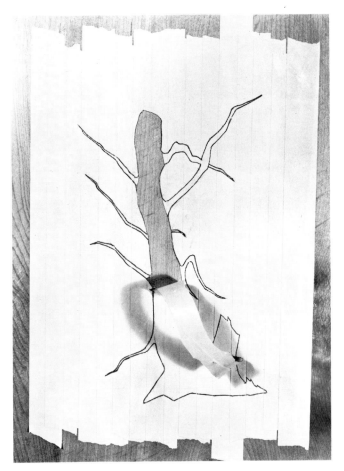

Figure 25. When the stencil is at least 2″ wider than the intended subject, draw the outline directly on the tape. Take a tree for your subject and you can use it for your own project on painting trees. After you've outlined the tree, cut along the sketch with a sharp utility knife or single-edge razor blade.

Figure 26. Remove the cut-out areas. This is easier to do if you do it in stages — the trunk first and then the limbs. Cut through the trunk-limb junctures with the knife.

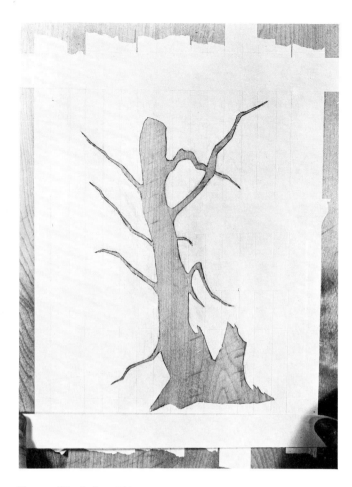

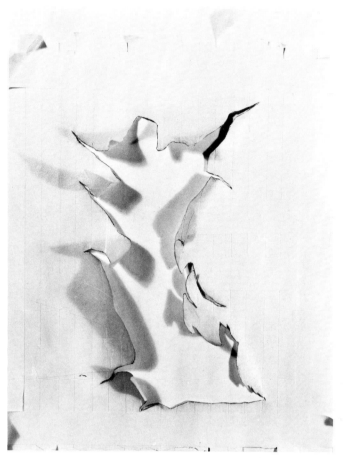

Figure 27. Before lifting the stencil from the cutting board for transferral to the painting surface, reinforce the stencil with tape strips crosswise at the top and bottom. Other crosswise reinforcements along the sides are also recommended.

Figure 28. Peel the stencil from the cutting surface and place it on the painting surface. An impermeable, hard-surface paper is suggested, such as the white pyro cover stock used here. At first the stencil will look like this. Then press down the cut-out edges as if the stencil were wallpaper. Work from top to bottom and take care to avoid wrinkles.

PAINTING
PROJECTS

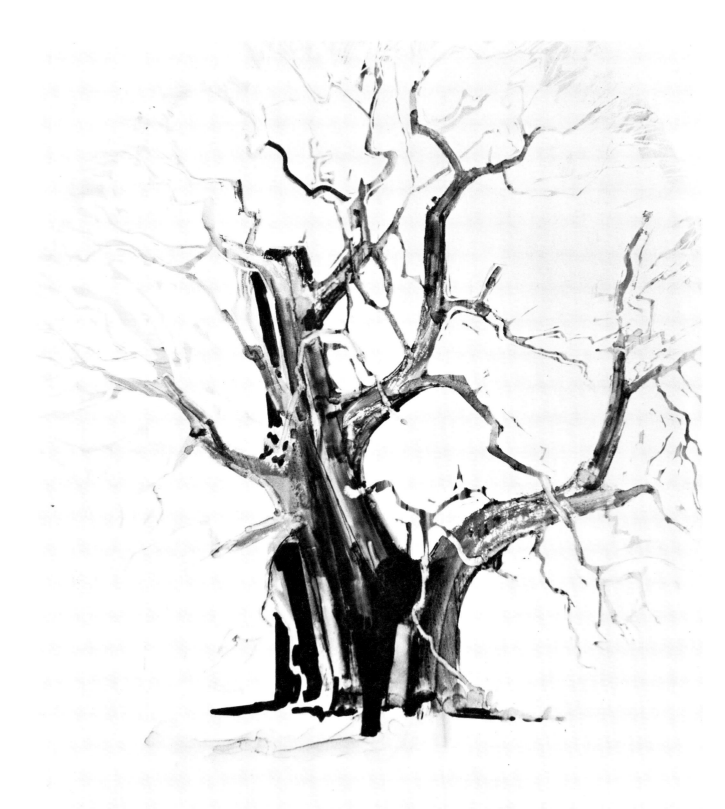

Oak Tree. Developing trees to the point of including twigs — as in this stylized study of an oak — pretty well precludes the use of tape for stenciling. Few artists would venture painting as freely in this study without the use of a stencil. So a brushed-on stencil was used on coated stock. Sudsy frisket was used to achieve texture in several spots.

Having worked your way through the exercises, you're now in a position to appreciate the tremendous versatility of porous-tip markers. For our first group of painting projects, you'll put that versatility to the test with one of the most challenging subjects that confronts an artist — trees. Often, beginners try to copy trees literally. But the attempt is frustrating since trees are overwhelmingly complex. They need to be simplified. An artist must distill the essence from superfluous details, and he frequently must rearrange forms and patterns into a more meaningful whole. For these tasks — and especially for simply and quickly grasping only the essential details — markers are an ideal medium, as you'll see.

Because trees are so intrinsically diverse, we'll employ several techniques already presented to put down on paper the fundamental nature of different species. We'll start with a stark oversimplification that's very easy to do, then become progressively more complicated and interpretive.

Materials Required

In the step-by-step demonstration that follows, these materials were used:

1. Roll of 1" wide white masking tape or correction tape

2. Sharp cutting knife

3. Clean cutting surface (drawing board, Masonite panel, or any other smooth surface that can be sponged clean)

4. Sheet of paper with a hard, impermeable surface, preferably coated or varnished. (Pyroxylin-coated cover stock was used here, but acetate overlay sheets or heavyweight vellum will do.)

5. Selection of blue-black, blue-violet, blue, red-brown, green, and dark green markers.

For subsequent painting studies which you can do, you'll need:

1. Illustration board (see recommendations in Chapter 2)

2. Vellum paper or acetate sheet

3. Canvasette pad

4. Ordinary sketch paper

5. Coated cover stock

6. Masking liquid — gum water or maskoid

7. Selection of markers, plus a Flo-Master fountain brush

With these tools, we'll explore several means of interpreting trees, as well as the component parts of individual trees, and finally create a group of trees in a natural setting.

Painting Trees Simply, Sensitively

The backbone of any tree, of course, is its trunk, thrusting up from the ground with a girth proportional to the bulk of foliage it has to support. The trunk tapers toward the crown as its primary branches cleave and redivide into smaller and smaller branches and twigs. If an artist is perceptive and has made trees his fond companions, all the character and personality of an entire tree can be summed up in a sensitive rendering. Such sensitivity is poignantly evident in Emile Troisé's painting of a weathered old tree, the culmination of the step-by-step demonstration that follows.

To obtain a draftsmanlike precision and simplicity, Mr. Troisé employed a masking tape stencil prepared from memory in the studio after the tree had been studied and sketched on location in Long Island. The benefits of tape stenciling, as explained in the preceding chapter, are mainly threefold. First, stenciling automatically produces bold, crisp edges. Second, it effectively forces the artist to focus on major forms and shapes rather than on details, since cutting small details in the stencil is difficult and irksome. And third, it frees the artist from excessive concern over controlling the application of colors, since the subject is defined by the stencil which masks and protects the rest of the paper. Thus, the artist's painting style can be relaxed.

Review of Making a Cut-Tape Stencil

Here again are the main steps Mr. Troisé used in making a cut-tape stencil to use in painting his tree.

After cleaning the cutting surface so the tape won't pick up dirt or oils that might interfere with adhesion to the painting surface, Mr. Troisé laid down strips of tape in a shinglelike, overlapping pattern, drew the tree on the tape, then cut it out (Figure 29). He discarded the tree-shaped cutout (Figure 30), then reinforced the stencil with crosswise tape strips and transferred the stencil from the cutting surface to the painting surface (Figure 31). Special care was taken that all cut-out edges were firmly pressed down to prevent ink from seeping under. The surface is now ready to paint (Figure 32).

Painting From Dark to Light

Since an impermeable surface is used, it's possible to underpaint selected areas with an appropriate mood color — a color

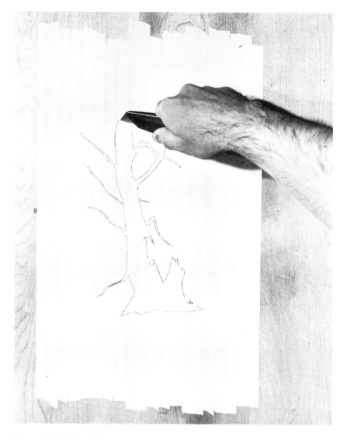

Figure 29. After the overlapping strips of white masking tape are laid down on the cutting board, a sharp utility knife is used to cut along the penciled sketch.

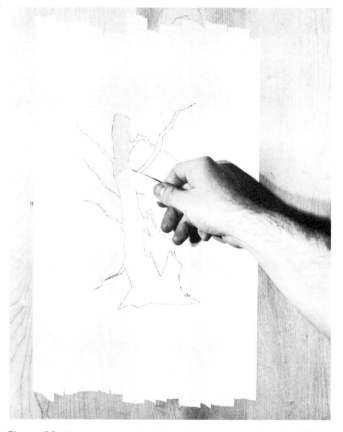

Figure 30. The cut-out portion is peeled away and discarded. This is more easily done in stages, by cutting through the junction of the trunk and limbs so they can be removed without tearing.

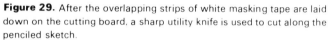
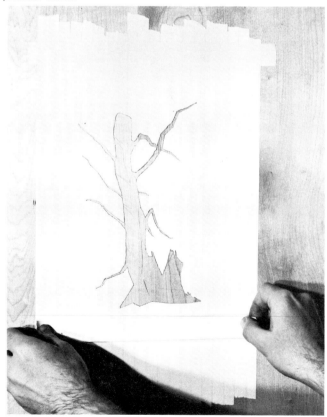

Figure 31. The stencil is reinforced with crosswise strips of tape. This ensures that the stencil will stay in one piece. Then, the stencil is carefully removed from one corner first.

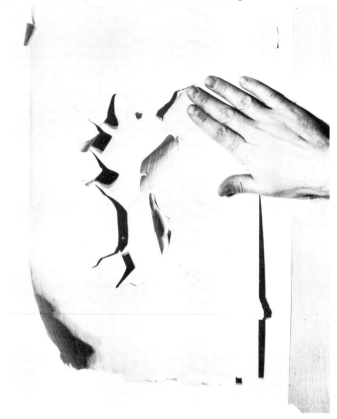

Figure 32. The stencil is transferred to the coated cover stock and is applied as though it were wallpaper. The cut-out edges are tightly pressed to the painting surface so that ink won't seep under and spoil the crisp edges.

which will be blended later into overpainted colors that more closely approach reality.

As these "real" colors are applied, their solvents rewet the dried mood color inks and *physically* mix and blend during the overstroking. How much mixing occurs can be controlled by the amount of pressure exerted on the marker. Pressed hard enough, the mood color will be obliterated, pushed aside and blotted up by the porous tip. Consequently, a dark color can be painted over with a much lighter color, even though it's a transparent ink, and the lighter color will look almost as pure as if it had been put on virgin paper.

With permeable paper and transparent inks, colors can also be blended by superimposition. The underpainted colors penetrate into the paper's fibers and will hardly be affected by the overpainting. No physical mixing of the two inks will occur, and the first color won't be wholly or substantially removed by strong strokes of the second color. Hence, putting a very light color over a dark one is of little value on permeable papers, for the net change will be negligible.

Two characteristics of the weathered old tree on Long Island were so outstanding that Mr. Troisé felt compelled to give them expression through mood colors. The tree's solitude was conveyed with blue. And despite its age and isolation, the tree possessed a remarkable vitality. Green was a natural choice to symbolize this quality.

Mr. Troisé thus began his study by stroking on a deep, rich blue-violet along the left edge, where it would remain relatively undiluted and also function as a shadow (Figure 33). Several adjacent regions that would be overpainted more heavily were colored a colder blue (Figure 34). Then, with long, quick — almost careless — strokes and a minimum of pressure on the marker, the trunk and limbs were filled in with a medium green (Figure 35). While these sweeping strokes followed the tree's contours and overpainted the cold blue areas, little blending occurred because of the light pressure applied. Next, in Figure 36, specific areas were modeled with a darker green and certain shadows were intensified with blue-black (Figure 37).

Finally, Mr. Troisé took a reddish brown marker and went over the trunk and parts of several limbs, exerting light, moderate, or heavy pressure, and stroking rapidly from top to bottom or in the direction of a limb's growth. The tracks of these upward and outward thrusting strokes help give visual evidence of the tree's vitality and solidity while creating a barklike texture. The varying pressures caused some strokes to push aside nearly all of the underpainted colors; others mixed with the existing blues and greens according to the degree of pressure. Except for overlapping strokes, this procedure was accomplished with the fewest possible strokes to preserve sparkle and to avoid muddying the colors.

Following several minutes' pause to give the inks time to dry thoroughly, the stencil was stripped away to reveal the underlying study (Figure 38).

Look closely at the finished tree (Figure 39) and you'll see occasional fuzziness at the edges — a kind of ghost image. This may happen when you use a new or "wet" marker. An excessive buildup of ink will attack the tape adhesive and allow some color to seep under the stencil. For razor-sharp edges, use old or "dry" markers — about half empty is ideal. Or you can clean up the edges by scraping with a razor blade.

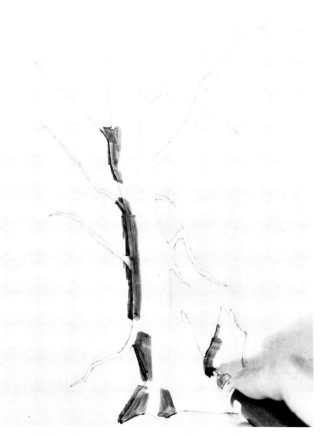

Figure 33. The first color stroked on is a deep, rich blue-violet, chosen to symbolically convey the tree's austerity and loneliness.

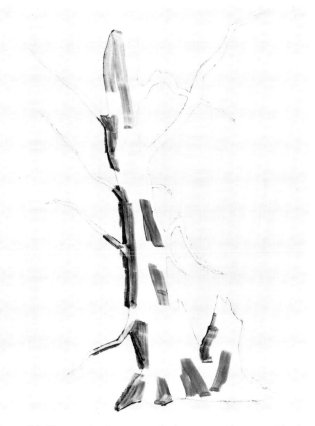

Figure 34. The mood color was worked on top and bottom with a less intense blue. Some meager strokes of this color are brushed along the opposite side.

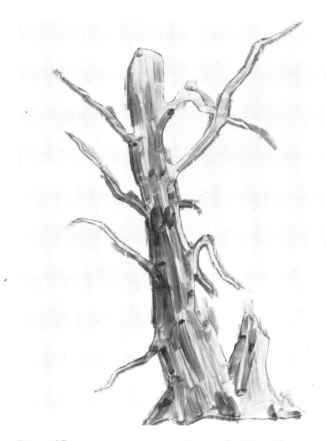

Figure 35. Then, the trunk and limbs are filled in with long, quick strokes of medium green. Minimal pressure is used in following the tree's contours. Some blending with the blue occurs with a light touch.

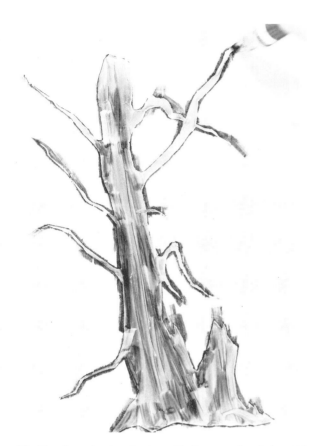

Figure 36. Blending of colors begins with the use of a dark green marker. Some preliminary modeling is done. Not too much pressure is used and the strokes are kept fairly long, conforming to the contours.

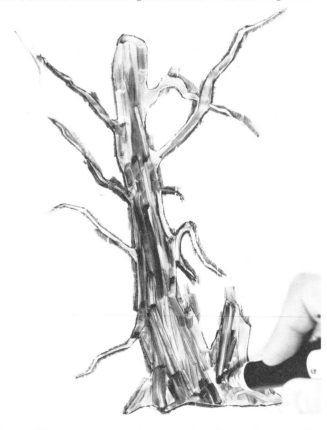

Figure 37. A blue-black marker is used to deepen the appropriate shadows and to enhance the sense of depth in the bark of the trunk.

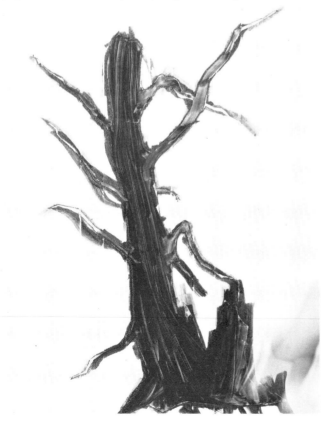

Figure 38. Finally, a reddish brown marker is used to overpaint in long, sweeping strokes. Different pressure is used on various strokes, which produces varying degrees of blending with existing colors. When the colors are thoroughly dry, the stencil is stripped away.

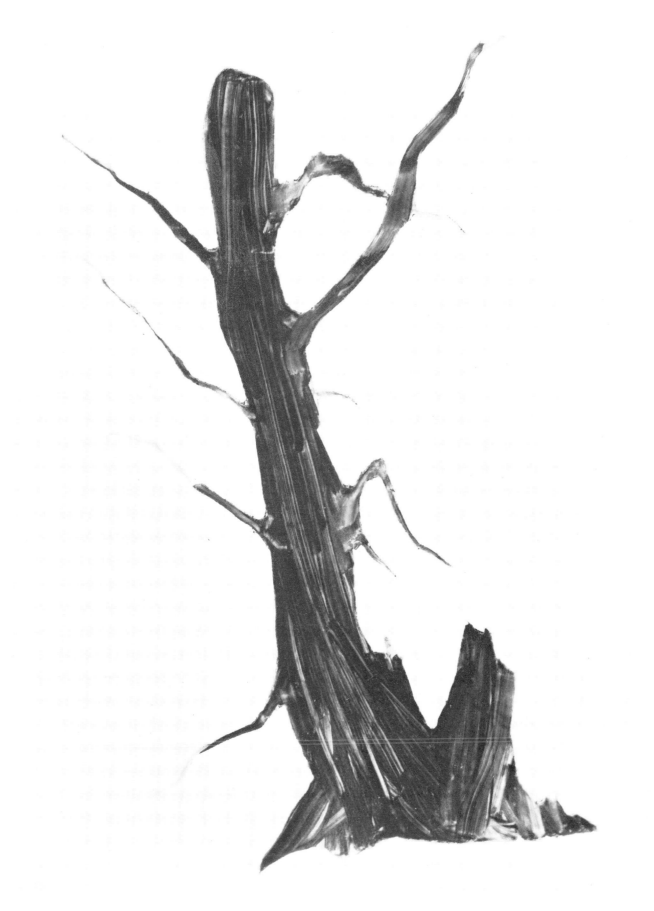

Figure 39. The last step is done with the fewest possible strokes to prevent muddying of colors and preserve sparkle so the final study looks like this.

Limitations of Tape Stencils

Although this tape-stencil technique yields highly appealing effects, it nevertheless has serious limitations. For one, it's impractical for complex subjects. Imagine the tree's limbs filled out with intertwining branches and twigs and forming multitudinous "islands" all of which would have to be individually transferred from cutting to painting surface! Of course, this objection can be turned around: tape stencils can force an artist to *oversimplify*, if that's desirable.

Another drawback is that tape should rarely be applied over painted areas as some color may be stripped off with the tape. Even spraying the color with fixative is no guarantee against pickup on impermeable papers. Thus, using a tape stencil usually means that you have to *start* with a painting's main compositional element, *then* add the balance, including the background.

A twist on the foregoing technique — essentially a reversal of the process (you might call it "positive" stenciling) — is a method of overcoming the latter objection. Suppose, for example, that the tree is a white birch. Instead of discarding the tree-shaped cutout, it can be pasted to the painting surface and the rest of the cutout discarded. After everything *but* the tree is painted in, the tape mask can be zipped off to reveal virgin paper ready for development with markers. But such "positive" stencils are still limited to simple forms — forms easily cut out with a knife. There's another brushed-on (or liquid) stencil method, however, for more complex forms.

Brushed-on Stencils for Complex Forms

To get the crisp edges that stenciling provides, yet render complicated subjects, liquid stencils can do the trick. With a liquid stenciling medium — such as gum water or another frisket — you can brush on a stencil that would be next to impossible to cut into tape. Liquid stencils can be either "negative" or "positive." The latter type can be removed, when dry, by rubbing with a soft eraser or the tip of your finger.

Furthermore, if you're *very* careful and use oil-based markers, you can often brush a liquid stencil over marker colors without picking up the colors when you remove the stencil. Lay in the stenciling medium thickly so you can remove as much as possible, as though the dried film were tape. Give the mask plenty of time to dry, then lift one corner with a piece of pressure-sensitive tape or by rubbing lightly with your finger. Don't try this with water-soluble markers — not unless you fix the existing colors first. Otherwise, the colors will bleed into the stencil and you'll lift off most of the ink with the stencil.

Again, using oil-based markers on waterproof — or at least water-resistant — paper, you can mix a little soap or liquid detergent with the masking medium. Then the dried stencil can be washed away with a wet sponge or under a faucet. Most manufacturers of masking liquids recommend that you first wet and soap the brush to facilitate cleaning it.

How to Get a Veined Effect

If you increase the amount of soap, whipping it so the frisket-and-soap mixture is sudsy (the more bubbles, the better), you can achieve a really marvelous veined effect. For, as the suds dry, a profusion of tiny cracks and broken bubbles are left through which marker inks can penetrate to the surface of the paper. An example of this effect is evident in Figure 40, especially in the accompanying detail enlargement (Figure 41). The painting of this tree essentially duplicates the procedure described for the tape-stencil study. The same colors were used and applied in much the same manner. But the stencil was created with masking liquid. No doubt an enterprising artist could, given enough time and patience, cut this tree's shape from a tape stencil; but the question is whether the effort would be justified when a brushed-on stencil requires a fraction of the time. Also, you could never cut a tape stencil that would simulate the veined effect.

Controlling the sudsy frisket medium can be tricky, and it takes some practice to master it. Slightly different results can be obtained depending upon four factors. The first is the liquid you use. Gum water is preferred, as it dries "harder." The second is the soap you use. Cake soap was used in this painting. Dishwashing liquids are also good, for their suds will last long enough for the mixture to dry properly. The third factor is the surface finish of your paper. And the fourth factor is the characteristics of your local water. Beyond these variables, the ultimate result will be influenced by the ratio of frisket to soap, whether you brush the mixture on "straight" or with a swirling motion, how big the bubbles of the suds are, etc. You can experiment with brushing on the suds, then adding and mixing the frisket on the paper. Adding a drop of marker ink (from a refill can for Flo-Master markers) while the suds are still wet might be interesting. Whatever you try, be certain that the stencil is completely dry before you attempt to stroke over it. Fifteen minutes isn't too long to wait, and thirty minutes is better, because the stencil will peel under the marker tip if the frisket isn't absolutely dry.

When to Use Liquid Stencils

Developing a tree to the point of including twigs virtually precludes cut-tape stencils or cut pressure-sensitive frisket paper stencils. For instance, the stylized *Oak Tree* study (p. 46) conclusively demonstrates the advantages of liquid stenciling. To cut this tree's form in tape would be hopeless. Yet few artists would care to venture painting with as much abandon as in the strokes defining the trunk without the insurance of a stencil mask.

Several features of this study deserve comment. Observe the double-image appearance of certain branches and the free-form shapes in various open spaces. These were entirely accidental, the result of a too thin stencil border and inadvertent voids, despite the fact that black water-soluble ink was added to the frisket medium to aid in identifying the areas that had been masked. The accidents were retained, nevertheless, because they were judged appropriate to the stylistic rendering of a twisting oak. Note, too, the secondary branches that cross over the primary limbs. These were simply stroked in without regard to colors already present. The marker solvents rewetted the existing, dried inks and they were pushed aside. Finally, notice how spot applications of sudsy frisket were used on a couple of limbs to simulate the texture of bark.

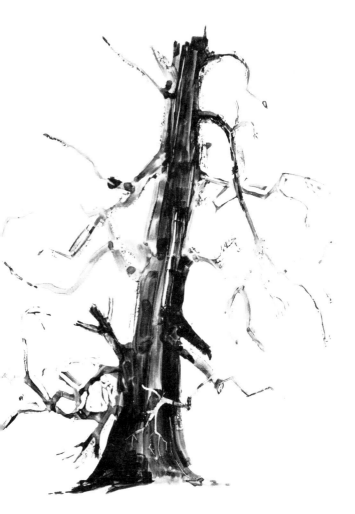

Figure 40. For trees as complicated as this one, tape stencils are impractical. Yet, if you like the freedom that stencils permit — or the sharp-edged effect that almost automatically results — liquid stenciling medium, such as gum water, can turn the trick. Except for the fact that this tree was rendered through a brushed-on stencil, it was painted in much the same manner as the previous study. And the marvelous veinlike effect, most evident around the bottom left branch, is possible only with a liquid stencil.

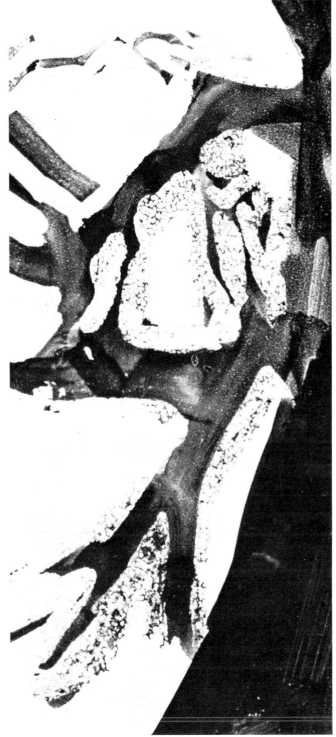

Figure 41. The veinlike effect around the limbs was produced by whipping soap suds into a masking liquid. As the stencil dried, soap bubbles cracked and opened a profusion of lines through which the marker ink penetrated to the paper. The mottled appearance of branches, which complements the veined effect, resulted from spraying the painting with a fixative that absorbs ultraviolet light. It contains a solvent that wets the marker colors, causing mottling.

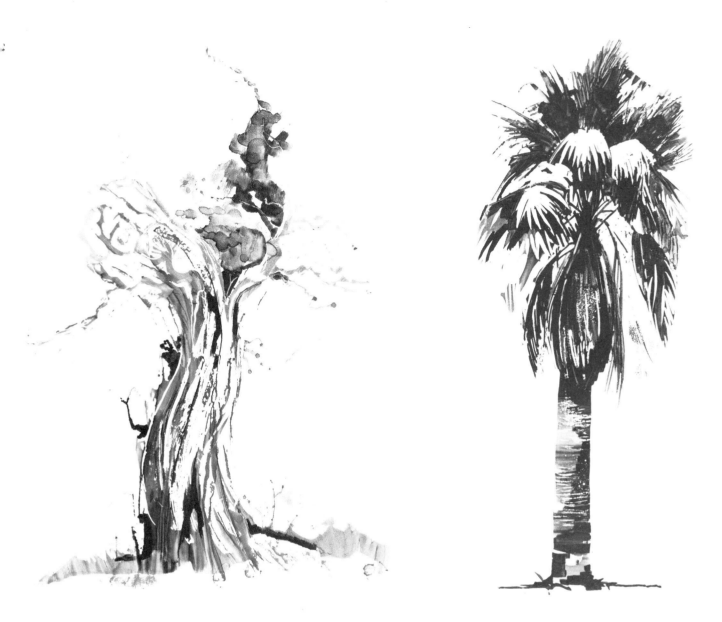

Old, Gnarled Treetrunk. The bark texture was done with a liquid stencil, sometimes mixed with suds, on heavyweight vellum. Foliage was softened by rubbing gently with a Q-Tip slightly moistened with turpentine. Flecks of color around the foliage were "accidents" which were kept.

A Palmetto Tree. This study combines virtually all the stenciling techniques already presented. Both "positive" and "negative" masks were employed for foliage, and the trunk exhibits a beguiling sense of freedom in execution. The painting surface is illustration board.

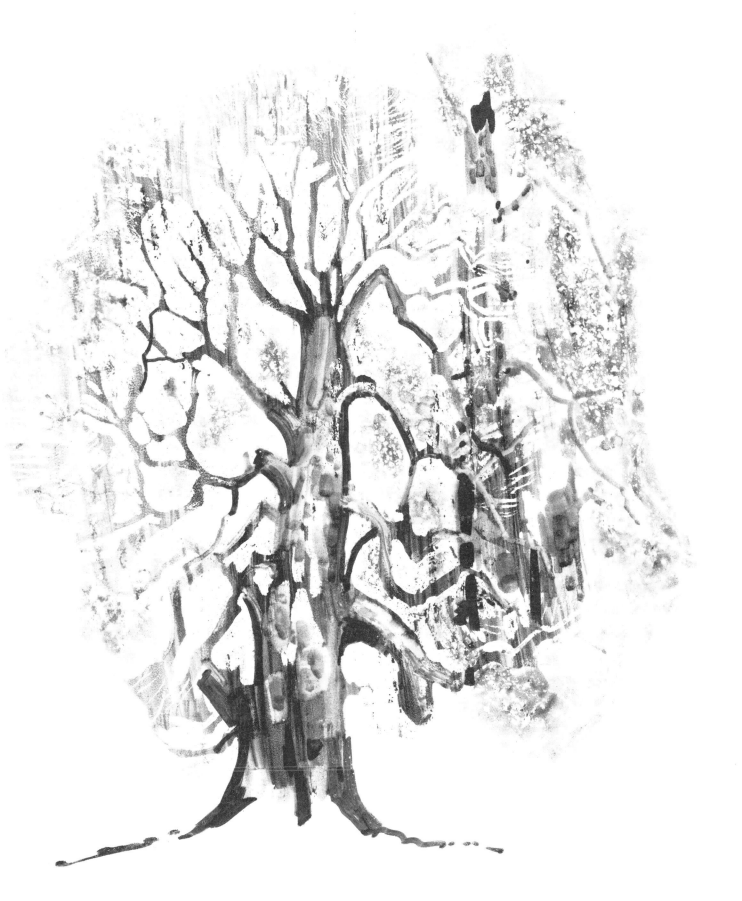

Sycamore in Snow. This study demonstrates another effect possible with liquid stencils. The liquid is diluted with water as well as suds. Consequently, the liquid "beads" and dries so thinly in some areas that ink seeps through. On slightly grained paper, such as the pyro coated cover stock used here, pinholes will also result. The peeling bark typical of sycamores was easily rendered: pale green was stroked over the brown with enough pressure to push aside the existing color, then touches of ochre were added over the green.

Alpine Fir by Meredith Hupalo. Starting a habit of carrying two or three markers — fine-tip black and two shades of gray — can make producing a sketch like this very easy.

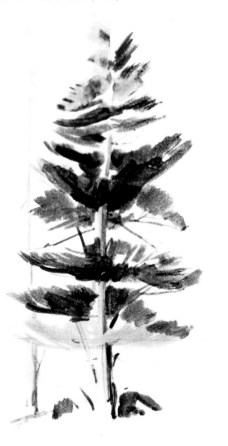

A White Pine by Meredith Hupalo. For some exceptionally appealing effects, chisel-tip markers in the same colors capture the spirit of an upsweeping pine such as this one.

Much more emphatic is the bark texture in the study of the *Old, Gnarled Treetrunk* (p. 54). Here, too, the stenciling liquid was brushed on both to define the boundaries of the trunk and to model its craggy surface, with the texture-bearing strokes sweeping along in the direction of growth. For the purpose of a forceful demonstration, the masked portions of the trunk were left untouched after the stencil was removed, but water-based markers could have been used to touch in color without disturbing the fine details achieved by the oil-based markers (the two types won't mix).

Making Use of "Accidents"

The trunk and limbs are predominantly brown and gray, with grass green blending up from the roots. Foliage was intentionally softened with a little turpentine on a Q-Tip in order to attain marked contrast with the trunk's hardness. This was done after the frisket stencil had been removed, of course. Flecks of ink around the foliage were accidents, but, again, they were retained.

Similar flecks — this time "planned" accidents — were used tellingly in the next study, *Sycamore in Snow* (p. 55). For best results in duplicating this effect, use coated paper with a subtle, leatherlike surface grain. Dilute the masking liquid with sudsy water almost to the point where it won't form a protective film when dry. You won't be able visually to detect the pinholes through which the marker inks will penetrate, but a little experimentation will teach you to control the results with relative ease. When the frisket film is this thin, it's even more important that it dry as long as possible — or the marker tip will rub it off. It's also a good idea to use a new "wet" marker, which will allow you to lay in colors with minimum pressure.

The white "falling snow" splotched effect (most evident along the right-hand side) was produced by thinning the frisket with water and only a few suds. The bubbles tended to coagulate or clot and dissolve into solid "islands" as they dried, concentrating the masking liquid into a thicker mass. The thin, diluted areas around the clots were permeable to a degree, but the clots weren't, so they prevented any ink from reaching the paper. Later on, we'll see how a comparable effect can be achieved by spraying with turpentine.

How to Heighten Grain

To heighten the over-all grained look of the study, it was sprayed with a fixative that contains not only an ultraviolet-light absorber to guard against fading of marker ink dyes but also a marker ink solvent, which tends to cause a grained appearance. The colder the can is when used, the more pronounced the grain will be. Coarseness will also be increased by holding the aerosol can nearer the painting and by spraying a thicker initial coat. If such an effect isn't desired, it's better to use another fixative (see Chapter 2). But we've gotten ahead of ourselves, for other aspects of the sycamore study need to be discussed.

Capturing the Character of Sycamores

The rendering of the peeling bark that's so characteristic of sycamores was achieved very simply, by stroking over the

Acapulco Greenery by Meredith Hupalo. For sketching outdoors, markers are surely no less valuable — and they are much more versatile than most other mediums which can be conveniently carried in purse or pocket. Quick line sketches like this require only a pen-type marker.

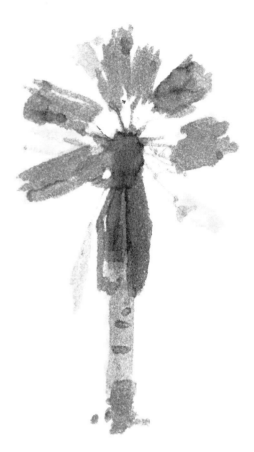

Figure 42. Fine-point markers were used to paint a palmetto which looks like Japanese brushwork.

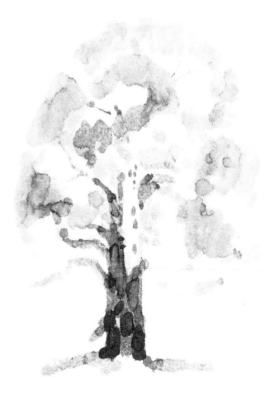

Figure 43. On sketch paper, intermediate tones can be achieved as in this sycamore.

finished trunk with lighter markers — a pale green over the original dark brown or grayish brown — then adding touches of ochre over the green. Sycamore bark tends to peel from brown to ochre to pale green.

Note the relative indistinctness at the left of the study. After the stencil was removed, that area was gently wiped with a soft cloth dipped in turpentine. The turpentine was allowed to evaporate until the cloth was barely damp to the touch, then the cloth was pulled very, very lightly across the painting with just enough pressure to drag some ink along. But the edges weren't really blurred by smearing.

Before leaving this presentation of stenciling techniques, let's take a look at one more study, *A Palmetto Tree* (p. 54), combining most of the techniques we've been examining. Particularly effective is the use of positive stenciling to mask out foreshortened leaves so white paper shows through in the finish, augmenting the illusion that these leaves project toward the viewer. Also note the trunk. It exhibits a refreshing sense of freedom, yet the banded effect is tightly controlled, thanks to a brushed-on stencil that defined the trunk's edges.

Using Markers on Field Trips

However valuable you find the markers for painting trees in the studio, their extreme versatility and convenience can make them indispensable on field trips. Take an ordinary sketchpad and a minimal selection of markers and you have all the essential tools for capturing the particular characteristics of trees. In the beginning, you can restrict yourself to fine-tip markers and line sketches, such as *Acapulco Greenery* (p. 57), a study by Meredith Hupalo. Mrs. Hupalo's other sketches — *Alpine Fir* and *A White Pine* (both p. 56) — are also excellent examples of what you can do with just two or three markers, using the side as well as the tip of fine-tip markers. Sketches of this genre are hardly different from the pencil, ink, or wash techniques with which you may already be familiar, so the new medium's flavor will be easy to grasp.

Fountain Brushes: Compact and Portable

There's so much to learn and appreciate about trees that you should never be without markers. Even if you can't always take along a sketchpad, you can normally find *something* to work on. Robert Fawcett frequently sketched on newsprint, with pleasing results. And if you haven't room for a selection of markers, perhaps you'll want to buy a Flo-Master fountain brush, which is undoubtedly the most versatile marker available. This marker's truly amazing flexibility is evident in the drawing *Woodland Edge* (p. 62) by Henry C. Pitz.

Learn to Vary Lines

Once you're accustomed to markers, you ought to consider subordinating line to tone, for here's where markers can display their virtuosity, as well as help train your artist's eye. Leave the fine-tip units at home (to avoid temptation) and use a corner of the chisel tip, instead, when a thin line is absolutely necessary. The effects you can expect to achieve are shown in the sketches of a palmetto (Figure 42), a sycamore (Figure 43), a

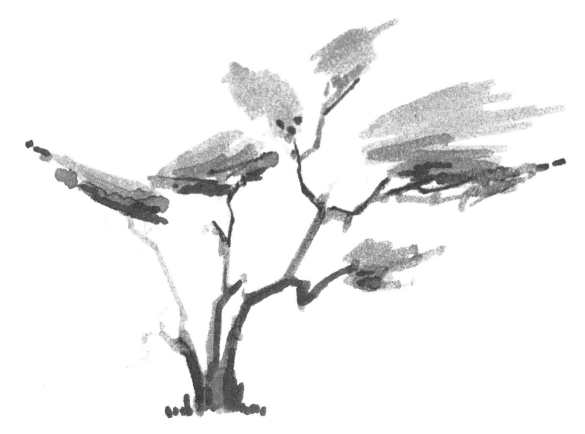

Figure 44. This Monterey cyprus was painted on a 4″ x 6″ sheet of sketch paper.

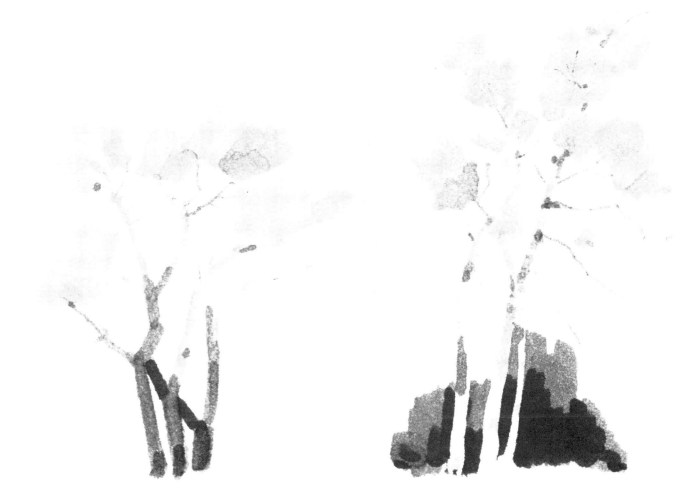

Figure 45. Dark, medium, and light grays were used to show the textures of this gray birch.

Figure 46. White birch is also represented by different tones of gray.

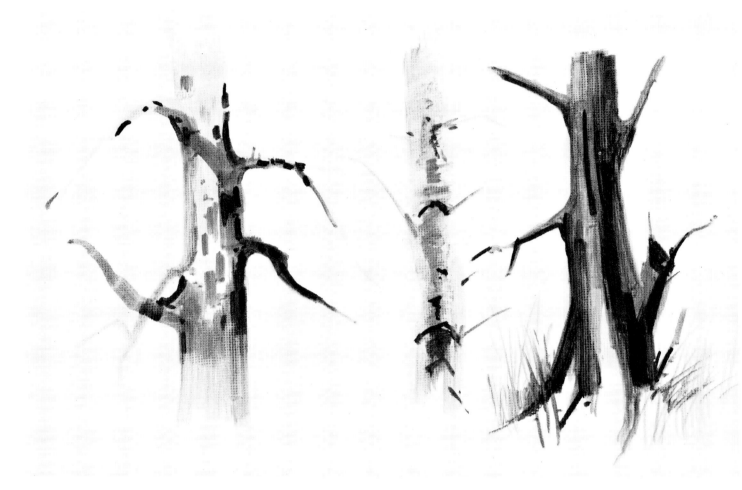

Figure 47. (Above) Markers are helpful in doing studies of the various elements of trees. A familiarity with bark textures, patterns of limb-and-branch growth, leaf clustering, and so on is a prerequisite for drawing believable trees. This study, on simulated canvas paper, indicates how markers can help you to train your eye for grasping fundamentals without being overwhelmed by details. Note how the direction and length of each stroke contributes to the over-all expression.

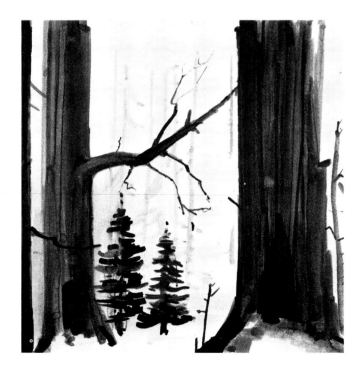

Figure 48. (Right) Studying bark textures is particularly important because the only effective way of dramatizing contrasts in size is to show just a portion of the bigger tree — and usually that portion will be the trunk.

Monterey cyprus (Figure 44), a gray birch (Figure 45), and a white birch (Figure 46). All of these were done with only three chisel-tip markers: dark, medium, and light gray. They were done in a 4" x 6" format.

Exhibiting the grace and charm of Japanese brushwork, these studies express the fundamental personalities of the trees with minimum detail. The sycamore's peeling bark, for instance, was suggested with splotches of color. Leaves were indicated with a few simple strokes, attempting only to capture the growth patterns of leaf masses that distinguish each tree. Intermediate tones were created by overpainting the grays; since the sketch paper was absorbent, the top color couldn't displace the existing one, and so the first color was darkened.

Study Parts of Trees

At the same time that you're interpreting the total personality of trees, you should also scrutinize the component parts of trees: bark texture, the twisting and turning of branches (no two species are quite identical), how leaves cluster in groups, depth and density of foliage, and so on. Time spent in studying these elements is never wasted, not if you want your tree to be believable. Imagine how distracting a painting of an old, gnarled oak with the smooth bark of a young sapling or even of a mature beech would be! Or picture the incongruity of a tall elm with the asymmetrical, flattish foliage of a dogwood.

Although it's not the purpose of this project to teach you how to draw trees *per se*, three simplified studies of bark texture (Figure 47) are included to demonstrate what's involved in capturing the qualities of different barks: the patchwork appearance of sycamore; the banded, somewhat flaked look of birch; and the dark, slightly craggy feeling of maple. Note, especially, how the direction and length of each stroke contributes to the over-all impression. Bark textures merit your careful attention because, as Figure 48 demonstrates, often the only effective way to achieve pronounced contrast in size is to show just a small portion of the bigger tree — and usually that portion will be the trunk. Many artists have written extensively on the "how to" of painting trees, and their books contain hints for beginners which are applicable to marker paintings. (Some of these books are suggested reading and listed in the Bibliography in the back of the book.)

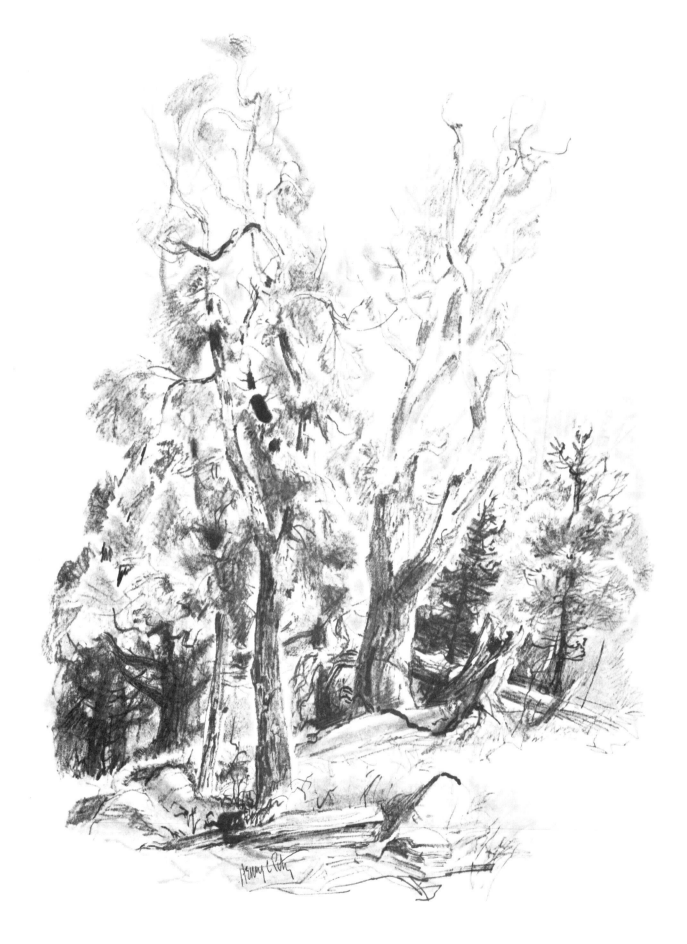

Woodland Edge by Henry C. Pitz. For optimum flexibility in drawing outdoors, use a Flo-Master fountain brush. One such marker, filled with black ink, produced this drawing. If you can afford it, you might want several Flo-Master pens, each filled with a different color. (From *Drawing Trees*)

When you paint trees and other outdoor subjects, you'll often portray some manifestation of nature's "green thumb," particularly leaves and grass. Unless the greenery is a focal point of the painting, though, you'll want to avoid becoming bogged down in details that are probably superfluous. Which is why you'll like markers. With markers you can suggest masses of greenery almost by magic. Using techniques adapted from the texturing methods presented in Chapter 5, you can produce "detailed" renderings easily and quickly.

Necessary Materials

To reproduce the various studies in this chapter, you'll need these materials:

1. Markers, both fine and chisel tips, in shades of green, brown, and yellow

2. Similar selection of fine-tip, water-based markers (two greens, one brown, and one yellow will be sufficient)

3. Vellum, acetate overlay sheets, or other impermeable paper

4. Sketch paper, illustration board, or other permeable paper

5. Gum water or another masking liquid

6. Turpentine

7. Q-Tips

8. Paper towels

9. Facial tissue

10. Typing paper or common stationery

11. Plastic bread bag or a dry cleaner's bag

12. Cigarette "soft pack" paper

13. Rubber roller

If you don't smoke, don't rush out to buy cigarettes; to obtain the "soft pack" paper the cover from last month's *American Artist* will do. The main thing is that the paper be relatively stiff. Likewise, if your bread doesn't come in plastic bags, and if your dry-cleaned suits and dresses don't come in plastic bags either, you can substitute a sandwich bag or the limp plastic wrap from a package of paper towels.

And as long as we're on the subject of plastic bags and wraps, let's use some plastic to put leaves on one of the tree skeletons from the preceding project. The choice of paper isn't too important for now, so whatever you have at hand will do.

On-the-Spot "Rubber Stamps"

Take about six square inches of plastic film and casually crumple and roll it into a rough cylinder with a diameter of 1/2" or so. Flatten one end by tapping it on your drawing board. Now paint the flattened surface with a light green marker. Quickly — before the ink can dry — stamp the inked end on a piece of sketch paper. The result should be something like the impression in Figure 49. Repeat this procedure several times, rotating the stamp and using the edges as well as the full surface, overlapping and printing over successive impressions. With just a little imagination, the appearance of leaves should take form (Figure 50).

Remember how the branches and twigs of a tree grow; use a darker green and repeat the procedure, adding contrast and shadow areas. But be more selective. Arrange the stamped impressions into purposeful, leaflike patterns. Use other shades of green if it pleases you, and soon you'll have what can readily pass for a tree bough (Figure 51). It might not stand up to close scrutiny, but representing leaves on a tree is usually more a matter of over-all form, texture, and density than it is of individually realistic leaves.

Now try the same thing again, only this time use a rather loose 1" stamp instead of a tight cylinder. Simply crumple and crush a wad of plastic wrap, then tap down a flat face. Wet it with marker ink and press down on paper. The result should not be too different, except in size of the single "leaves" — as you can see by comparing Figure 52 with Figure 51. Depending on how you arrange the impressions and what colors you employ, these plastic-bag stampings could represent dense tree foliage or lush tropical vegetation.

If the tree you want to paint is characterized by crisp, airy foliage, then use a stiffer paper to make the stamp. For instance, crumpled typewriter paper in a tight roll and a loose one will yield impressions similar to the ones in Figure 53. These hardly look like leaves, but a judicious sense of composition soon turns the random shapes into perceivable leaf clusters. The point is that "rubber stamped" greenery is no less artistic. The technique demands an artist's guidance if the finish is to be believable.

Combining Stamps and Other Techniques

In the same vein, a creative artist will recognize that impromptu stamps can be a jumping off point in the search for proper effects. The typing-paper stamp is a good example. It's admittedly quite hard in appearance. So, instead of stamping over different ink colors (which produces an effect something like that in Figure 54), why not add body with some quick

Figure 49. These two patterns were stamped with a piece of crumpled dry-cleaner plastic bag painted with a marker.

Figure 53. Common paper, being stiffer, is a good medium for making a stamp impression such as this.

Figure 50. Multiple impressions made with the same stamp used in Figure 49. The viewer's imagination begins to "read" this as leaves.

Figure 54. Multiple impressions done with a paper stamp create a feeling of light, airy foliage.

Figure 51. With arranged stamp impressions, a credible sense of leaves is achieved.

Figure 55. Impressions similar to Figure 54 are used as shadows with overpainted leaf forms. Use oil-based or water-based inks for initial strokes, then the other type of markers for overpainting to preclude blending of inks.

Figure 52. A loose wad of plastic film creates larger flat areas in the stamp and produces this effect.

Figure 56. Two stamps were used here. Harder impressions were made with wadded typing paper. Softer leaves were created with a paper towel stamp.

strokes of a chisel-tip marker? The bough in Figure 55 was done this way. First a few, skimpy stamp impressions. Next, the forms suggested by these impressions were filled in with a light green marker. Over this, some fast indications of leaves with a medium green, fine-tip, *water-based* marker; finally, more stamp impressions with a dark green, oil-based marker. The bough was done on vellum, hence the initial stamp impressions were partly obliterated by the chisel-tip overstrokes. Had a more permeable surface been used, the first stampings wouldn't have been necessary.

Another approach is to combine two or more stamping materials (see Figure 56). This started with a typing-paper stamp, a section along the edge of which produced a stark, twiglike line. This line was used to create, with four aligned impressions, a backbone branch that's clearly visible. Next, pockets of dense foliage were stamped in, using the flat face of the paper, in a lighter, medium green.

How to Obtain Softened Effects

To obtain softer foliage, a stamp made from a paper towel was used. Some impressions were done in the same medium green transferred with the typing-paper stamp, but because the towel is more absorbent, less ink ended up on the paper and a seemingly different color resulted. Other impressions, notably those along the edges, were done with a lighter green.

For still softer effects, try using facial tissue. The clump of leaves in Figure 57 was achieved this way. We haven't by any means exhausted the possibilities. Different effects will be produced by waxed paper, canvas, and other cloths — even aluminum foil. Whatever comes to mind or happens to be handy is worth a little experimentation. The results depend not only upon the material you choose but also on how you form the stamp (tight roll, loose wad, etc.) and, to a lesser degree, on what kind of paper surface you use.

However, there's one characteristic intimately linked to the choice of paper — the less absorbent the paper, the better. Vellum will do, but acetate overlays or pyroxylin-coated stocks are preferable. For a rigid surface, Marlite paneling (Masonite with a plastic coating on one side) is ideal.

The advantage of working on such impermeable surfaces is that you can pick up colors with lighter colors or with turpentine. To see how this works, lay in a small area of any dark color, including black. Give it a chance to dry thoroughly, and then stamp it with another color. A tissue or paper-towel stamp will pick up more of the original color, but a typing-paper or plastic stamp will leave behind more of the second. If you merely want to lighten the original color, use a stamp dipped in turpentine — but wait until the turpentine has all but completely evaporated if you want good, sharp definition. Either way, what you can expect is illustrated in Figure 58. And what you can do with this technique is shown in the next clump of leaves (Figure 59). The three foreshortened areas which are circled fairly jump out of the dark mass.

When to Paint Individual Leaves

Up to this point, we've been discussing masses of leaves. But suppose you want to depict individual leaves or leaf clusters

Figure 57. These soft, diffused forms were stamped with facial tissue.

Figure 58. The "stamp pad" technique can also pick up colors from impermeable surfaces, as shown here. Wet the stamp with turpentine or rubber cement thinner.

Figure 59. These leaves were first stamped out in two shades of green, then highlighted with a third stamping wetted with turpentine.

Figure 60. Even individual leaves can be stamped with a fair degree of realism, as this paper towel stamping demonstrates.

Figure 61. Paint a rolled-up cigarette soft pack — or a crumpled magazine cover — with a marker and you can stamp patterns such as these.

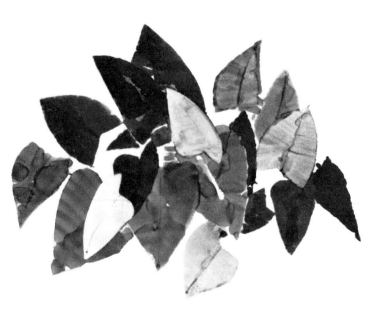

Figure 62. Producing individual leaves with stamps has size limitations. Hence, there's a point where stenciling takes over. This sketch was done with cut paper stencils.

that are identifiable without overpowering the larger context of the painting. Is the "stamp pad" technique still viable? To some extent, yes. Only now you'll have to consciously shape the stamp, for you can't rely on visual impressions of textural mass to help communicate "leaves" to viewers.

Consequently, rather stiff materials are easier to work with. To create a leaflike stamp from a paper towel isn't impossible (see Figure 60), but it does demand considerable trial and error, and the stamp has a relatively short, useful life because it soon starts to distort. More acceptable is something like a magazine cover — or a cigarette soft pack. This latter object is what produced the leaves in Figure 61. Rolled up with the cellophane wrapper and foil inner lining, cigarette packs make an agreeably semirigid stamp that can be controlled with ease.

In rendering individual leaves, however, stamping soon approaches a critical size limitation at which you begin thinking about linoleum blocks — or the stenciling techniques presented in the previous chapter. The leaves in Figure 62 were done through paper stencil cutouts on vellum, including the two foreground leaves superimposed on darker leaves. Again, this demonstrates the advantages of working in markers on impermeable surfaces. (Note: save these stencils for use in the next project.)

While it won't be demonstrated for several more projects, another technique worth mentioning here is the rubber-roller method used by artist David C. Baker in his abstract project in Project 14. To do the same, you need a can of marker ink, which you use to create a large ink pool on a flat metal, glass, or Marlite surface. To reproduce a leaf, you lay an actual leaf on the wet ink, press it down with a rubber roller, then transfer the leaf to your painting surface and roll it down again. If the ink pool dries, you can rewet it by spraying with turpentine.

Versions of Grass

Most of the techniques used to portray leaves can be adapted to grass. Clumps of grass, for instance, can be quickly done with the edge of a paper-towel stamp that's lightly stroked upward. The effect will vary according to how much of the surface of the stamp you apply to the paper and according to the length of the stroke. Two of the virtually endless possibilities are shown in Figure 63. The corner of a dry artificial sponge yields somewhat similar results. And for shrubs and lush undergrowth, try some facial tissue containing just a trace of moisture (Figure 64).

When it comes to more exact renditions, fine-tip markers (either oil or water based, often both) are helpful. There's no trick to stroking in grass with such markers. All you have to do is pretend you're using a pencil or brush. But there are a couple of points in regard to producing an illusion of depth.

For an example, you're working on an impermeable surface. To prevent overstrokes from blotting up background colors, you can combine oil-based and water-based markers. The stand of grass in Figure 65 was obtained this way. The faint background strokes are brown and green (with yellow highlights) water-soluble inks. Over these the same colors were applied, but in darker shades of oil-based inks. As the two inks won't mix, there's a feeling of depth — or perspective — that's difficult to match with just one of the two types of markers.

Figure 63. Grass can be interpreted by shortcut methods not unlike stamping. Here, a paper towel stamp is stroked upward on the edge. Shorter strokes with wadded paper towel give effects like this. The corner of a dry artificial sponge can also be used.

Figure 64. A slightly moist facial tissue was formed into a stamp for this semblance of dense undergrowth.

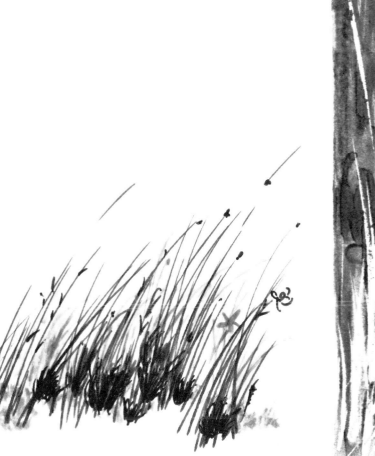

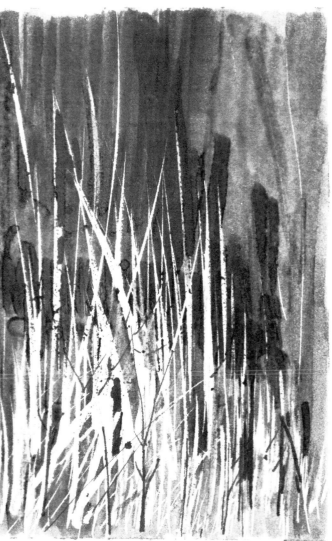

Figure 65. When grass is critical to your painting, you can resort to fine-tip markers. In this study, water-based inks overpainted with oil-based markers were employed for the background.

Figure 66. Light grass on a dark background is achieved simply with a gum-water mask applied with a brush. The background can then be painted in. Removal of the masking stencil reveals virgin paper, which can be left as is or painted.

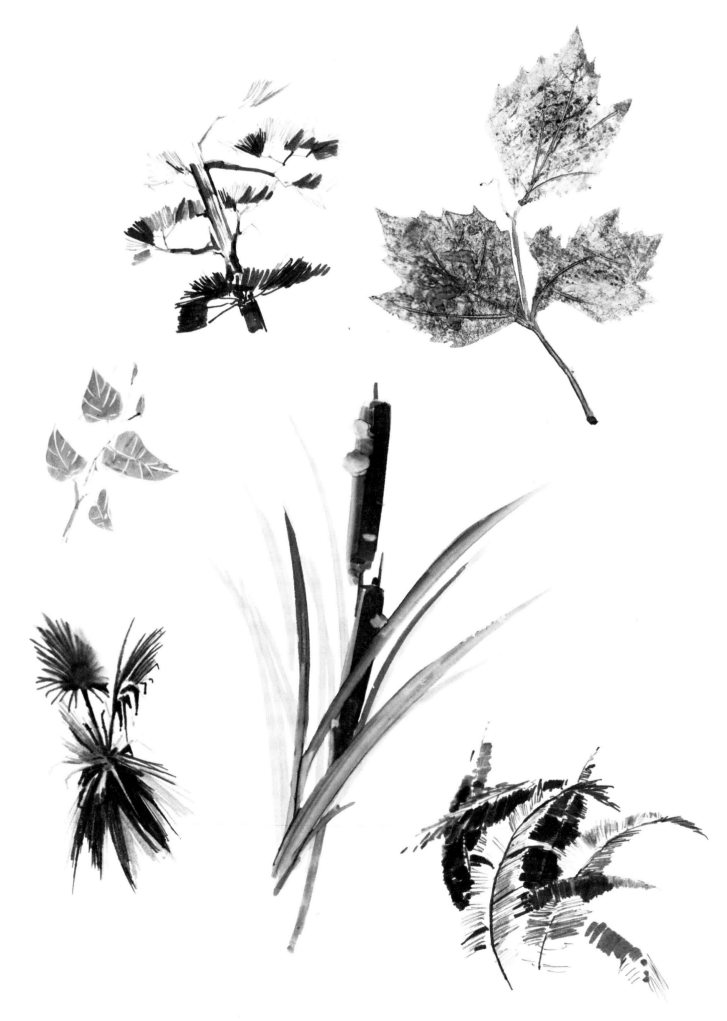

Suppose, now, that you want to obtain some light blades of grass against a dark background — similar to Figure 66. This particular effect was produced on illustration board, using gum water. The liquid was brushed on as if it were watercolor. Once it had dried, the backdrop was painted in. Then the mask was rubbed off. As shown here, the blades of grass are still mostly virgin white, but they can be colored as desired.

On impermeable paper, the approach would be more direct: a lighter color — or pure turpentine in a refillable marker — could be stroked over the dark background, and the over-stroking would effectively erase existing color while simulta-neously depositing the new one. The cattail (Figure 67) shows the use of erasing colors with turpentine from vellum. The reed's leaves were stroked to a relatively sharp point, but not really sharp enough. Compare the tips of the leaves at lower left with the two foreground leaves on the right. The extra sharpness is the result of this procedure: a sheet of vellum was laid over the leaf, exposing a thin strip of edge but screening the bulk of the leaf; then, with a Q-Tip dipped in turpentine and squeezed practically dry, the exposed strip was erased. A few quick dabs with the Q-Tip also produced the characteristic "fur" in the plant's terminal spike.

Figure 67. (Left) When greenery is essential in your painting, it can be executed with care and attention to detail. You'll recognize the stenciling at left upper center and the texturing with gum water mixed with soap at upper right.

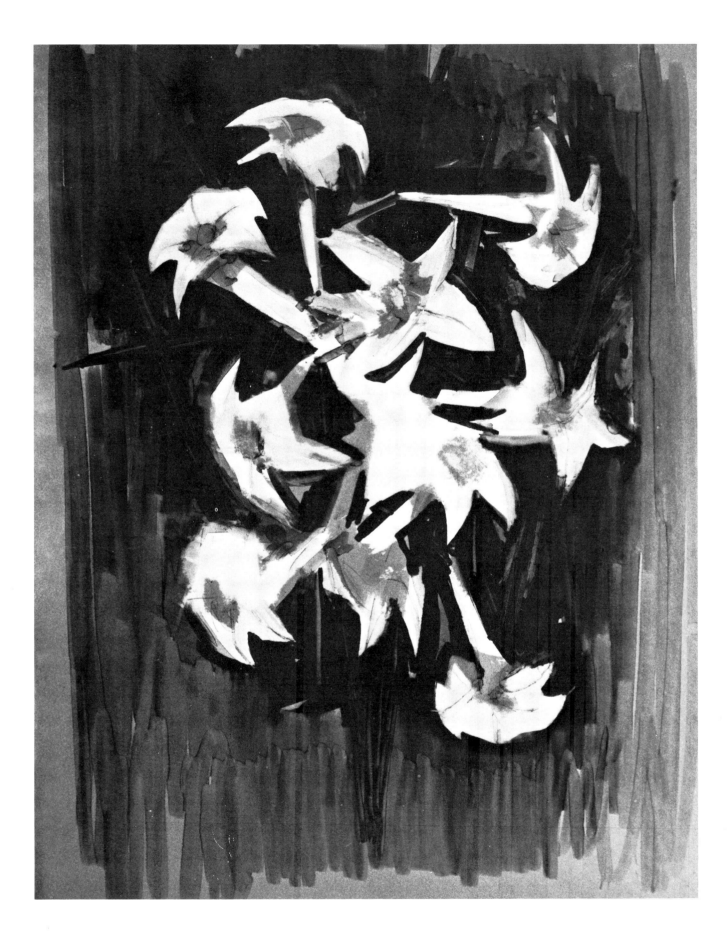

Easter Lilies. An imaginative composition of Easter lilies was done on the back of a sheet of shading film. The only areas "shaved" with a razor (scratchboard style) to allow the mounting board to show through are the flowers.

Who hasn't felt the urge to seize and preserve on canvas the beauty of flowers? Whether outdoors — growing wild or cultivated — or indoors as the focus of a still life, flowers are a perennial joy to artists everywhere. And we think you'll agree, when you finish this project, that flowers and markers are made for each other.

First we'll trace the step-by-step demonstration of the *Chianti Rose* still life (Figures 68-74), then we'll discuss two more still life studies and a semiabstract, and finally wind up with drawings of various flowers in their natural habitats. In the step-by-step sequence you'll learn about a new material, and toward the end of the chapter you'll find a shortcut technique or two, taken from Project 2, for indicating flowers when they're but a minor part of your composition. Much of the remainder of this project is on the use of techniques already discussed.

Materials Used in Flower Studies

In the step-by-step painting, these materials were used:

1. Acetate overlay sheet, 11″ x 14″, with a matte surface on one side (get 0.005″ thickness in preference to 0.003″)

2. Markers — forest and olive green, crimson and cadmium red, yellow ochre and cadmium yellow, sepia and burnt sienna, burnt umber, and ultramarine

3. Sheet of 30% black shading film, self-adhesive. (This is the new material used. Name brands can be found in the Suppliers List at the end of the book.)

4. Single-edge razor blade

5. Sheet of sketch paper, at least 9″ x 12″

6. Q-Tips

7. Turpentine

And of course there are the models. For the step-by-step demonstration, artificial roses in a Chianti bottle were used. Unless you've painted roses regularly — or you're familiar with their qualities — it's recommended that natural flowers be used, if possible. Photographs are another alternative. A small, spherical vase or bottle is the last prop needed.

For subsequent paintings these materials were used:

1. Additional acetate overlay sheets

2. Heavyweight vellum, 11″ x 14″

3. Markers — the above colors, plus light blue, peacock blue, lilac and/or magenta, and dark gray

4. Sheet of 50% black shading film

5. Razor blade

6. Q-Tips

7. Turpentine

8. Paper towels

The Chianti Rose Study: Step-by-Step

After the flowers were arranged in a pleasing composition, the main elements of the *Chianti Rose* still life were blocked in on sketch paper with a fine-tip marker (charcoal, soft pencil, or pen are equally good). The basic composition chosen here — more evident in the final picture than in Figure 68 — are two balanced triangular areas described by the bottle and by the top two and the center roses, the apexes of these triangles projecting into a circle of leaves.

When the sketch was completed and fastened to the drawing board, it was covered with the acetate overlay sheet, matte side up, and the acetate fastened in place. The basic color scheme was filled in. (See also the color plate on p. 106.) As shown in Figure 69, there was no attempt to be precise. The roses, starting from the top left and going clockwise, are crimson, cadmium red, cadmium red with burnt sienna blended shadow, crimson washed out with Q-Tip and turpentine, and cadmium yellow. Leaves and stems are forest green and olive, plus blends of these two greens. The same greens are used for the exposed glass, with a dab of crimson for the usual simulated-wax seal near the bottle's neck. The straw basket was rendered in ochre, sepia, and burnt sienna with burnt umber shadows. The colors were allowed to dry, then the sketch was removed from beneath the acetate.

The roses are developed and the bottle has been modeled (Figure 70). Following the composition as a clock face, we see the rose at twelve o'clock was modified with strokes of magenta. The rose at one o'clock was washed with a Q-Tip containing a trace of turpentine. Magenta was added to the rose at six o'clock. Olive green was used to fill in the glass bottle, but the color contained considerable amounts of forest green picked up from the edges. The straw basket was also developed by working over the colors applied in Figure 68 with ochre and sepia markers. Burnt sienna and burnt umber verticals emphasize the basket's slat-type construction.

In Figure 71 the still life is near its finished form. Quite a bit more work is apparent in the roses and in the bottle, but the colors are essentially unchanged. What has changed, and drastically so, is the rendition of the leaves. The manner in

which they were rendered — by stroking from the center out — is at first glance mystifying. How were the outside edges controlled? Let's return briefly to the project on leaves — to Figure 62, specifically. You'll recall that this was a group of leaves painted through cut-out paper stencils, and that you were asked to save the stencils. Here they were used again or, if the size was disproportionate, at least the same technique was used again.

The inks were allowed to dry for several minutes to a half hour. Then the shading film's protective backing was peeled off and adhered to the acetate (Figure 72). It was smoothed down firmly from top to bottom, and care was taken to prevent entrapped air pockets (any that cropped up were eliminated by pricking them with a pin and brushing out the air).

A razor was used to gently scrape off the shading-film ink from wherever it wasn't wanted (Figure 73). After the desired gray tones were retained, the finished study — acetate and shading film — was ready for framing just by turning it on its reverse side (Figure 74). A searching comparison of Figure 71 and the final picture will reveal that the gray ink was kept mainly as an outline element around the flowers and certain leaves and stems. Also, the gray functions as shadows in the two red roses, near the intersection of the two compositional triangles, and as shading in the straw basket.

Figure 68. After the flowers were arranged in a pleasing composition, a preliminary sketch is made.

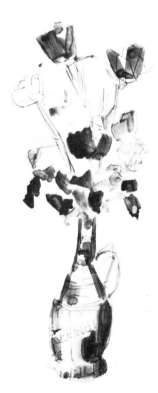

Figure 69. The acetate sheet is laid, matte side up, over the sketch, and a color scheme is established.

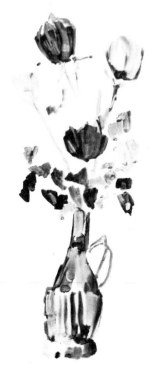

Figure 70. The sketch is removed from underneath and the study is developed. Because acetate is impermeable, the colors are easily superimposed and blended.

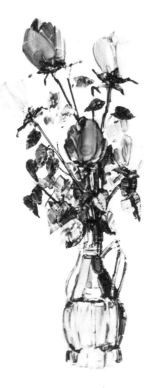

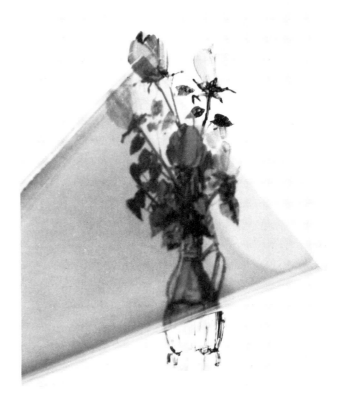

Figure 71. Here, the painting nears the final form as the leaves are executed with the aid of cut paper stencils. Stencils permit strokes to be made from the center outward without concern for leaf outlines.

Figure 72. A sheet of self-adhesive shading film is applied over the marker colors. The shading film not only allows the unusual shadow effect produced in the next step but also protects the marker inks.

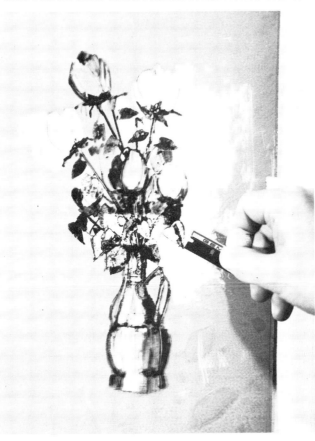

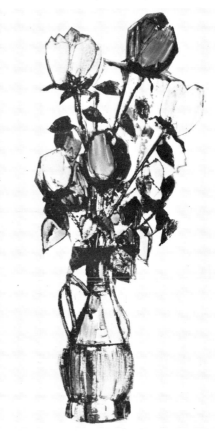

Figure 73. Ink is scraped from the shading film with a single-edge razor. The outline borders around the leaves as well as other shaded areas are kept. Completed, the painting can be turned over for framing.

Figure 74. This final step shows a crisply stylized painting on acetate, with both sides of the transparent plastic used, and has a very modernistic flavor.

Cactuses. Desert flowers were executed with many of the techniques presented. At center right are blossoms similar to roses. Below these is a leaf that obviously was stenciled. The small white spots (pores) on the large cactus leaves were achieved by dotting with a turpentine-moistened Q-Tip. The grass was simply overpainted.

Yellow Flowers in Blue Vase. An impressionistic flower arrangement was done from memory. The flowers were "dreamed up" to complement this attractive peacock blue vase.

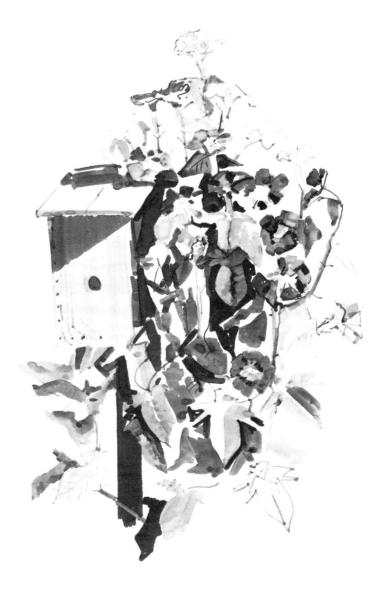

A Birdhouse With Morning Glories. A more conventional handling of this in-the-field sketch shows agreeable results. But the effect is markedly in contrast with other works which use the overpainting technique.

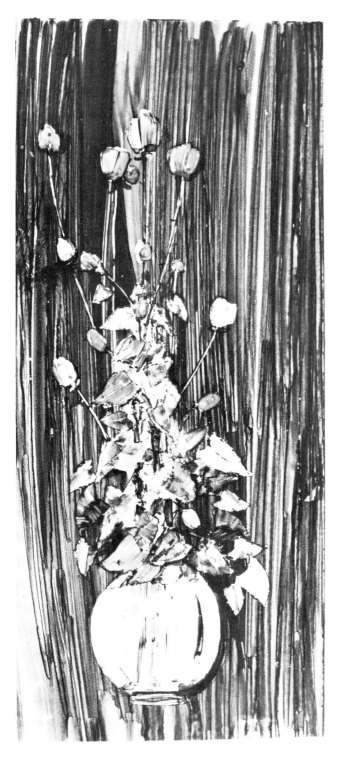

Baby Roses. The coloring and treatment of this still life resembles Figure 74. The entire painting was superimposed over the background, which was an attempt at another painting that didn't come off and was obliterated with sweeping marker strokes. The glass vase was rendered by picking up marker colors with turpentine on a Q-Tip.

Figure 75. Adaptation of the "stamp pad" technique discussed in Project 2 created this flowerlike impression. The stamp was merely pressed down and rotated simultaneously.

Figure 76. Multiple impressions of Figure 75 yield a workable method of rendering masses of flowers for preliminary sketches or atmosphere in finished paintings.

Another Example of Roses

Baby Roses (p. 75 and also the color plate on p. 106) represents another way of treating roses. Indirectly, this painting by Emile Troisé also exemplifies the freedom afforded by markers — for the backdrop is actually painted over an earlier work. A leaf study was started on vellum (similar to Figure 62 in Project 2), became unsatisfactory and was simply obliterated with sweeping strokes of ultramarine and magenta. Traces of forest green and olive are still faintly visible in the original. Except for the vase, which is glass-clear and was achieved by picking up all color with a turpentine dampened Q-Tip, the color scheme is similar to Figure 74. The roses are various shades of crimson, cadmium red, and magenta. The leaves are forest green and olive — and rendered with cut paper stencils that were used before to mask the background.

Two minor features of this painting deserve note. The center vein is a thin white line in one large leaf at bottom left and two leaves near top left. These lines were produced simply by scratching with the corner of a razor blade, which was also used to create the crisp left edge of the vase. Also observe how the corner of the green marker employed to stroke in the rose stems easily picked up backdrop colors while coincidentally laying in green.

Flowers of the Mind

Two paintings forcefully demonstrate that a talented artist need not rely on physical models, for they were done essentially from the artist's imagination, aided only by dictionary illustrations.

The first, a semiabstract composition of *Easter Lilies* (p. 70) also by Mr. Troisé, is rendered directly on the peel-off backing sheet (not peeled off, of course) of a 14″ x 17″ piece of shading film. Only the white of the flowers is scraped away to allow the mounting board to show through. The lilies and their green leaves are surrounded by a free-form halo of ultramarine that blends into cadmium yellow. Because of the 30% black ink on the obverse of the shading film, the yellow looks quite dark in the illustration here, and the visual appearance of this color in the original is between yellow ochre and golden ochre. Executed entirely from the artist's memory and during a lunch-hour break — the lilies study drew its inspiration from an earlier oil painting of a similarly juxtaposed group of sea gulls frozen in flight above a Maine coastal cliff.

The second painting, *Yellow Flowers in Blue Vase* (p. 74 and also the color plate on p. 106), is likewise a product of Mr. Troisé's mind. All he had to work with was a beautiful peacock blue vase. The task he therefore set was a flower arrangement and color scheme that would complement the vase. Although some of the flowers discernible in this still life may resemble actual blossoms, there was no concerted attempt by Mr. Troisé to represent real flowers.

The painting proceeded along these lines: first the vase was painted in, then, with a few rapid up-and-down strokes of yellow plus touches of olive and sepia in the shadowed central area immediately above the vase, the general mass of the blossoms was blocked out. Signs of these initial vertical strokes are visible in the finish, but not all of these vertical accents are remnants. Some were added later, as we'll see.

Next, working over the yellow and sepia with yellow and sepia markers, quick, almost haphazard strokes were made to designate the poinsettia-like (or daisy-like) blossoms. A few of these flowers were also rendered in magenta and red. Because acetate — an impermeable surface — was employed, this painting was merely worked from the background outward to the foreground. Any blossom executed over previous blossoms simply eradicated those parts of the already existing flower, making it appear that the more recent flower is closer to the observer. Hence, the flowers were piled on top of one another to give the bouquet a very real sense of dimension.

Finally, indications of small flowers were added in magenta. These are especially obvious around the left side and are little more than quick dabs of the chisel-tip marker. Some pussy willows, sepia and dark gray stems, and a few leaves (forest green and green-and-gray blends) were the finishing touches. The manner in which the pussy willows were rendered is interesting. After the stem was drawn, a Q-Tip barely moistened with turpentine was gently rotated through the stem, picking up some of the stem's color and blending it with the background color. Then the Q-Tip was used to fashion the oval shape of the blossoms with a U-shaped stroke. This produced a darker area in the center of the U — where the two flows of ink came together — that perfectly captures the natural cleavage observable in a pussy willow.

Flowers Outdoors

Before you put down any color, study *Cactuses* (p. 74) for a moment and you'll see that it shows many of the techniques just discussed. Except for color, the large cactus leaves were achieved in much the same manner as in the peacock blue vase and the initial, vertically stroked mass that later became a bouquet of flowers in the yellow flowers study. The flowers in the upper right quadrant of the cactus study resemble the roses of Figure 70. The small but prominent leaf projecting out from the center of the right-hand edge was obviously done through a cutout stencil, paralleling Figure 71. And the small, light dots on the cactus leaves are the result of dabbing with a Q-Tip that was moistened with turpentine and squeezed dry.

Now examine *A Birdhouse With Morning Glories* (p. 75), a quick sketch made on location with both fine- and chisel-tip markers on a vellum pad. As this study shows, markers can also produce very agreeable results when handled conventionally. There's minimal overpainting in this work. All that was wanted was a quick, uncomplicated visual impression of the forms, composition, and colors making up this scene. Although the colors were simply laid in, they look muted enough to give the delicate effect.

Suppose you're outdoors and there's a bank of flowers to be sketched. With a slight twist — literally — the same "stamp pad" technique that we used to produce leaves back in Project 2 can also create effective flowers. The blossoms and leaves in Figure 75, for instance, were both produced with the same paper-towel stamp — twisted a quarter or a half turn when rendering the flowers. The lighter blossoms near the center are yellow worked over red. Similarly, with a comparatively large typing-paper stamp, the individual flowers in Figure 76 were produced with a stamp-and-twist procedure. The actual size of these renderings is $1\frac{1}{4}''$ to $1\frac{1}{2}''$ wide.

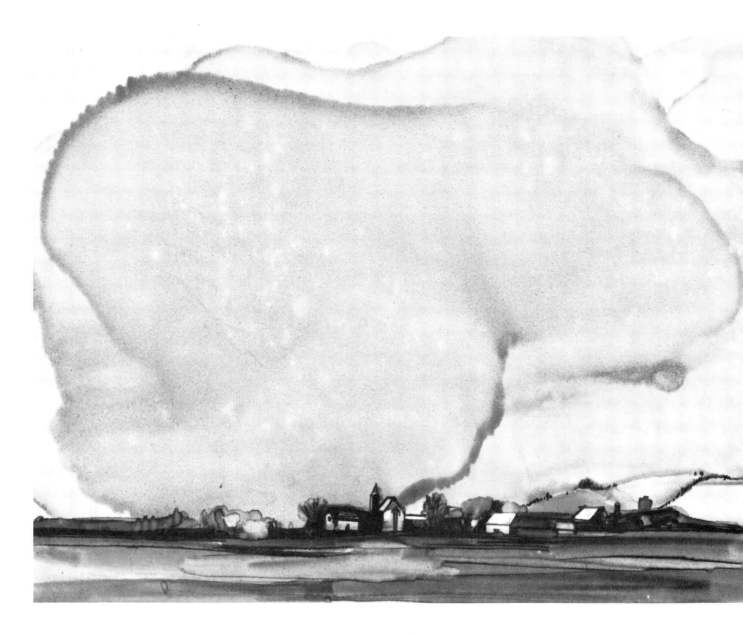

Figure 77. Immense storm clouds were rendered quite simply with markers. First, the sky was painted blue, then gray was blended in. Next, a small area of dark gray was overpainted. A few drops of turpentine were then poured on the dark gray and the painting was tilted enough to cause the turpentine to run or flow. The hard edges mark the limits of successive flows.

A few examples are now in order of how the methods we've been exploring can be translated into clouds. Clouds will, of course, fill the skies of many landscapes, so it will help to know how they can be produced with considerable ease. Clouds can be most useful in conveying the mood of your painting. They range from the ominous and oppressing (Figure 77) to the light and airy (Figure 78). No doubt you remember the types of clouds — cumulus, cirrus, altostratus, etc. — from a science course in school. If not, let nature be your teacher and this chapter will demonstrate some ways to render with markers the airy, floating "pillows" you'll observe.

Materials Needed

For the various exercises here, you should have:

1. Markers — one or two blues and a dark and medium gray
2. Several sheets of impermeable paper (vellum is ideal)
3. Turpentine
4. Facial tissue
5. Q-Tips
6. Bristle (oil) brush
7. Watercolor brush

All the studies in this project were done on a nonabsorbent surface. While it's possible to use porous paper and adapt certain techniques from other media (for example, wetting the surface with turpentine and painting in blue around your cloud shapes), the results will not be as pleasing, by and large, and control is considerably more difficult. If there's a compelling reason to employ watercolor techniques, such as wetting the paper with a glycerine-and-water solution, then you should use water-soluble markers, although you may still encounter trouble. Unless the marker is new and very wet, the felt tip may soak up the water from the paper instead of applying color.

A better approach with permeable papers is to mask the clouds with gum water or maskoid according to the technique presented in Project 1, especially the method used for *Sycamore in Snow* (p. 55). Later on, you'll learn how to seal the surface of absorbent papers to make them impermeable. But for now a sheet of vellum will suffice.

Painting Storm Clouds

The storm clouds in Figure 77 were achieved very simply. First an over-all sky background was painted with blue, then overpainted with medium gray. Next, an area near the center was painted solid dark gray. The size of this area was roughly a quarter to a third of the entire sky. Then pure turpentine was poured onto the dark gray area. After you paint your cloud, use just enough turpentine so it will flow across the surface when you tilt the drawing. Maneuver the flow first to the extreme edges of the cloud size you want, then concentrate the fluid in the center and give the edges a chance to dry partially. Now maneuver the flow outward again, toward the established boundary. You can repeat the procedure several times to build up an impression of depth and cloud layers. You can add objects after the sky is completely dry, such as the village in Figure 77.

Figure 78 was achieved by a modification of the above, by omitting the dark gray. The sky was painted solid blue. Turpentine was poured near one corner and then the study was set aside to dry. The surface wasn't tilted at any time. Afterward, the borders were cleaned up with a paper towel just barely moistened with turpentine.

Other Clouds

The billowing clouds in Figures 79 and 80 were produced by modifications of a technique that is by now familiar. In both cases, the first step is to paint a solid sky with a blue marker (or blue blended with another color of gray, if you prefer). Depending upon whether you want the clouds to be dark and threatening or white and fluffy, you can add dark gray patches as we did in Figure 77. Then moisten a facial tissue with turpentine and pat the sky until you get the desired effect. The dominant, pure white mass in Figure 79 was obtained by patting the still wet clouds with a dry, clean tissue.

Figure 81 is the result of a similar routine. But here the tissue was shaped so that several tiny "ears" projected and these were moistened with slightly more turpentine than you've found advantageous thus far. Consequently, the surface was barely "kissed" with the ears, sometimes with a short stroke added. When most of the turpentine had evaporated from the tissue, it was reshaped into a round wad and patted lightly to produce the larger cloud patterns.

Virtually the only feature distinguishing Figure 82 from Figure 80 is the striated effect at the cloud's base. These striations were accomplished with a bristle brush. Dip the bristle tips in turpentine, dry them with a quick wipe of a facial tissue, a paper towel, or a rag, then stroke from the cloud's edge inward.

A different sort of cloud striation is one you'll often see in the sky (Figure 83). A brush was used here, too — this time, a

Figure 78. A modification of the step used in Figure 77 produced this cloud. The sky was painted blue, then turpentine was poured on from one corner. The painting was immediately set down flat to dry.

Figure 79. Repeat the step in Figure 78 for this cloud — only pat the turpentine-wetted surface with a dry facial tissue. Use enough pressure to blot up the colors.

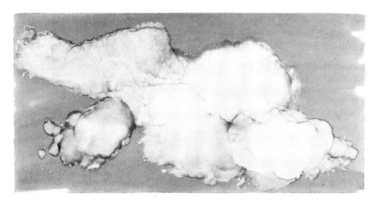

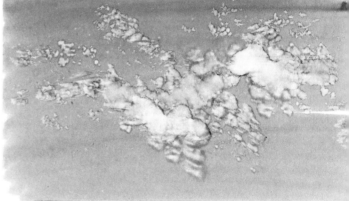

Figure 80. This cloud was achieved a bit differently than in Figure 79. Here, the facial tissue was pre-moistened with turpentine and patted only very lightly so as not to blot up all the color.

Figure 81. Do the step as in Figure 80 — but just "kiss" the turpentine-wetted inks with facial tissue folded like a man's vest-pocket handkerchief (with projecting "ears") and you'll create this cloud.

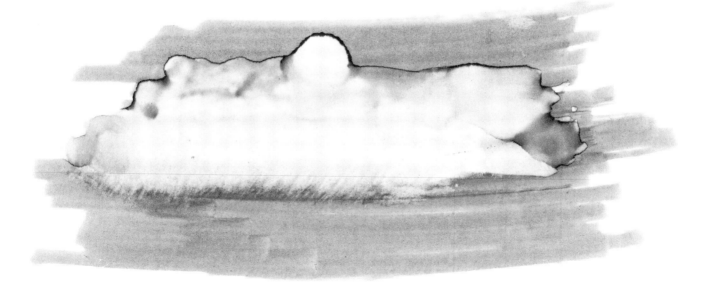

Figure 82. The "feathery" bottom edge distinguishes this cloud from the one in Figure 81. An oil bristle brush, stroked gently over the still wet colors, will produce the effect.

watercolor brush. First the sky was painted a solid blue (you'll rarely observe these clouds when the sky isn't a sparkling blue). A little turpentine was poured into the center to create the billowing form there. And then a dry brush was used to stroke outward from the center at two or three spots. After several minutes, when the painting was almost dry, the brush was used again, moistened lightly with fresh turpentine, to stroke in the long, horizontal shapes. A slight touch-up with a facial tissue in the foreground was the final step.

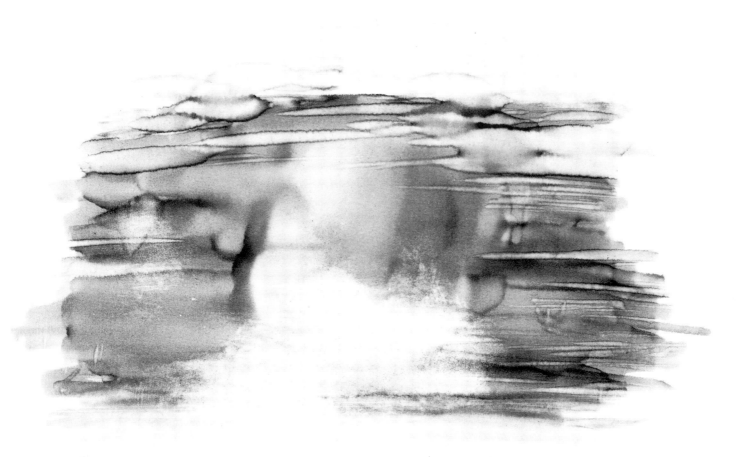

Figure 83. Reworking with a brush was also done here, plus a final few pats with facial tissue. Use a dry watercolor brush to move large amounts of turpentine soon after adding the liquid; this will create the larger horizontal bands. When the study is nearly dry, use the point of the brush and some fresh turpentine to add the smaller streaks.

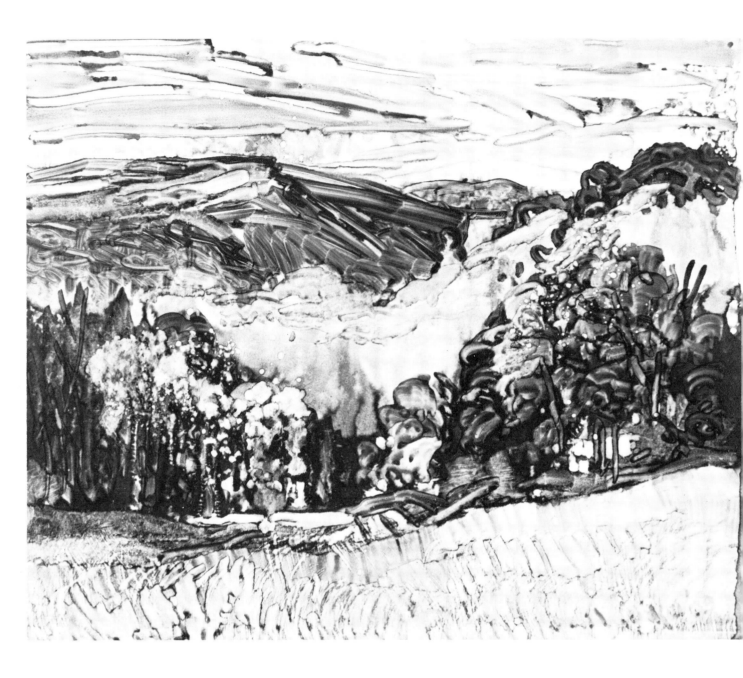

Variegated Landscape by David C. Baker. Assorted brushes and even a wallpaint roller were employed for various effects on an 8″ x 10″ Marlite board. The light dots in the trees were produced by turpentine spray.

HILLS AND MOUNTAINS

Of all the subjects frequently painted by artists the world over, one theme with almost universal appeal is the majestic grandeur of mountains. For the next few pages, then, we'll look at mountains in three perspectives: first, as the focal point of a painting, with rock formations and ridges as the primary compositional element; second, as one of two or more dominant subjects in a landscape; and third, as the backdrop of a painting that centers elsewhere.

Perhaps the most important objective of this chapter is to introduce a new and different technique — a technique developed, appropriately enough, by New Hampshire artist David C. Baker, whose home is near the Presidential Range of the White Mountains. The contrast in style between the works of Mr. Baker and Mr. Troisé is particularly illuminating with regard to the versatility of markers. Mr. Baker's work tends to be fluid, amorphous, soft; Mr. Troisé's paintings, on the other hand, tend toward cubism — with harsh, crisp, rigid lines and forms.

Materials Used in the Studies

In addition to some materials with which you're now familiar, some rather unusual equipment was used in the following studies. All are easy to obtain, however. You can experiment with the different materials in similar paintings.

1. Pyroxylin-coated cover stock, with a leatherlike textured surface

2. Marlite panels (you can have the 4' x 8' panels cut to size if you don't care to do this for your own projects)

3. Markers — a full range of colors, with at least two shades each of green, blue, brown, and red — plus yellow, orange, black, and three warm grays (Nos. 1, 5, and 9)

4. Turpentine

5. Q-Tips

6. Stiff-bristled paintbrush, 2″ to 4″ wide

7. Short-nap paint roller, 4″ to 6″ wide

8. Spray bottle (such as an empty bottle of window cleaner), filled half full with turpentine

9. Inexpensive watercolor brushes — small, medium, and large.

Rock Formation (p. 86), by Emile Troisé, was done with chisel-tip markers on leatherlike cover stock. In the sketch, Mr. Troisé was interested mainly in capturing the pre-eminent design of therefore, is subordinated to chiseled forms and colors.

The rock study displays the artist's penchant for abstraction (compare the Easter Lilies painting on p. 70). When Mr. Troisé chanced upon this cubistic rock formation, he pulled his car over and produced the study in about ten minutes. The color sketch is a fairly good literal rendition of the outcropping and hence will undoubtedly bear little resemblance to the finished painting that one day may evolve.

"Accidents" Can Be Manipulated

For a drastic contrast in styles, compare Rock Formation with Rolling Foothills (p. 85). The latter is one of David Baker's early efforts in marker painting — a painting on Marlite done only with black ink. Even a cursory inspection of the work gives you an idea of how it was achieved — by manipulating ink flows. This may sound as if Mr. Baker's technique is largely haphazard and accidental. To some extent it is. But if minute details aren't completely predictable, at least gross effects are. Practice and experience with the technique also helps. Mr. Baker has been working with controlled flows (but of watercolor) for several years and has refined the process to a system. Fortunately, these years of experimentation, trial and error, and discoveries are for the most part directly translatable into marker paintings. The result: a mature technique for working with the comparatively new medium of markers.

The study developed as follows. First, the crest of the background range was outlined with one sinuous marker stroke. Along this line two dense areas were filled in with additional strokes (one area is left of center, the other is on the right). Next, with a 2″ paintbrush dipped in turpentine, the crest was retraced, depositing a substantial amount of turpentine on the panel while picking up a quantity of rewetted ink and dragging it across the surface. Successive overlapping strokes of the paintbrush continued until the background hills were blocked in to the crest of the foreground ridge. Then the panel was lifted to stand on the lower left corner — and the ink flowed and melted into the turpentine-wetted surfaces.

When the initial flows were dry, essentially the same procedures were used to produce the foreground mountains. But a slight modification was made. Before the ink flows were completely dry, the panel was taken off its lower right corner and placed vertically on the bottom edge, inducing a few still wet flows to branch off from the original direction, and then the panel was replaced on its lower right corner. Notice the flow patterns near the bottom right edge. A third repetition of the process produced the hill in the bottom right corner.

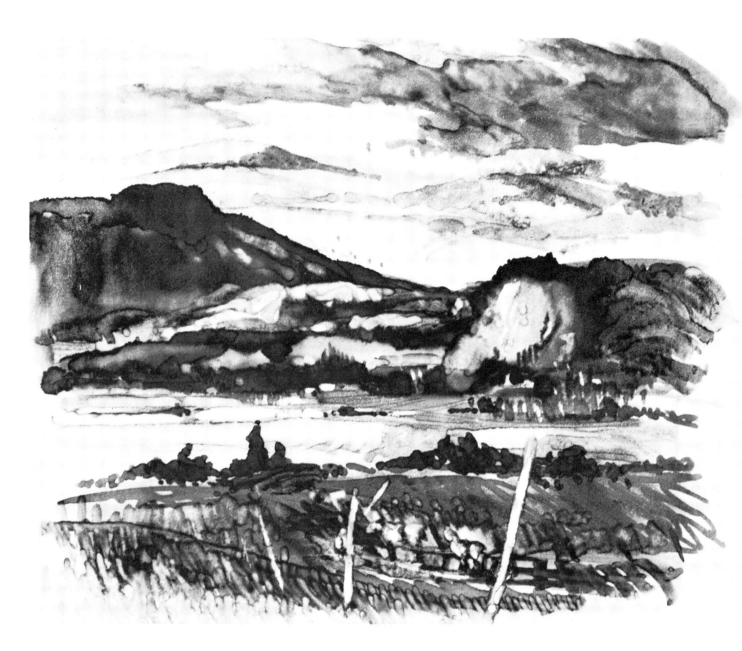

Fence by David C. Baker. A more conventional handling of markers is obvious here. However, this painting, done on 11″ x 13″ vellum, is actually just a step beyond *Variegated Landscape*. The difference is in the extensive reworking of marker inks with a watercolor brush and turpentine. Note that edges of distant objects are less distinct; this was achieved by using more turpentine on the brush, which resulted in softer edges.

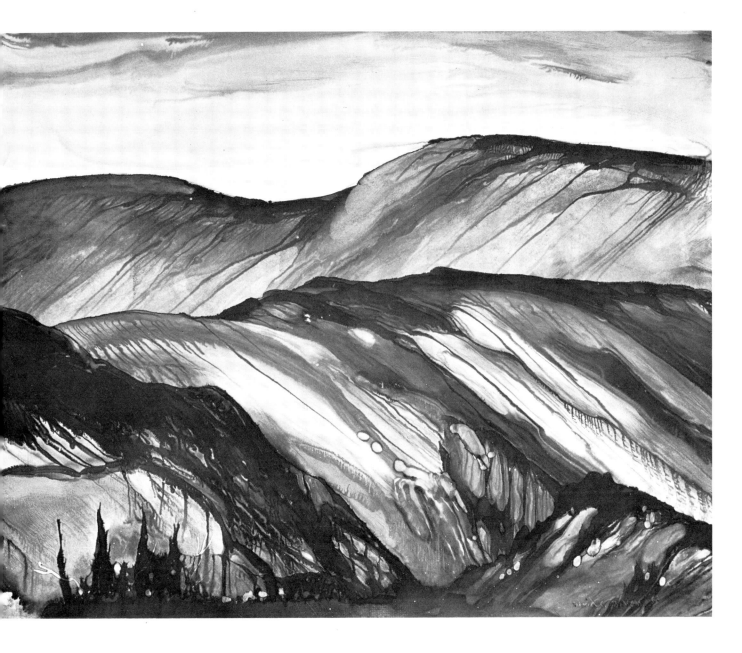

Rolling Foothills by David C. Baker. These mountains are really the happy result of manipulated "accidents." The scene, done on 24" x 30" Marlite, began with a sinuous marker stroke delineating the horizon. Next, a 2" paintbrush containing turpentine was used to wet the area from the horizon down to the crest of the next range of mountains — and to rewet the marker ink. Then the panel was tilted up on the bottom left corner, allowing the wet marker ink to run down the surface. After the ink flows dried, the same procedure was repeated for the next range of mountains. Smaller strokes of turpentine with a watercolor brush provided details.

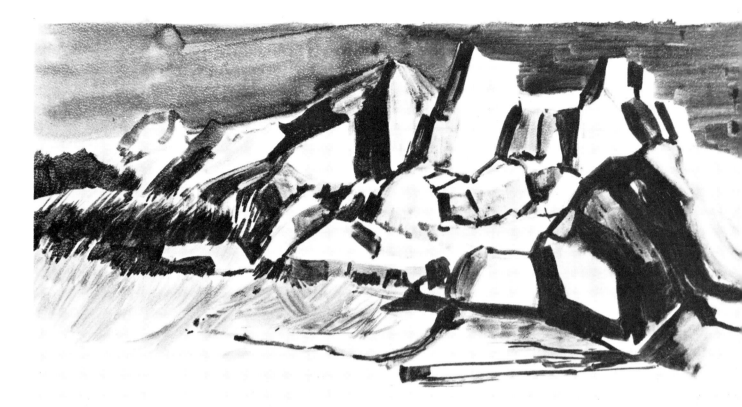

Rock Formation. A sense of monumental nature of rocks, of solidity, is graphically conveyed in this study, which took about ten minutes to complete. For this kind of effect, chisel-tip markers are a definite asset; the tip's configuration forces avoidance of too-fine details. This painting was done on 10″ x 17″ Canvasette paper.

For the sky, the panel was positioned on its right side. The 2″ paintbrush was dipped in turpentine, wiped so as not to be too wet, then used to cut down the crest of the backdrop hills by a half inch or so. The ink that was picked up was painted across the sky, then a touch more turpentine was added just above the hill crest to create a flow. Finally, the panel was turned upside down to achieve the crown-shaped vegetation in the lower left corner.

Finishing touches called for a medium-size watercolor brush and the panel's return to its proper position, resting on its bottom edge. A stroke or two of turpentine, in the lower right corner along the imaginary diagonal from top left to bottom right, resulted in the vertical flow evident there. Then, with the panel lying flat, the round watercolor brush was used to dab turpentine in several spots along the bottom edge — and to outline some almost white branches in the crown of the vegetation.

Textures Modified by Spraying

Believe it or not, *Variegated Landscape* (p. 82) was executed with some of the same methods that produced *Rolling Foothills*. Unfortunately, black and white photography makes this painting on Marlite appear crude. To appreciate the beauty of the original you'll have to do something similar. Here's how. Color the top and bottom quarters (where the sky and grass will take form later) golden tan, or blend sepia and cadmium yellow. Spray these areas with turpentine from a window cleaner bottle, then immediately roll down the bottom quarter (the grass) with a small paint roller. Allow the mottled effect to dry in the top quarter (that is, don't roll that area). Then draw in the mountain crest with umber and continue painting in umber until the middle half is covered. Dip a 2″ brush in turpentine and retrace the mountain crest. Lift the panel and let the turpentine

flow downward. As umber flows into the grass area, periodically roll it out. The tan will become darker, of course.

Now stroke in the long clouds, using forest green (darkest strokes) and sepia (middle tones). Don't cover all the sky. Outline the mountain crests with the forest green and also use this color to indicate traces of vegetation on the sides of the mountains. Use green, too, to block in the dark triangle coming into the center from the left edge, and for the base of the middleground trees on the right. Cover the distant mountains with ultramarine, leaving some of the green showing through. Highlight the crest of the lower hills with violet, and at the extreme right with No. 9 warm gray. Also use this gray to stroke in treetrunks. Autumn foliage on these trees is executed with swirling strokes of sepia, burnt sienna, and vermilion. Work back over the grass in yellow green or lemon yellow, with short, abrupt strokes. Then dip the 2″ paintbrush tip in turpentine and lightly stroke over the grass. Finally, give the trees at left and right one quick squirt of turpentine.

Using a Brush for New Texture

The color scheme in Mr. Baker's *Fence* (p. 84) is not too different from the painting done on Marlite. In fact, at one stage, it even looked like the latter. The remarkable change in appearance was accomplished by reworking nearly the whole painting with a round watercolor brush, sometimes only just moist enough to smooth out the marker strokes, other times quite wet to produce a small controlled flow. Notice how Mr. Baker deliberately increased the average amount of turpentine in the brush as he worked further into the background. Consequently, the sense of depth is enhanced.

Another appealing theme next to mountains and hills is the sea and other bodies of water, and we'll cover this topic in the next project.

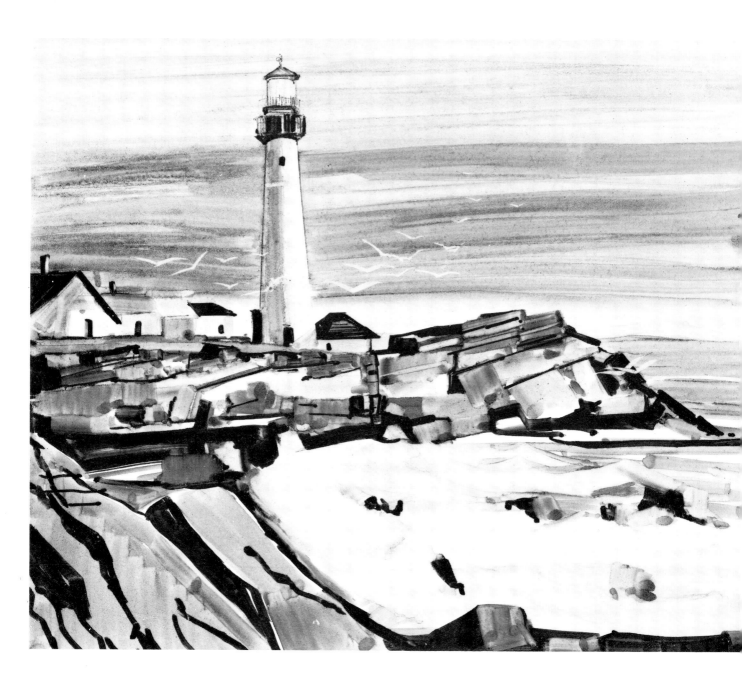

Seascape With Lighthouse. Another method of "not" painting water with contrasts is to use different shapes. The fluidity of water, for instance, can be enhanced by surrounding it with hard, forceful rock formations — rendered with straightforward strokes of chisel-tip markers. The effect of white water at the shore's edge was produced by dabbing with facial tissue moistened with turpentine. Several elements in this painting were produced with stencils.

STILL AND MOVING WATER

There's a mystery about the sea that has fascinated man since time began, and the allure of fresh waters, though often different in mood, is equally ageless. Painting the sea and other bodies of water is rightfully the subject for an entire book. Indeed, several excellent ones have been written and it would be a good idea to buy one. (See the Bibliography at the end of the book.) But in this chapter we'll attempt to convey the essentials of painting water with markers. We'll begin with a few sketchbook samples and then progress to finished paintings like *Moody Sea* (p. 95).

In the course of the project, we'll come upon new techniques as well as applications that extend the use of some of the techniques already studied. For instance, we'll see how marker paintings can provide the esthetics of watercolor yet escape watercolor's limitations.

Materials Necessary

In the works presented a rather large selection of markers was used. If you haven't purchased one of the sets available from at least three manufacturers, it's suggested that you do so.

1. Vellum

2. Coated cover stock

3. Sketch paper

4. Cold-pressed, medium-toothed illustration or watercolor board

5. Canvasette paper

6. Marlite panels

7. Turpentine — also rubber cement thinner (optional)

8. Q-Tips and small cotton balls

9. Spray bottle (such as an empty window cleaner dispenser)

10. Gum-water frisket

11. Razor blade or utility knife

12. Facial tissue

Landmarks in Painting the Sea

The unusual thing in painting seascapes is that frequently you don't paint the *sea* so much as the *objects* bordering it. If you ponder this thought, however, the reason becomes obvious. The oceans (even fresh-water lakes) are so immense that no canvas is big enough. And very few artists are talented enough, or perceptive enough, to paint *just* an expanse of water and capture in it a slice of the overwhelming emotion one experiences from standing on the shore or on the deck of a ship. To communicate some semblance of this feeling, then, a convenient crutch is to give the painting scale by including some landmark that will be familiar to viewers. And if this landmark shows signs of weathering or other effects from being near the sea, so much the better. It emphasizes the sea's relative immortality in comparison with the land or the transient works of man.

Some of the easiest ways to "not paint" water involve strong contrasts with the surrounding terrain. In the *Beach With Rowboats* study (p. 90), by Emile Troisé, for instance, the sense of water is achieved through contrasts. The water is simply a flat area of ink on vellum — producing a feeling of placidity, which in turn implies size and locale (a small, resort area lake) although only a tiny portion of the water is depicted. Around the water are objects offering marked textural contrasts. Even the beach, which is unpainted save for the two rowboats and a skimpy few strokes and dabs, manages to be significantly different in texture. Note that whatever textural elements are used, they become progressively more pronounced as they approach the water's edge. Also note the white flowers and stems at bottom center; these were scratched out with a razor blade.

More Examples of Contrast

Another example of a study in contrasts, *Seascape With Lighthouse* (p. 88), also by Mr. Troisé, employs differing shapes as well as textures. In this study, done on coated cover stock, the fluidity of the water is enhanced by surrounding it with hard, forceful, linear rocks which were achieved with simple, straightforward strokes with chisel-tip markers. The overcast sky was laid in with sweeping, side-to-side strokes (the lighthouse had previously been masked out with gum water). Then the foreground water was rendered. Initially, the whole area was no more than overlapping wavelike strokes — of the sort even children employ to depict water. Cubistic rocks projecting above the swells were next added. And then, to achieve the effect of white water dashing against the shore, facial tissue containing traces of turpentine was used to blot up the inks. To finish the painting, the gum-water mask was removed and the lighthouse painted in, along with the adjacent buildings. Note the edge of the shadow ascending the lighthouse. Originally, it was merely a hard edge of a vertical marker stroke, but Mr. Troisé softened it with a Q-Tip dipped in turpentine. Finally, paper stencils were cut in the shape of gulls.

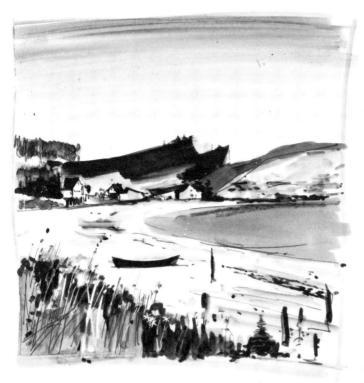

Beach With Rowboats. An easy way to paint water is "not" to paint it, as illustrated here. The sense of water is achieved by means of textural contrasts. The water is simply a flat area of ink, creating a feeling of placidity that one associates with a small lake. Surrounding the water are objects offering marked textural contrasts. Note that these contrasts become progressively more emphatic near the water's edge.

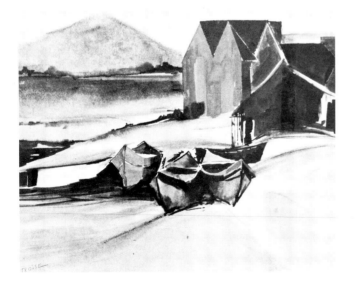

Lake, Boats, and Barn. A more sophisticated example of using surface reflections to indicate the presence of water also reveals another aspect in marker versatility: effects very much akin to those of watercolor painting. Despite this painting's softness, it has a color intensity uncommon to watercolors. The softness is produced by brushing on a relatively heavy coat of turpentine immediately after the colors were laid in on medium-toothed watercolor board.

These were placed on the painting and washed over with a Q-Tip containing rubber cement thinner (turpentine will do equally well, though it won't dry as quickly), which picked up the marker inks and left behind graceful white silhouettes.

The use of contrasts to "not paint" water is also evident in *Acapulco Beach* (p. 91), a black and white sketch done on location by Meredith Hupalo. There's nothing fancy or magical about this approach, and there's a good chance that in your own paintings you may be employing it already, consciously or not. What counts is that it works effectly. A different handling, illustrated in the *Study of a Wet Road* (p. 92) by Emile Troisé, entails a different kind of contrast — logical contrast, if you will. In a small rain pool in the road we see reflections of objects that we intuitively know can't be where we see them. So our minds leap to the conclusion, based on past experience, that the visual stimulus is caused by the reflectivity of water. Still, we haven't actually painted water *per se*.

Emulating Watercolor

A more sophisticated example of water's reflectivity is presented in *Lake, Boats, and Barn* (p. 90 and also the color plate on p. 103) by Emile Troisé. Moreover, this painting debuts another facet of marker virtuosity — effects typical of watercolor paintings. Despite the painting's softness, however, it has color intensity uncommon in watercolor. If a "markercolor" and a traditional watercolor are compared side by side, the difference in color intensity borders on a magnitude akin to the increase between an ordinary color and fluorescent pigment.

This work was painted on cold-pressed, medium-toothed board. The softness is produced by laying in a relatively heavy coat of turpentine shortly after the marker inks were stroked in. It's possible, but not generally satisfactory, to wet the surface with turpentine *before* applying marker colors. The difficulty with this handling is that the porous marker tip tends to absorb the turpentine and therefore emit little or no ink. The mountain across the water in the painting is emerald green and aqua, washed with turpentine. Along the edge of the water at its base is a jagged strip of Prussian blue, only partly washed, that the viewer's eye interprets as trees and vegetation. In the water, a thin strip of Nile green immediately blends into peacock blue, then shading into ultramarine and then more Nile green and touches of yellow. The turpentine wash works from the foreground back into the edge of the ultramarine.

Adjoining the lake is a barn of magenta, crimson, and vermilion, with cadmium orange and chrome orange doors. The roof and shadows are obtained by overpainting the reds with umber. The barn's third dormer (on the right) is olive and overlays of emerald green and a peacock blue border at the apex. The adjacent roof on the right is navy blue. Along the painting's edge are burnt umber and burnt sienna forms: The building nearest the boats is ultramarine with Prussian blue and black shadows. From the left, the rowboats are white with navy blue trim, Nile green with vermilion trim, peacock blue with ultramarine interior (both washed) and black trim, forest green (washed) with orange, red, and black trim, and ultramarine with black shadows. The ground around the boats is heavily washed to produce very light pastels of green, blue, brown, and yellow.

Acapulco Beach by Meredith Hupalo. A minimum number of strokes with a water-soluble marker hint at the existence of water in this location sketch. This approach, of course, is commonly followed by many artists — yet it is another example of "not" painting water.

Study of a Wet Road. A different handling entails "intellectual contrast," if you will — or "logical contrast" — to communicate the presence of "not painted" water. In a small rain pool in the road, we see reflections of objects that we intuitively know can't be where we see them. We therefore conclude that the visual stimulus is the result of reflection in water.

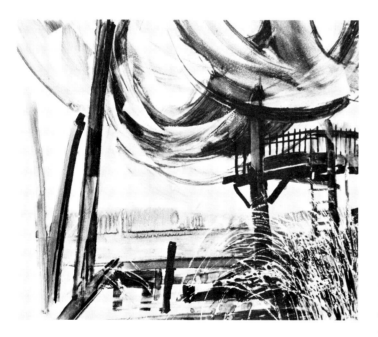

Wharf With Fishing Nets. Fishnets drying in the sun and breeze were painted in with markers on canvas paper. Stencils were used for several important elements. For instance, the foreground grass was executed by masking with gum water, then after the stencil was removed, suggestions of yellow and orange were added. Most of the grass, though, is simply left white. The nets were created by washing umber and sienna colors with turpentine, then further thinning selected areas with the help of triangular cut paper stencils.

Working with markers in this manner does impose restrictions, though they aren't as severe as those inherent in conventional watercolor. The restriction is that a color applied to a permeable paper cannot be removed. But this is ameliorated by the fact that, with markers, you can overpaint and correct several times before you begin to lose sparkle and clarity.

Seaside Wharves as Subjects

A very colorful painting is an interpretation of the Monterey, California, wharf. This painting, executed on coated cover stock, is a medley of brilliant colors against a stark white background — a mosaic of blues, greens, reds, and yellows laterally confined between brown, black, and deep green pilings and brown and dark blue roofs. So vibrant is this composition and color scheme that the painting seems to expand off the sides of the paper — kaleidoscopically (see color plate on p. 101).

But what's of prime interest, here, is better illustrated in Figure 84, which shows how the simple yet very effective treatment of water was handled. The jumble of pilings was painted from the background toward the foreground. Periodically, the lower part of one or more pilings was wiped with a cotton ball wetted with turpentine, thereby smearing the ink to the right and left, creating the impression of water. This impression is reinforced by the ghost image of the piling under the water's surface. To arrive at this retained image (Figure 85), the painting was wiped very gently, or else the choice of the cover stock must be made with great care. There are certain paper coatings that are permeable to a degree — neither really impermeable nor really permeable in the sense of sketch paper — and will hold such an after-image no matter how hard you try to eradicate it with turpentine or solvent.

Fishing nets drying in the breeze is another favorite subject of artists. *Wharf With Fishing Nets* (p. 92 and also the color plate on p. 104), by Mr. Troisé, is how you might handle such a scene with markers on canvaslike paper. Apart from the blue water and yellow blades of grass, the color scheme is predominantly umber and sienna, with some grays used for the pilings. The design of the painting is also noteworthy, particularly the mirroring of the sweeping arcs of the nets in the foreground grass. This grass, incidentally, was executed at the start of the painting with gum water and a small sable brush — in other words, a "negative" stencil. And the final step was to remove the mask and touch in suggestions of color with lemon yellow and chrome orange. No more than half of the grass is colored, the remainder was left with the white paper showing through.

Several techniques were employed to render the nets. First, sweeping strokes of raw and burnt umber and raw and burnt sienna were painted in. Then a turpentine-moistened cotton ball was used to wash over the marker strokes. The curving, triangular highlight areas were achieved with cut paper stencils, gently washed over with a moist Q-Tip without removing too much color. Finally, the grainy texture was produced by spraying the painting with a fade-resistant fixative — with the aerosol can held closer to the painting than directed on the label. As mentioned earlier, these UV (ultraviolet light) absorbing fixatives contain a solvent that attacks marker inks. Often this is detrimental, but here it's used to advantage.

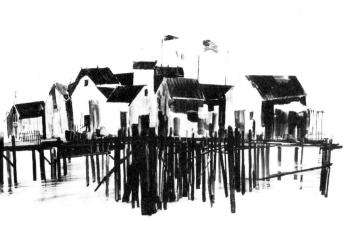

Figure 84. (Left) This Monterey wharf scene is a brilliant medley of colors against the stark white of the coated cover stock, with the heavy use of black and dark brown in the pilings. Vibrant blues, greens, reds, and yellows are employed in an almost mosaic manner.

Figure 85. (Below) A sense of water is produced merely by dragging color from the pilings with some cotton moistened with turpentine. The pilings were painted from back to front and periodically wiped with cotton so that the closer pilings could be painted over the more distant water. The cover stock used is not absolutely impermeable so the marker inks can't be completely eradicated with turpentine. This is advantageous in creating the "ghost" images of the underwater portion of various pilings.

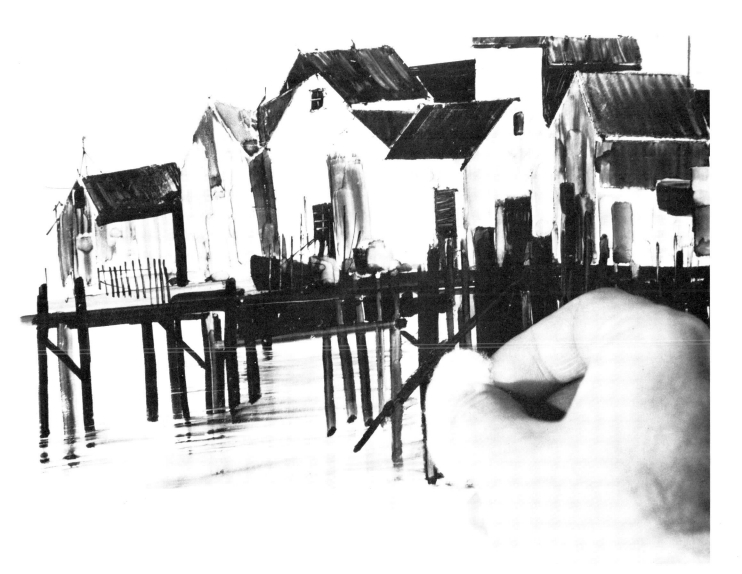

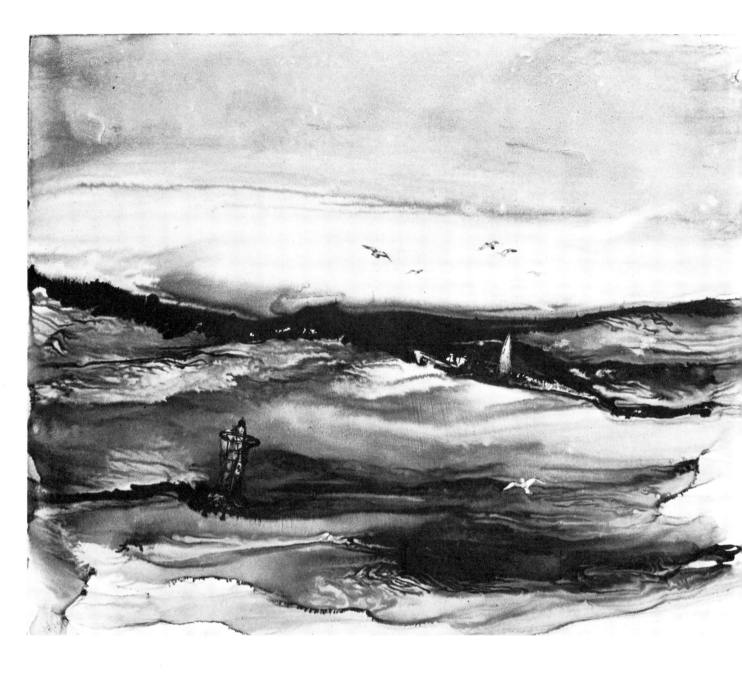

Sea and Birds by David C. Baker. The liquidity of the water was produced by utilizing the liquidity of turpentine. After the marker colors were painted on the Marlite panel, turpentine was brushed on heavily enough to flow across the painting's surface when the panel was tilted slightly. Several turpentine fluxes were used, each controlled by tipping the panel at various angles. Striking the edge of the panel while the flux is still wet will result in a white-waterlike effect.

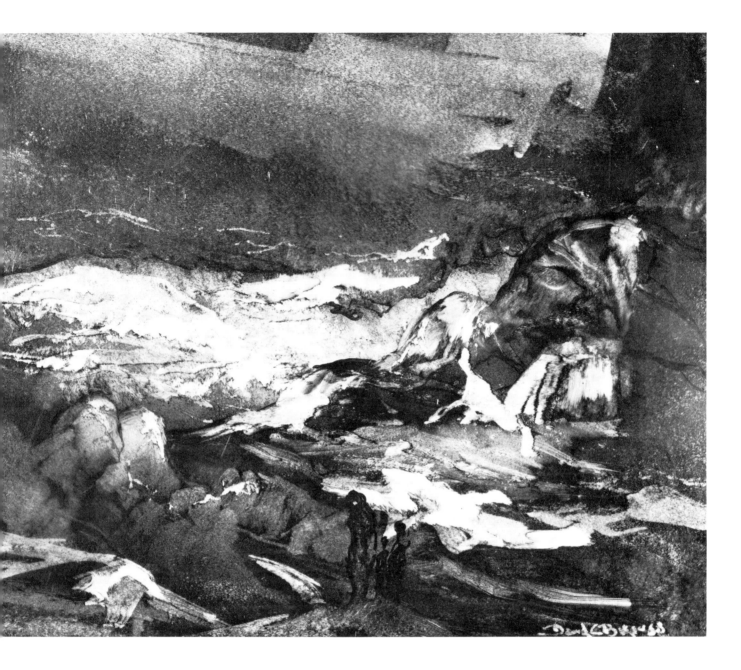

Moody Sea by David C. Baker. A moody, mysterious seashore is condensed into a scene consisting of a few waves and rocks. Various browns and grays predominate in this painting. Breaking waves were the last element, obtained by picking up marker colors from the plastic-coated Marlite with a watercolor brush and turpentine. Some colors were also brushed on. The grained appearance of the foggy sky was produced by spraying the painting (before shoreline objects were rendered) with turpentine, then rolling down with a felt wallpaint roller.

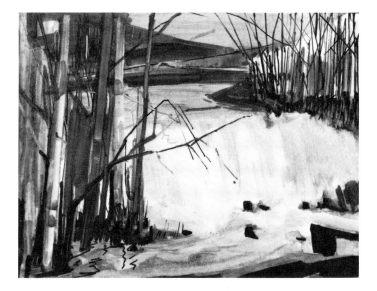

Waterfall. Painting the actual movement of water is a very trying task at which few artists demonstrate mastery. A good approach for beginners is to include just the barest detail and leave the rest to a viewer's imagination. It's also suggested that this method be augmented by "framing" the water with eroded banks or vegetation that help identify the water.

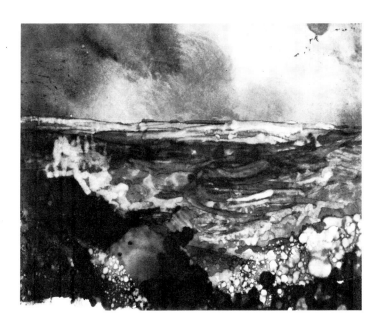

Seascape Abstract by David C. Baker. When you are unable to provide surrounding clues, markers can be most helpful in taking one step away from a literal rendition to a more interpretative portrayal. Successive color layers of color on Marlite were modified by brushwork, turpentine washes (some of which were sprayed on), and rolling with a wallpaint roller. The boiling white-water effect at lower right was achieved with turpentine spray.

Moving Water

When it comes to actually painting water itself, particularly turbulent water, it turns out to be a formidable task. Don't expect to gain proficiency in rendering moving water without years of practice and many failures. The number of artists who are capable of good surf scenes, for instance, is somewhat low. Too frequently, paintings of turbulent water have an artificiality about them that's hard to define — except to say that the water just isn't believable. To illustrate the point, if you're familiar with the work of Jean Khanbegian, a Nova Scotian who now lives in Bar Harbor, Maine, or if you have one of her books, compare her paintings of the Atlantic surf with something in a local gallery or a reproduction of another artist's work. It's very likely such a comparison will make it clear that in order to paint the sea well, you almost have to live beside it for an extensive part of your life.

Because moving waters are so extremely difficult, the best solution is usually to include the barest amount of essential detail. Use shoreline contrasts of texture and shape — and color — and let these clues communicate the sense of water. Let your viewers use their imaginations. *Waterfall* (p. 96) is an example. If you were to mask out the trees and river banks, what is left would hardly communicate the impression of water.

Turpentine Wash Effects

In the case of paintings where there are no surrounding clues — such as the *Seascape Abstract* (p. 96) by David C. Baker — markers can be of vast help, notably when you use them on an impermeable surface (Marlite panels, for example). This painting was executed by blending grays and blues for the sky, then working over the marker strokes with a cloth moistened with turpentine. The waves on the horizon were stroked in blue and green, and then washed with turpentine applied with a watercolor brush. The balance of the water was done by building color over color, interspersed with turpentine washes (some of which were sprayed on), until a satisfactory result was obtained. And then a large wash was applied at lower left and the entire foreground sprayed with turpentine. In a practical sense, this treatment of the foreground is advantageous in that it obviates excessive preoccupation with detail — and prevents the viewer from finding discordant details. Meanwhile, the impermeable surface permits the reworking of an area as much desired. If the area becomes muddy, it can always be wiped clean.

Another way of working with turpentine is illustrated in Mr. Baker's *Sea and Birds* (p. 94). Here, the feeling of liquidity is enhanced by *flowing* the marker inks in a turpentine flux. Apply colors as before, and follow with a heavy amount of turpentine from a brush — enough turpentine so that it will flow when the surface is tipped from the horizontal. By alternately tilting the painting this way and that, you can control the flow of turpentine as it mixes with the marker inks. Strike the edge of the panel or jiggle it vigorously and you'll get a white-water-like effect. It's best to confine a flux to a small part of the painting and work successively across the panel. This is easier and allows you to vary the effects from one part of the painting to another.

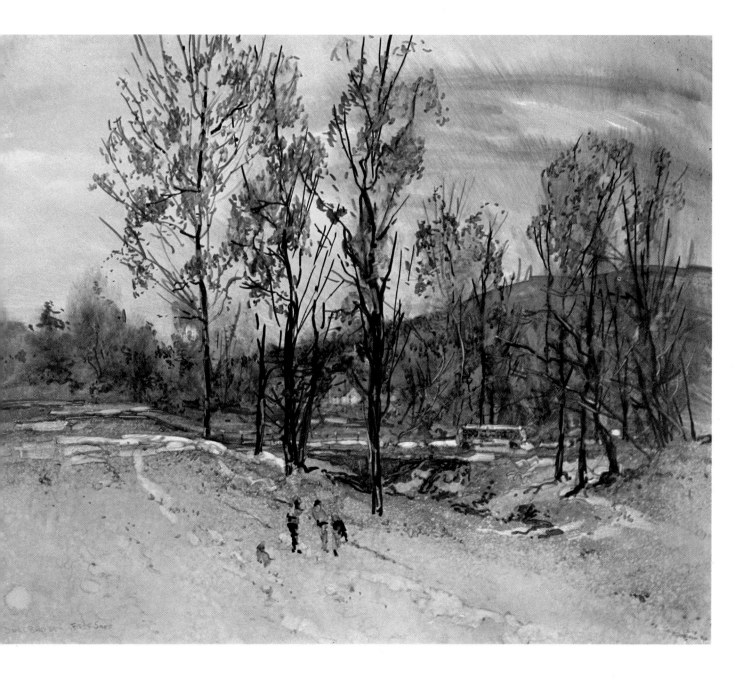

First Snow, David C. Baker. 18″ x 24″, markers on Marlite. Sprayed turpentine was used to create snow as ground cover in this painting. The trees, boys, and dog in the foreground were painted after spraying to keep the details clear, as they would be after a snowfall.

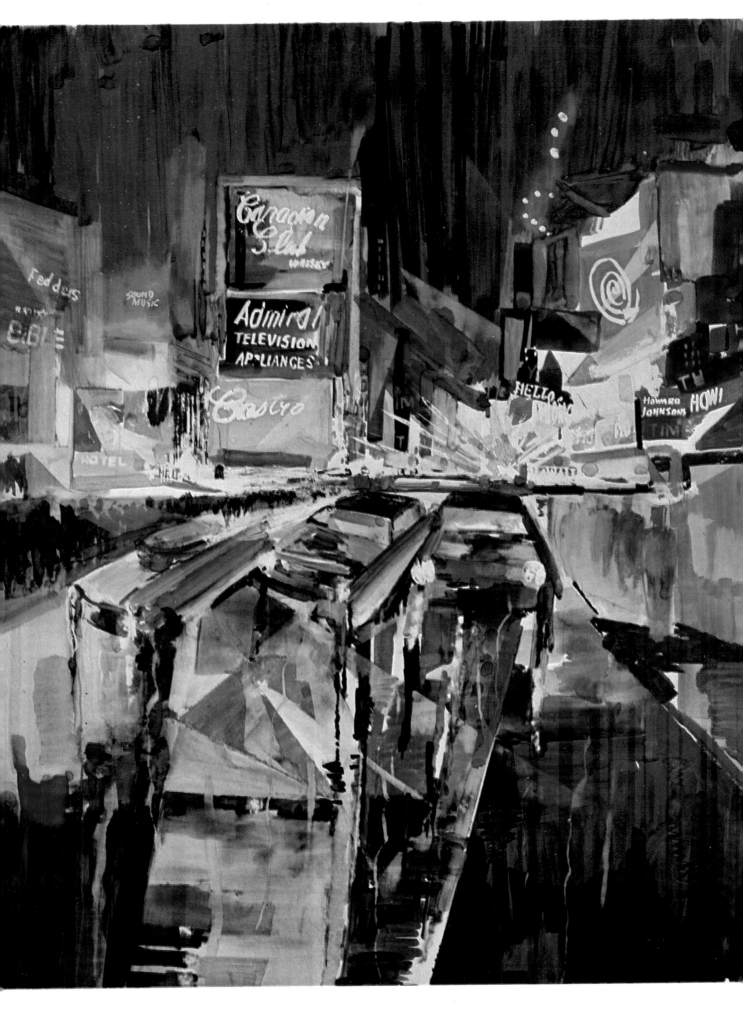

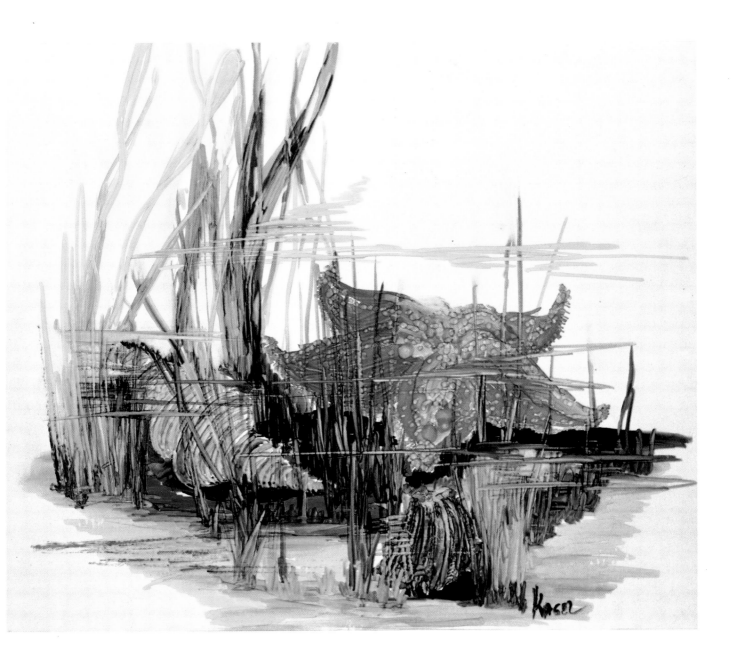

A Rainy Night in Times Square, (Left) Emile Troisé, 13½″ x 16½″, markers on pyroxylin-coated paper. Collection Mr. and Mrs. Robert Birnbaum. Triangulated planes of light are extremely effective in this painting of Times Square. The sharp edges along the triangular planes were achieved by using the edge of a sheet of paper as a mask during overpainting and washing with Q-Tip and turpentine.

Starfish (Above), Evelyn Kagel, 16″ x 20″, markers on acetate. This underwater scene was done with markers on an impermeable surface. No. 1 gray was used with heavier pressure to push aside the original layer of cadmium orange to give the dotted, additional dimension to the starfish.

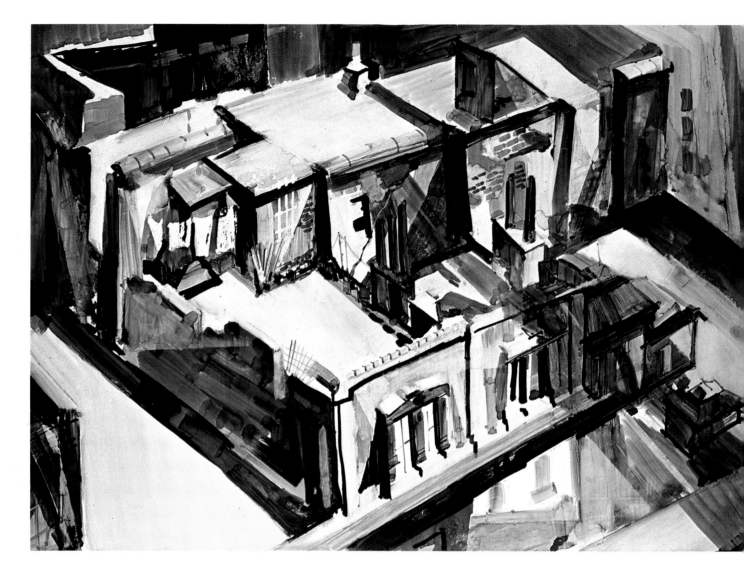

Brownstone Roofs, Greenwich Village, Emile Troisé, 11" x 14", markers on vellum. A conventional use of chisel-tip markers directly on the surface demonstrates the clarity and sparkle which markers lend to paintings. The colors are readily "erased" with turpentine or by overpainting as was done here.

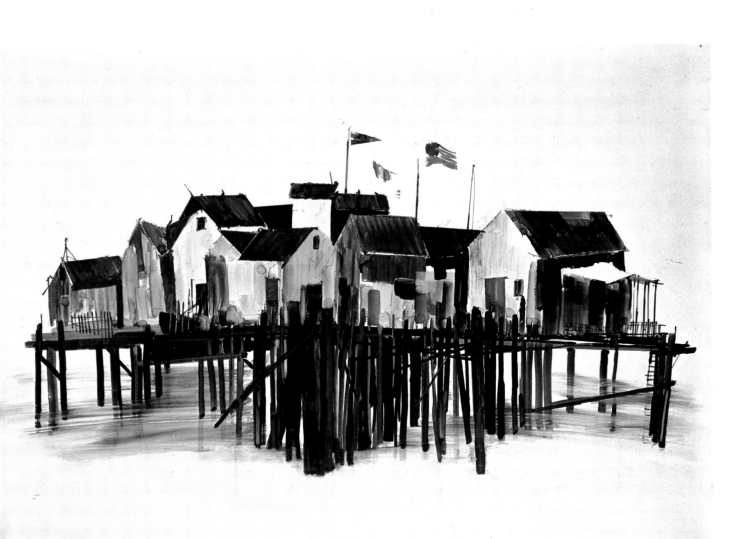

Monterey Wharf, Emile Troisé, 15″ x 24″, markers on coated paper. Collection Stuart Siegel. The supports of this Monterey, California, wharf have been wiped at the bottom with turpentine-moistened cotton, spreading color to create illusion of water, but leaving an after-image that emulates an underwater view of pilings.

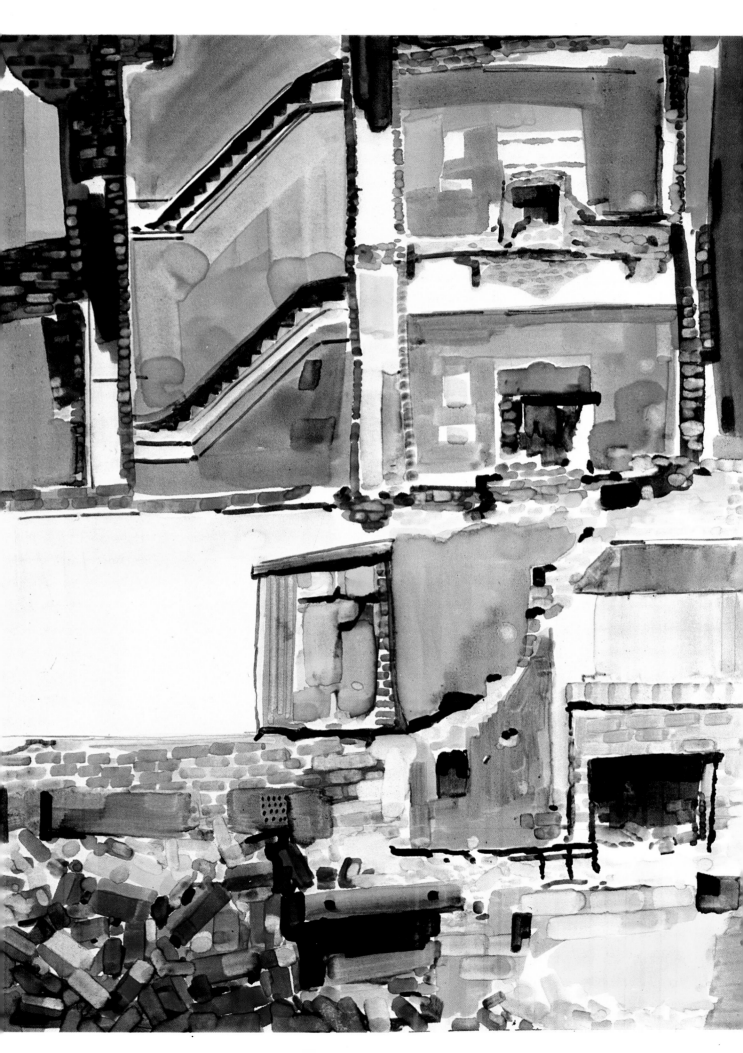

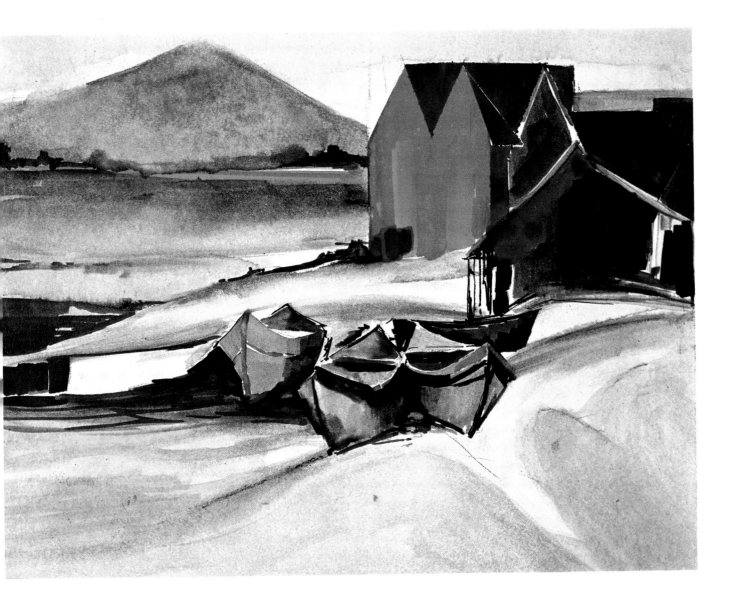

Demolition, (Left), Emile Troisé, 11″ x 14″, markers on vellum. Brand new, "wet" markers and minimal overpainting account for the fluid appearance of this almost abstract study. The site is an old building at downtown Fifth Avenue.

Lake, Boats, and Barn (Above), Emile Troisé, 21″ x 28″, markers on illustration board. Collection Mr. and Mrs. Guy Soirée. The soft wetness of the lake and distant hill was achieved by heavy turpentine wash after the marker colors were applied to absorbent paper. Note the pleasing contrast between the soft background and the hard, brilliant buildings.

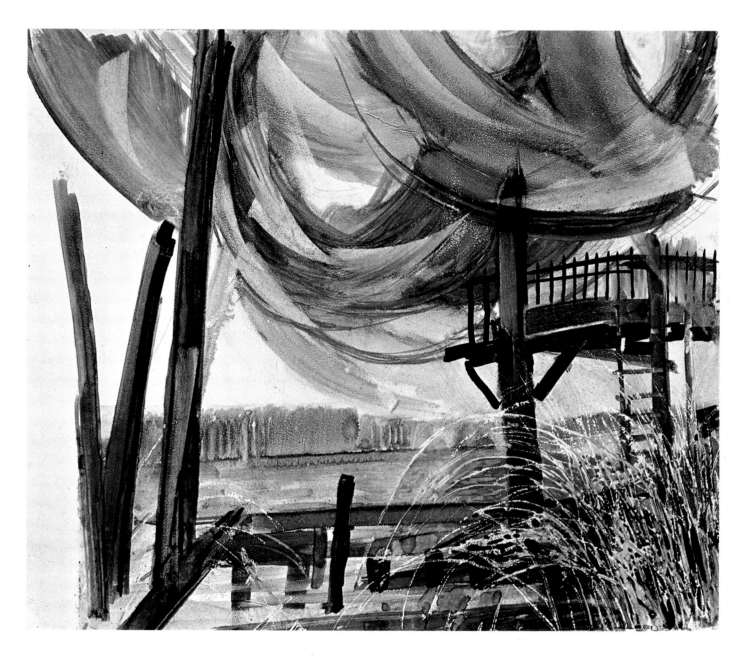

Wharf With Fishing Nets (Above), Emile Troisé, 8″ x 10″, markers on coated cover stock. The arching triangular planes of light in the nets were rendered through cut paper stencils by washing with turpentine. Note the fine grass at lower right. Individual blades were first executed with a brushed-on gum-water mask. When the painting was finished, the mask was rubbed off and some grass blades touched with color.

The Queensboro Bridge (Right), Emile Troisé, 20″ x 27″, oil impasto on cardboard. The underlying impasto in this painting was applied for texture and roughness to give the flavor of grim and gray surroundings. The cadmium red ball, peacock blue shirt, magenta jacket, and orange Gulf sign accent the over-all Prussian blue, violet, and lilac color scheme.

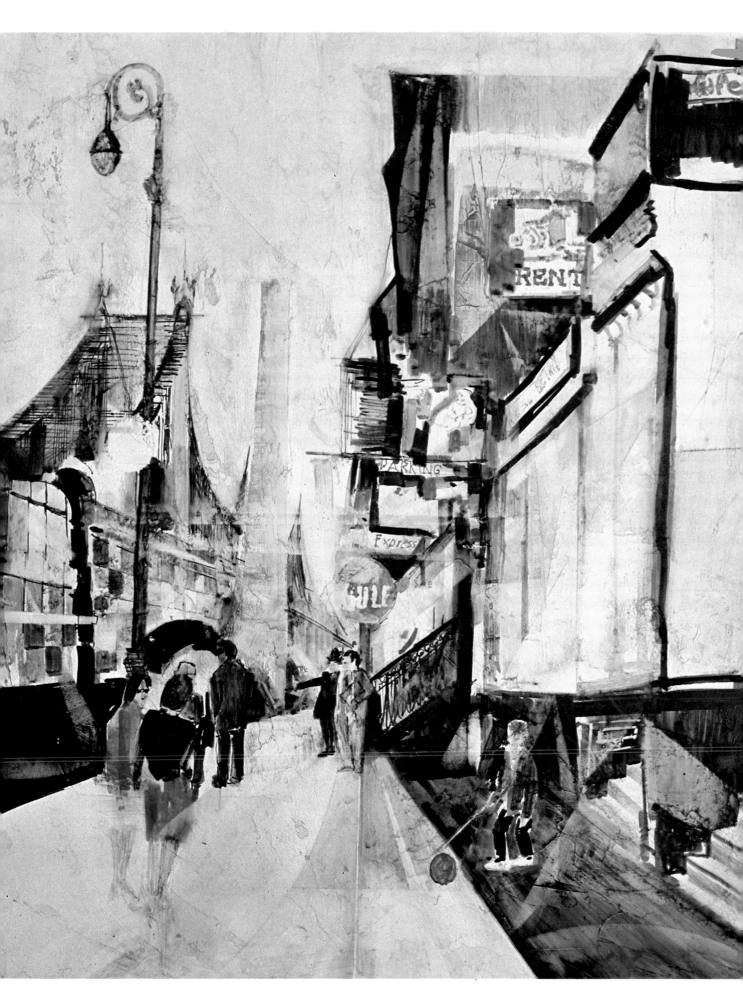

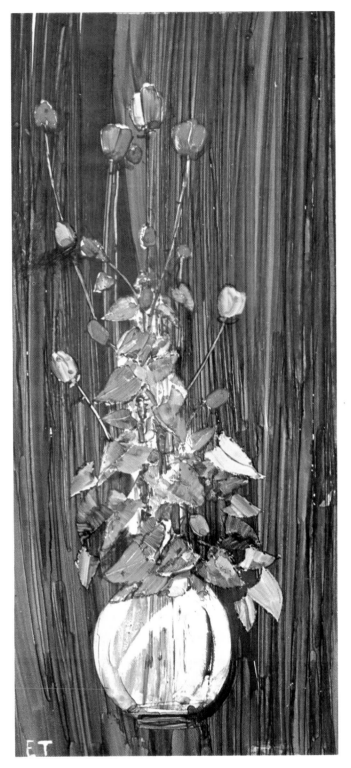

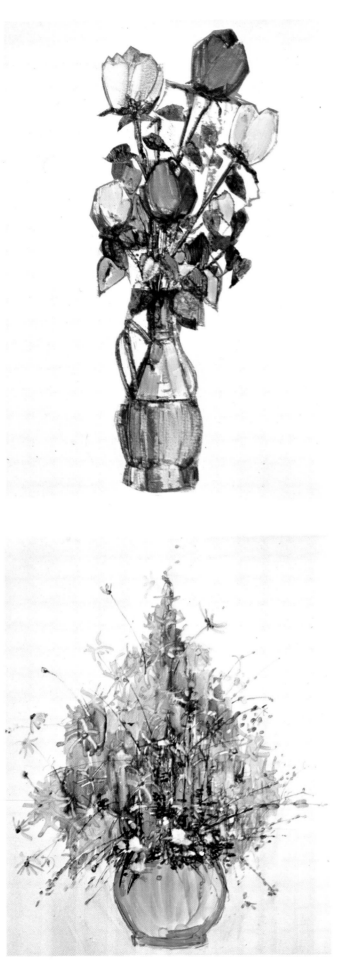

Baby Roses (Above Left), Emile Troisé, 5″ x 12″, markers on acetate. Collection Mr. and Mrs. Milton Horowitz. This still life was superimposed over the red and blue background of an unsuccessful painting. In some cases, colors were overpainted directly.

Chianti Rose, (Above Right) Emile Troise, 10″ x 15″, markers on acetate. Collection C. Otis Port. Blending colors by overpainting is evident in the roses and wine bottle, and the color of the pink blossoms was lightened by turpentine wash.

Yellow Flowers in Blue Vase (Right), Emile Troisé, 12″ x 15″, markers on vellum. Collection Mrs. Frances Scher. Purely from the imagination, this flower arrangement was conceived to fill an attractive peacock blue vase.

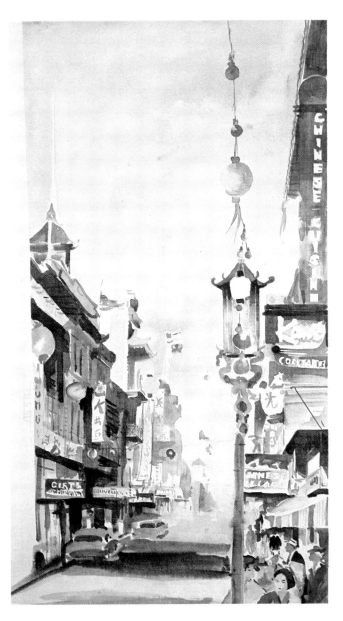

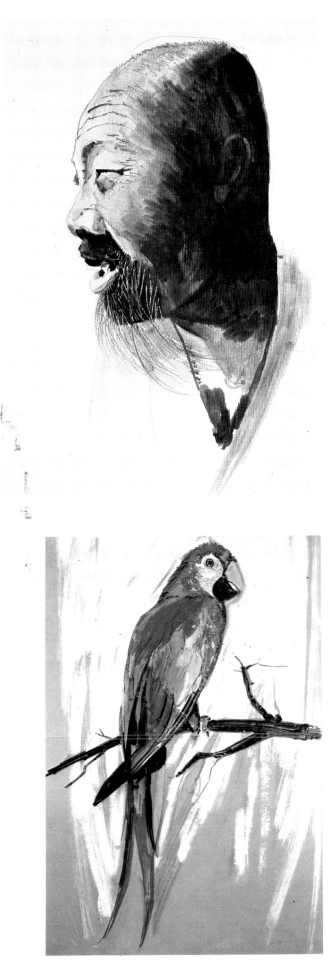

Chinatown (Above Right), Emile Troisé, 14½″ x 27″, markers on linen paper. Collection of Perry Backstrom. This scene was done on a sheet of old linen-laminated paper and has every characteristic of watercolor.

An Oriental (Above Left), Emile Troisé, 12″ x 18″, markers on Canvasette paper. Collection Mr. and Mrs. Leonard Kagel. The canvas-toothed paper lends the feeling of an oil painting, yet the marker colors retain the clarity of watercolors. The man's whiskers were masked out with gum water.

Parrot (Left), Emile Troisé, 19″ x 24″, markers on acetate. Vibrant colors here are handled with a fair degree of tightness. The gray background was done with shading film. In fact, the painting was rendered directly on the shading film's peel-off backing paper.

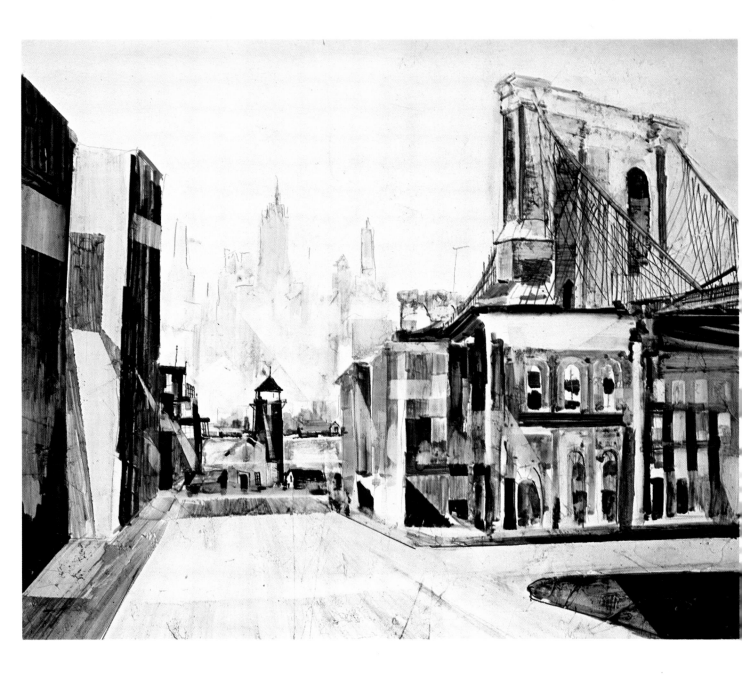

View of the Brooklyn Bridge, Emile Troisé, 16″ x 20″, markers on oil impasto. This is another example of the use of numerous triangulations of light planes; they were produced by washing a painted hue to a lighter shade along a straight-edge mask.

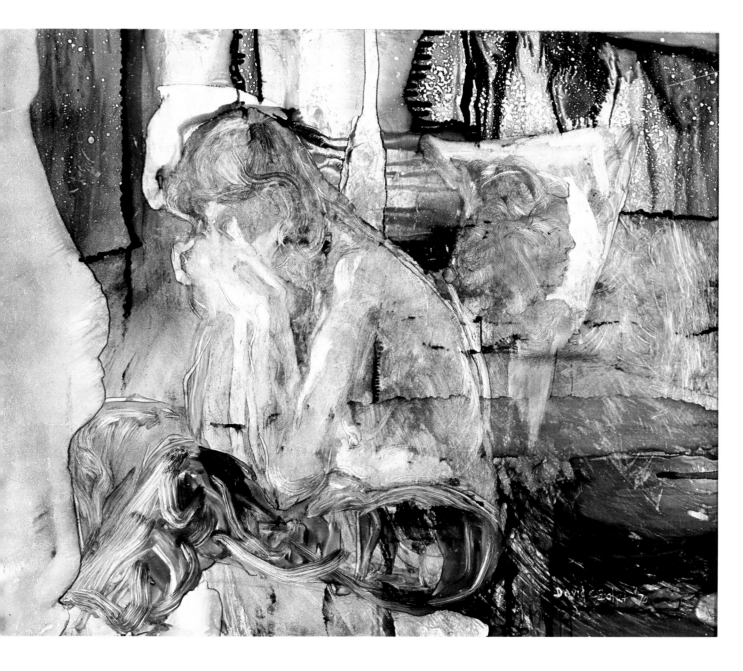

Model Resting, David C. Baker, 16″ x 20″, markers on Marlite. This impressionistic study was executed in a few minutes without the model being aware that she was being painted. The figure was superimposed on a portion of Marlite trimmed from another painting; hence the figure was designed into the existing color flows and forms.

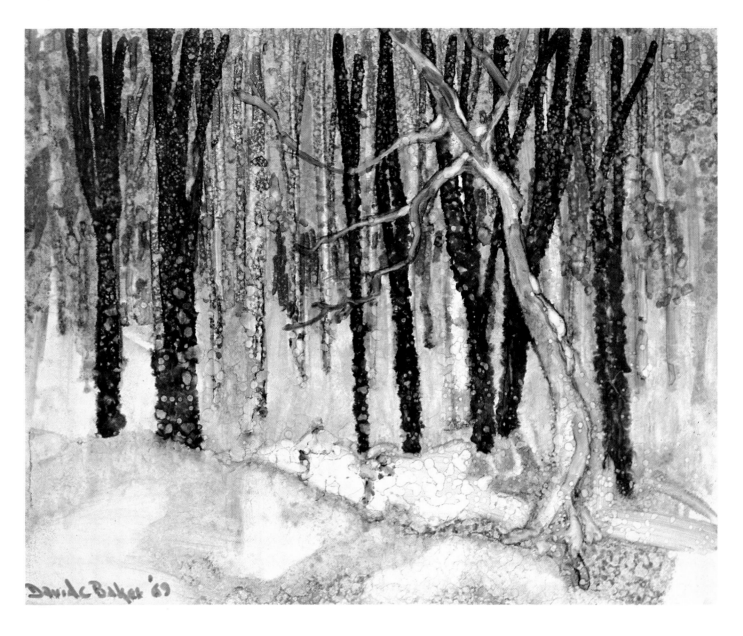

Falling Snow (Above), David C. Baker, 8″ x 10″, markers on Marlite. Sprayed turpentine helps to create the effect of falling snow in this painting. The right foreground tree was painted in after the first spraying, then sprayed again.

Nude in Woods (Right), David C. Baker, 10″ x 15″, markers on vellum. The montage effect was created by using actual leaves as "printing plates." One side of the leaf was painted with markers, then sprayed with turpentine to prolong wetness of the otherwise fast-drying inks. The painted side was then simply rolled down on the painting with a rubber roller (a felt wallpaint roller would also do).

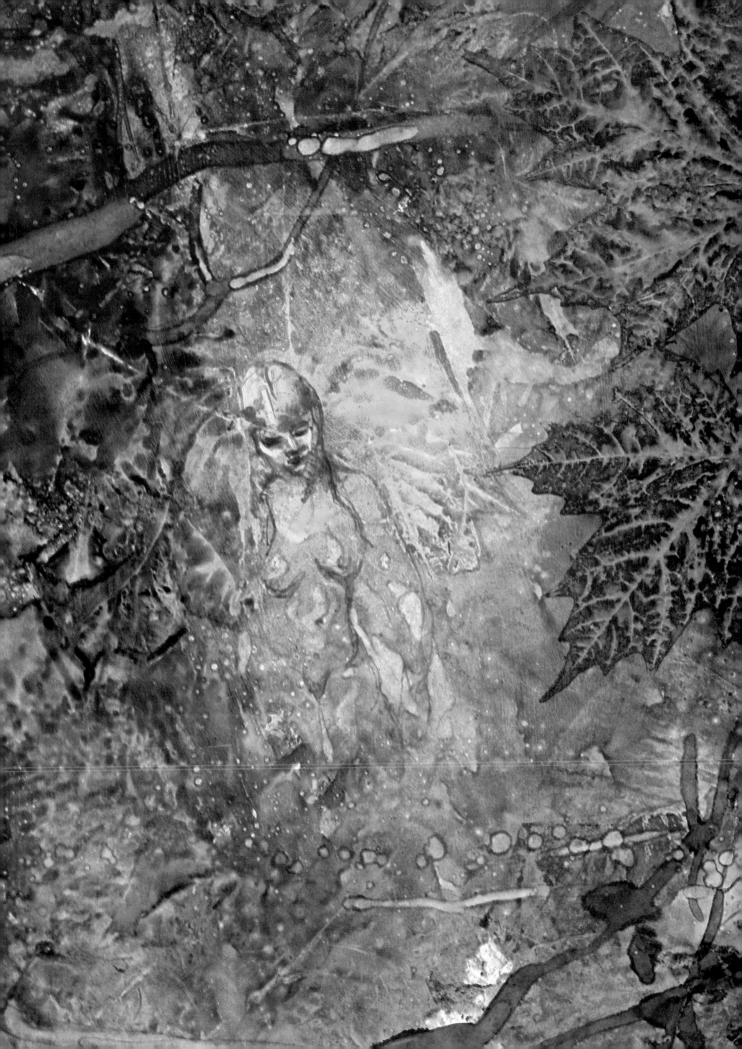

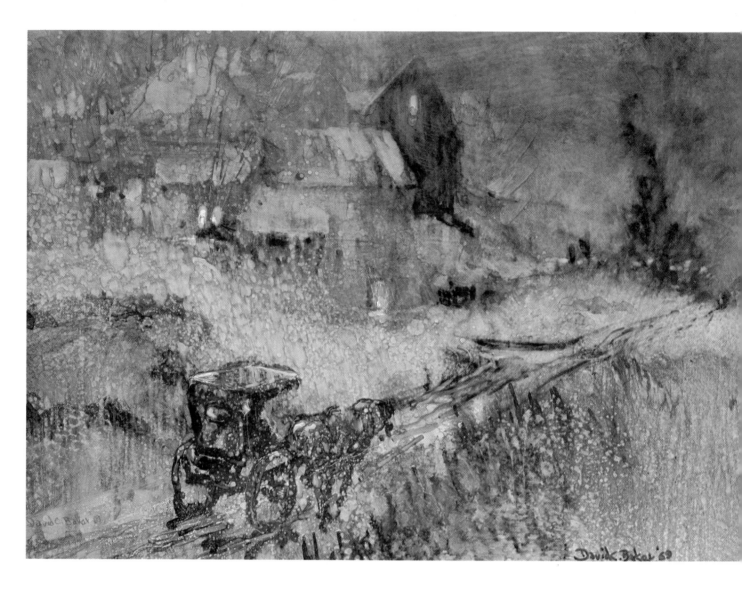

Dusk and Rain, David C. Baker, 10'' x 14'', markers on Marlite. A turpentine spray is used to create the mood of a rain storm at dusk. The spray is concentrated in the foreground, but the background at the upper right-hand corner was sprayed with turpentine, then rolled over with a felt wallpaint roller. The effect created is of indistinct raindrops in the distance.

One of the most difficult subjects to treat, without resorting to cartoon effects, is falling precipitation — whether rain or snow. As you'll see in this project, precipitation is no problem at all with markers. Also in this project, we'll examine various methods of rendering snow scenes, ranging from realistic to semiabstract approaches. Most of the studies presented here were created with the unusual techniques developed by David C. Baker.

Materials Needed

In addition to a selection of markers, the paintings in this project required:

1. Marlite panels (Masonite panels with a white plastic coating)

2. Spray bottle filled with turpentine (the dispenser used for Windex will do)

3. Vellum

4. Coated cover stock

5. Paper towels

6. Cotton balls

7. Paintbrush (hardware store variety), 1" wide

8. Large camel's hair watercolor brush

Painting Rainfall

Rarely is a painting as successful as *Dusk and Rain* (p. 116, and also the color plate on p. 112) by Mr. Baker, in capturing the strange mood of a late afternoon storm: eerie, haunting, yet somehow unoppressive, even gay, with lighted windows glowing a welcome through the haze. For its uncanny representation of rainfall, this painting relies principally upon the effect obtained when markers on an impermeable surface are sprayed with turpentine from a bottle of the sort in which window cleaners come. This technique can be remarkably effective, as shown in the painting. What isn't obvious in the painting, though, are the preceding steps which also involve spraying turpentine, along with some of the other techniques presented in Projects 5 and 6. For the purpose of this project, however, the previous steps aren't really essential — the final act of spraying turpentine will produce comparable results regardless of style.

It's enough to point out once again that markers are a very permissive medium. They can be handled to create exceptional-ly wide latitudes of individual style — ranging from the hard-edged, design-oriented flavor presented in the first two projects to the soft, amorphous feeling of *Dusk and Rain*.

It should be observed, nonetheless, that spraying turpentine to give the sense of rainfall is not simply a matter of squirting the liquid all over the painting. Look at the upper right-hand corner and you'll see that this area was *not* sprayed. The reason is simple. When you view a scene through rain, the rain is most pronounced, as a noticeable "overlay," in the foreground and middleground. Farther off, the raindrops quickly blur together and become more of a mist, a film that obscures details. The trick to simulating rainfall is to make foreground objects rather crisp, middleground content less so, and background features progressively indistinct, to the point of being indiscernible. And all this comes *before* the final spraying treatment. Then, when you apply the turpentine spray, concentrate it on the painting's focal points. Confine the spray to the foreground and middle-ground, but direct it particularly at those features to which a viewer's eye will be attracted — such as the scene of the horse and buggy and the hill in front of the farmhouse. To guarantee that none of the spray would carry over into the upper right, that section of the painting was masked by laying a piece of paper across the corner.

The painting was sprayed as it lay on a table (several thicknesses of newspaper were used to protect the table), with the spray bottle held almost vertically over the painting. Thus the turpentine droplets dried in roughly circular shapes. You can try alternatives. For example, if the painting was sprayed while it was standing upside down, the droplets would form a rough circle and then begin to run down the face of the painting. This could be controlled by laying the painting down at any time, and, when the turpentine dried, the effect of *falling* rain would be heightened (the viewer senses in *Dusk and Rain* that the rain is a gentle shower). For a windy storm, the spray bottle can be held almost parallel to the surface of the painting. Spraying across the painting from that position will produce long streaks.

Falling Snow

The same technique of turpentine spraying can be utilized to simulate falling snow. However, the handling needs to be a bit different. This is because there's normally much more air between snowflakes that there is between raindrops. Consequently, the "overlay" of falling snow is most noticeable in the middleground and distance. Foreground objects are much less obscured than is the case with rainfall. This means you can't complete the painting and end by spraying with turpentine.

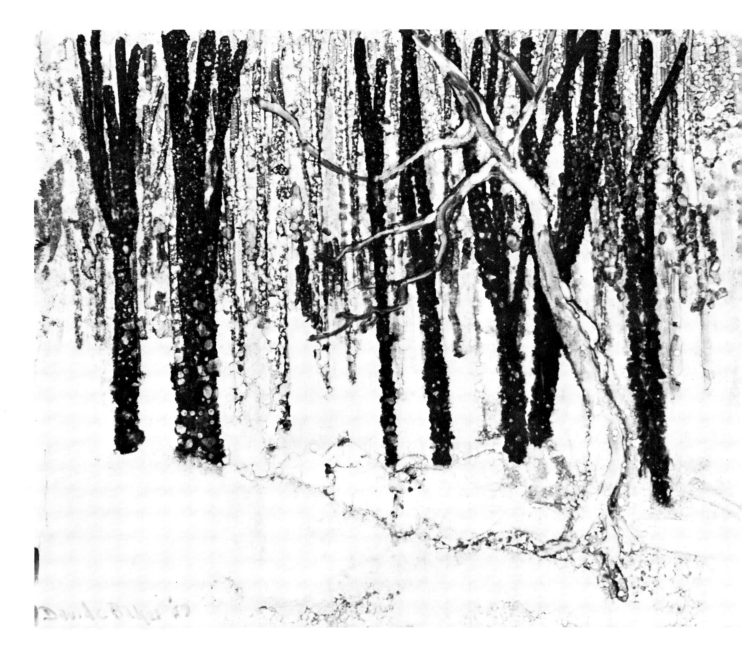

Falling Snow in Woods by David C. Baker. Falling snow can also be portrayed by using turpentine spray. The method is slightly different, however, due to the fact that individual snowflakes are more discernible in the middle and far distances than are individual raindrops, and foreground objects are less obscured by snow than by rain. Hence, this painting was developed in two stages. The middleground and background trees were rendered and sprayed first, followed by the foreground trees, which were sprayed with turpentine again — but more lightly.

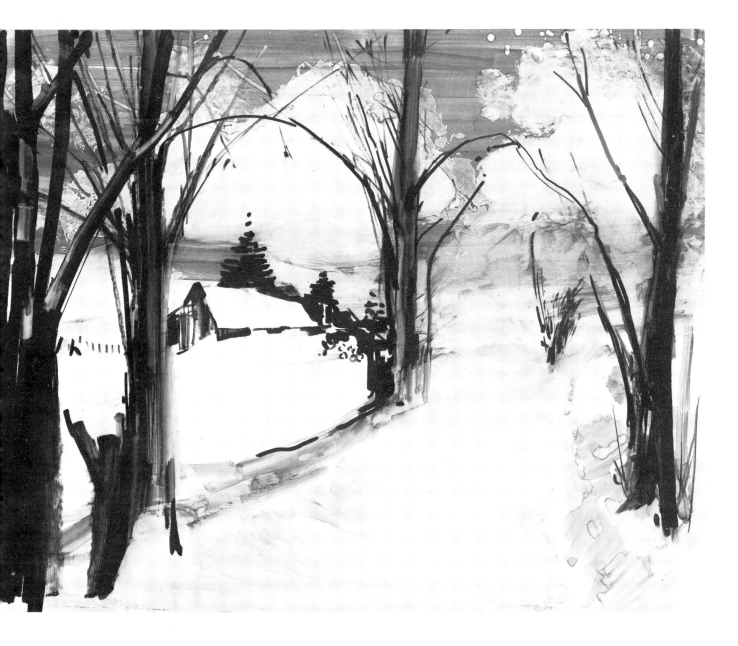

Country Snow Scene. When snow is whipped from the ground by gusts of wind, obliterating the horizon, winter scenes verge on a never-never land where earth and sky become undifferentiated. This study captures some of that feeling.

First Snow by David C. Baker. In this painting, turpentine spray was employed to render fallen snow, then softened by rolling the sprayed area immediately with a felt wallpaint roller. Since there was little or no falling snow, aboveground objects — children and dog, the school bus, and trees — were painted in after the snow cover had been sprayed.

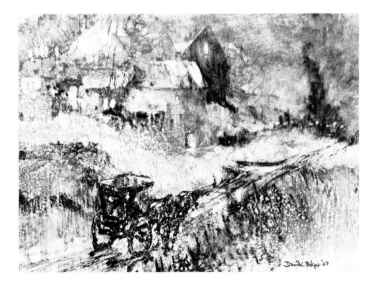

Dusk and Rain by David C. Baker. This eminently successful representation of a late afternoon rain shower relies upon effects obtained when marker painting on an impermeable surface, such as this 10" x 14" Marlite panel, is sprayed with turpentine. Turpentine acts as a solvent and produces white spots, which were softened by rolling with a small wallpaint roller.

Falling Snow in Woods (p. 114), by Mr. Baker, illustrates this point. Observe how much more pronounced the "snow" is behind the foreground tree on the right. How was this achieved? Quite simply, thanks to the fact that on an impermeable surface, such as Marlite, you can overpaint at will. Essentially, the painting was completed in two steps. The first version omitted the foreground tree. After it was sprayed with turpentine and dried, the tree was added and the painting sprayed again, lightly. Therefore, the spraying at the end of the first phase should be a little less than what you want in the ultimate version. Note, also, that in the case of snow the *whole* painting is sprayed, contrary to what we recommended for rendering rainfall. (See also the color plate on p. 110.)

Fallen Snow

Snow scenes depicting a ground cover of white (but never use pure white only; snow is like water in that its color is modified by reflections of surrounding colors) are basically studies of color and textural contrasts. These can vary enormously, depending upon the chosen locale and the mood you're after. Emile Troisé's study *A Country Church in Winter* (p. 118), for instance, is a location sketch in black and white on vellum that emphasizes the architectural geometry of a typical country church, with sweeping tree limbs used as a foil for the building's angularity. In a study such as this, the snow is simply expanses of black paper.

In *Country Snow Scene* (p. 115), on the other hand, Mr. Troisé begins to capture that sense of never-never land when the snow is whipped up from the ground by gusts of wind and you feel suspended in a place where there's no horizon, where the earth and sky come together in a single, undifferentiated entity. No doubt you recognize several of the techniques employed in this preliminary painting on coated cover stock. The clouds, to take one obvious example, were stamped out or blotted up from a solid blue-gray sky by means of the technique presented in Project 4. Other elements — barn, farmhouse, and trees — were added afterward. Last, the drifting snow that wipes out the horizon (especially apparent at the "end of the road) was achieved with a ball of cotton and a tiny bit of turpentine. Wiped over the inks, the cotton picked up the ice blue and light blue colors in the snow and carried these colors in streaks that blurred across the lone shrub at right center. The method is the same as that used for Figure 84 in Project 6.

First Snow (p. 116 and also the color plate on p. 97), by David Baker, shows that the turpentine-spray technique is also effective in rendering fallen as well as falling snow. Here, too, the painting was finished in two distinct steps. The three children, escorted by a dog, rushing to meet their school bus, were painted in over the already painted and sprayed snow — as were the two closest trees along the road. Sheets of paper laid over the painting masked everything but the road and lower right foreground to ensure that the turpentine spray wouldn't speckle other parts of the scene.

This is a very colorful painting, for the trees haven't yet lost all of their autumn foliage, which is rendered in lilac, orange, crimson, and yellow-green. The earth in the vicinity of the bus is covered with these leaves, and the side of the road is similarly

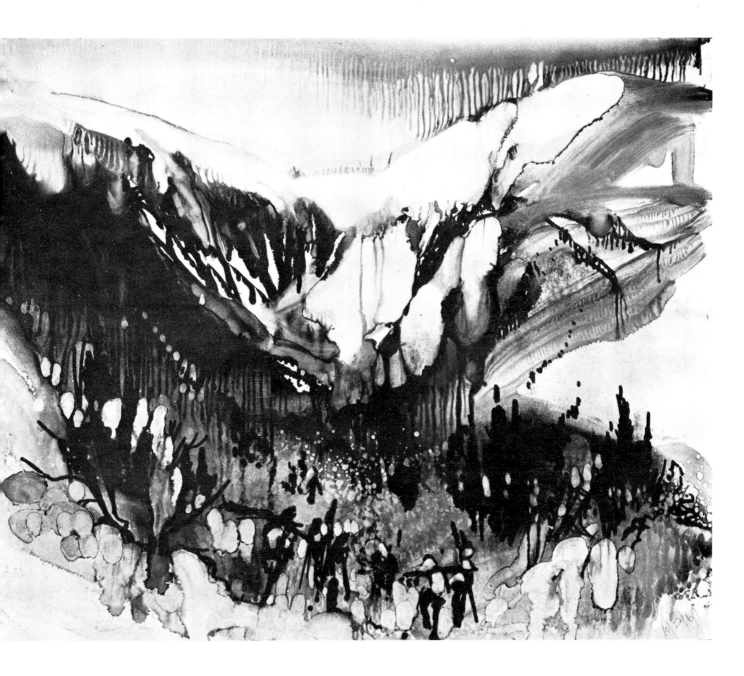

Snowscape With Skiers by David C. Baker. A very interpretative rendering of skiers and snow-covered mountains is most revealing of this artist's term for his unusual painting style, "vitreous flux." Seemingly random blocks and shapes of colors were arranged on a 15" x 20" Marlite panel, then liberal amounts of turpentine were applied with a large brush. When the panel was tilted, the turpentine flowed. The amount of fluxing was controlled by the angle of tilt and how long the panel remained tilted. The flux was frozen into a vitreous state by laying the panel flat.

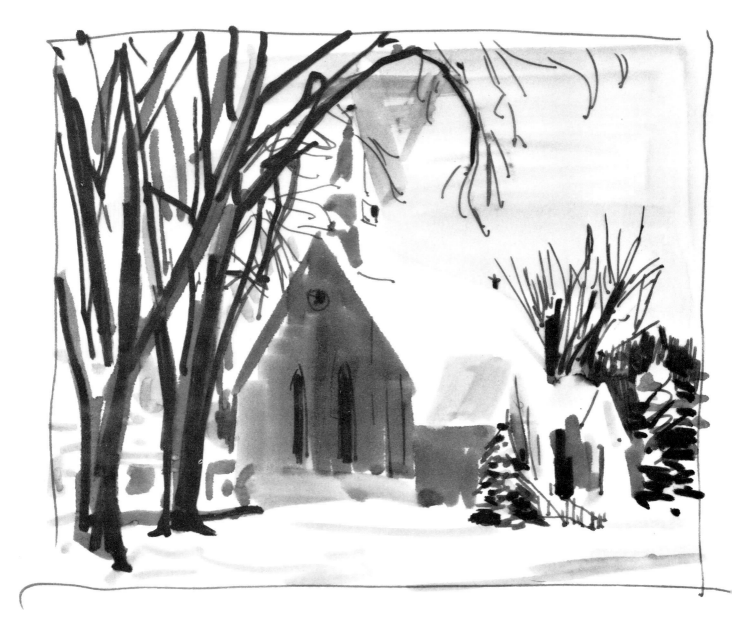

A Country Church in Winter. Snow scenes depicting a ground cover of "white" snow (snow will normally reflect some surrounding colors) offer opportunity for interesting studies of geometric and textural contrasts. Here, the architectural forms with arching tree limbs were emphasized as a foil for the building's angularity. Sketched in black and grays on vellum, the snow is simply expanses of blank vellum, with some snow-covered areas "erased" with turpentine and Q-Tip.

spotted with leaves that have fallen on top of the light-blue and light-green snow. The distant mountains are ultramarine washed down with some turpentine in a rag. And the sky is a glorious cadmium yellow and peacock blue sunrise. The streaked effect in the upper right was produced with a 1″ wide paintbrush, dipped in turpentine and wiped practically dry, then dragged lightly up from the hill crest toward the edge of the painting. A large but inexpensive camel's hair watercolor brush was used to brush on turpentine in the roadbed, creating the long, lighter areas which can be interpreted as car tracks.

Snowscape With Skiers (p. 117), also by Mr. Baker, is a very emotional rendering of snow, with a group of skiers at bottom center. If you find this style appealing, here's what to do to obtain something comparable. First cover the Marlite panel with a background mood color — in this painting it was ice blue. Over this, arrange blocks and shapes of other colors that you deem appropriate. The shapes should be rough approximations of what you want in the finish, but there's absolutely no reason to be very precise, as we'll see. Then, with a fairly large brush (for the 15″ x 20″ panel in *Snowscape With Skiers*, Mr. Baker used a 1″ brush), lay in liberal amounts of turpentine, in the form of strokes and/or dabs. There should be enough turpentine on the panel to run freely when you tilt the painting. Which is what you do next: tilt the panel at various angles to control the rate and direction of the turpentine flows as you think are suitable. You can also use a brush to channel a particular flow by wiping across it or soaking up excess liquid. The painting can be "frozen" at any moment by putting it down flat (some expansion of the still wet flows may occur, however). Objectionable effects can be painted over and details added wherever necessary. And if it doesn't turn out at all, which can happen since this technique demands much practice and patience, you can wipe the panel clean with fresh turpentine and start over.

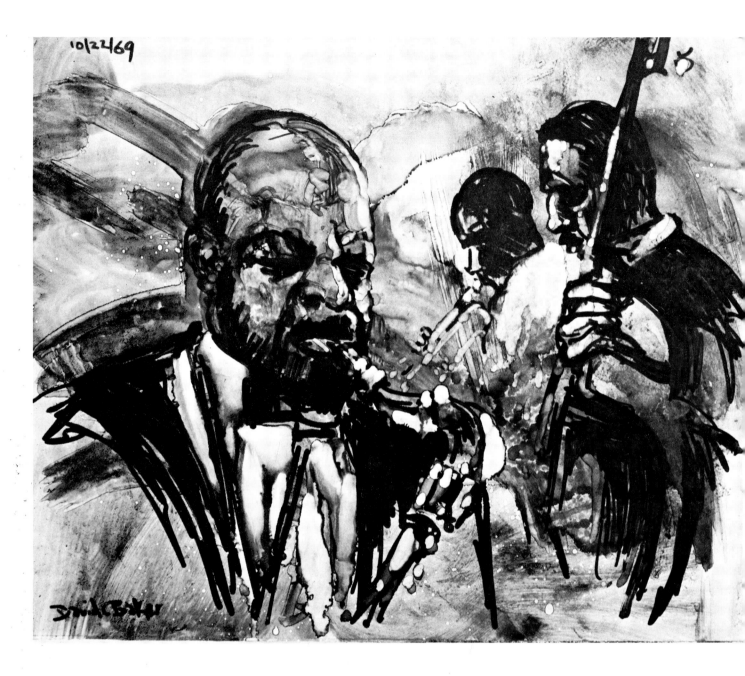

Chet Hawkins by David C. Baker. The fluxing (or tilting) of marker colors sprayed with turpentine shows a unique handling of markers and is quite suitable for this type of portraiture.

Throughout this book we've been extolling the versatility of markers — the fact that they can be used very loosely or controlled very tightly, how they can be handled to simulate either oil or watercolor, and so on. By the time you've worked your way through this project, we believe you'll be satisfied that our repeated praise of markers is fully justified. The faces and heads which are reproduced here span an unusual breadth of techniques and styles, including rendering with the appearance of pencil sketches, watercolor paintings (normally a difficult medium for portraits), and oils. Besides the techniques which are by now familiar, this chapter also introduces a new mixed-media method. Too, we'll see an example of mixed use of oil-based and water-based markers.

Materials Used in the Studies

1. A good selection of markers, including several fine-tip, oil-based markers (black or dark gray, umber, sienna, burnt umber, and burnt sienna) and fine-tip, water-based markers (black and two browns, as a minimum)

2. Canvasette paper

3. Illustration board, smooth surface

4. Vellum (or acetate)

5. Marlite panel

6. Inexpensive illustration board (or the backing cardboard from a large sketchpad, or Masonite panels or canvas panels)

7. Tube of white oil paint

8. Palette knife

9. Gum water

10. Watercolor brush, small

11. Razor blade

12. Spray bottle with turpentine

Markers: Ready When You Are

One of the advantages of water-based pencil-like markers is that the ink doesn't penetrate nearly as much as does the ink in oil-based markers. Therefore, you can obtain reasonably clean and crisp drawings on almost any surface that happens to be at hand. The study of *General Charles de Gaulle* (p. 123) by Emile Troisé is a case in point. He sketched General de Gaulle during a newscast. It was a spur of the moment decision — prompted by courtroom drawings earlier in the newscast — and rendered with a brown water-soluble marker on the cardboard backing of a small sketchpad.

A tighter sample of what can be done with water markers is shown in *Portrait of a Native* (p. 122) done on illustration board by Meredith Hupalo.

One more sample of impulse sketching is the study of Dr. Martin Luther King, Jr., (p. 123) by Mr. Troisé, which was taken from a TV newscast. As you can see from the width of the shading strokes on the right side of the face, this is a fairly small rendering, yet splendidly expressive. Three markers were employed on a small scrap of vellum: a fine-tip, black, water-based marker, plus two chisel-tip, oil-based grays. Because the two types of marker inks are unaffected by each other's presence, stroking the oil colors over the existing water-ink lines didn't disturb them, as would have been the case if they too were oil-based colors. But suppose both varieties of markers weren't available. What could be done? Easy — turn the vellum over and shade the reverse side. This is especially effective if clear acetate is used, instead of translucent vellum.

The appealing watercolor effects in the portrait of Dr. King can also be obtained in tighter fashion, as illustrated in Mr. Troisé's *Mother and Child* study (p. 123). The woman's face could have been easily handled more tightly, since working on vellum imposes essentially no restrictions on how many times you repaint or overpaint a given area. The characteristic sparkle and clarity of watercolors can be maintained after extensive reworking. And should the painting begin to get muddy, it can be erased with a wad of cotton and turpentine, or with a No. 1 gray marker, which is so light as to be undetectable on most painting surfaces, at least in the presence of other colors.

Portrait-Quality Paintings

Emile Troise's *An Oriental* (p. 123, see also color plate on p. 107) and his study of *A Korean Farmer* (p. 122) are excellent samples of marker work controlled with enough care and attention to detail that they assume the superficial appearance of oil paintings, though no doubt this impression is partly derived from the canvaslike paper which the artist chose. (In a moment we'll present a technique that even more closely simulates the tactile and visual qualities of oil.) Yet both paintings have a pleasing quality of transparency — or clarity — that somehow surpasses the results you would obtain by thinning oil paint to a liquid consistency. Perhaps it's because the marker colors are more vivid, since they're applied in their natural, undiluted state.

Take special note of the painting of *An Oriental*. Here we see

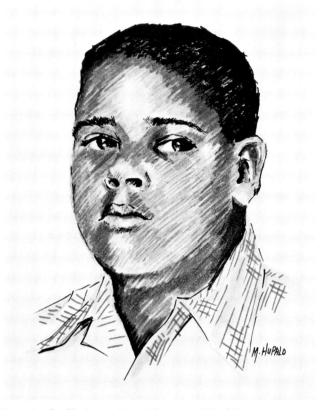

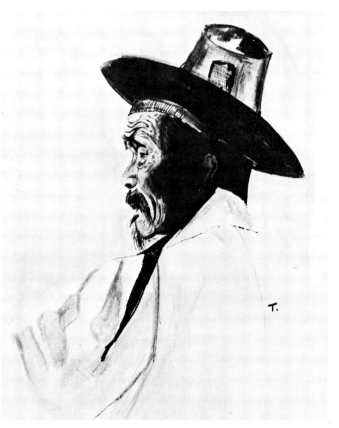

Portrait of a Native by Meredith Hupalo. This full-color portrait was done with fine-tip, water-soluble markers on illustration board. The technique here closely parallels drawing with color pencils.

A Korean Farmer. This painting is a good example of the sophistication in portraiture which can be achieved with markers. Both fine- and chisel-tip markers were used on Canvasette paper.

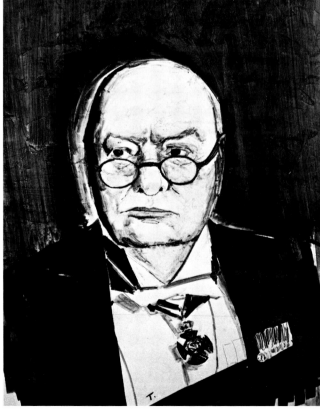

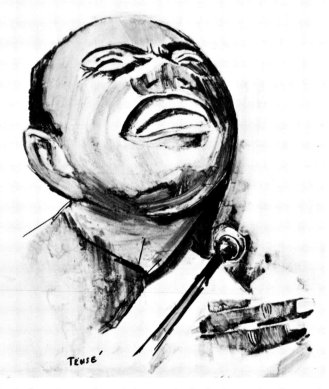

Sir Winston Churchill. Impasto textures are effective in emphasizing a portion of a painting. Here, for example, oil impasto was applied roughly — for maximum texture — in the background, while the facial area is relatively smooth.

Louis Armstrong. Smooth impasto in the background and a rough surface underlying the facial area also aid in creating an expressive study. The slight modeling of the face was also achieved with impasto, so that the facial area is somewhat higher, or raised, than the background.

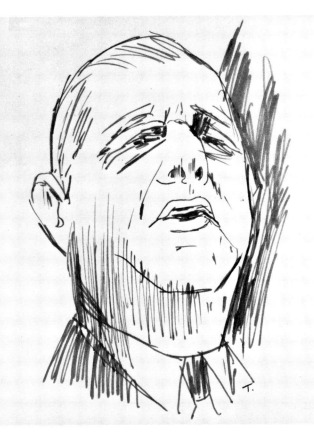

Mother and Child. This painting is basically a refined execution of the technique used in the portrait of Dr. King. Executed on vellum, the study is more closely controlled and utilizes a variety of colors.

General Charles de Gaulle. This quick sketch of General de Gaulle was done during a television news program with a brown fine-tip, water-based marker on the cardboard backing of a 5″ x 8″ sketchpad.

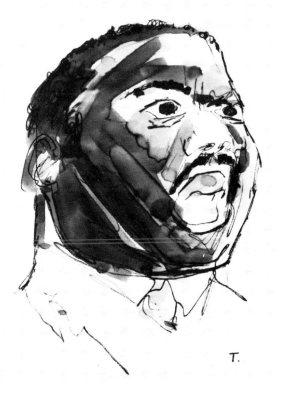

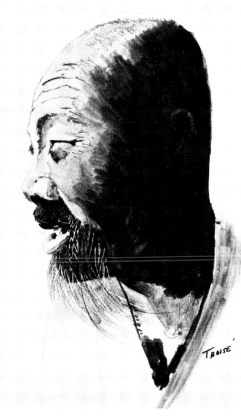

Dr. Martin Luther King, Jr. This expressive character study was done with a combination of water-based and oil-based markers on vellum. Three markers — a fine-tip, water-based black plus two oil-based grays — were used.

An Oriental. This tightly controlled portrait, executed on Canvasette paper with mostly chisel-tip markers, has the quality of oil painting. A gum-water stencil was used on the light hairs in the beard, and highlight colors were added after the stencil was removed.

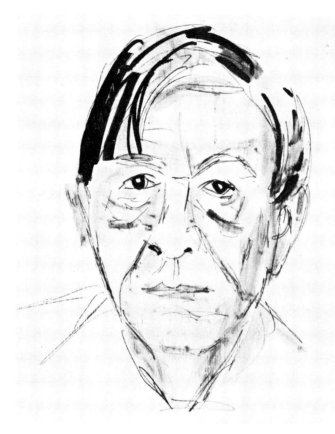

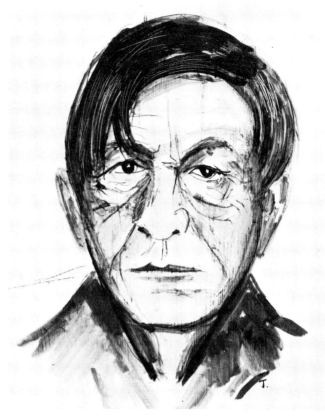

Figure 86. After the impasto was painted on a stiff backing board from a 16″ x 20″ watercolor pad, the main elements of the head were blocked in.

Figure 87. Note the textural effects in the finished head created by the palette knife "tracks" in the impasto. Also note the thin white hairs at upper left.

Figure 88. Here is a detail of the hair, showing the "scratchboard" effect in the thin white hairs. These lines were scratched out with a razor blade, which removed the surface of the oil-paint impasto and exposed virgin white paint.

that the masking liquid technique is applicable even to character studies. The long hairs in his beard were first rendered with a brush and gum water, precisely as were the long grasses in the foreground of *Wharf With Fishing Nets* (p. 92) in Project 6. After the blue-black portion of the beard was painted in, the mask was removed and the hairs left white and in places touched up with color.

In Figure 86, you see a stiff cardboard from a watercolor pad on which a relatively thick impasto of white oil paint was applied with a palette knife. Of course, it's the skin of this layer of paint that furnishes the "scratchboard" surface for creating details such as the etched hairs (Figure 87). This is another method of producing thin white lines which, after they're scratched in with a razor blade, can be left either white or colored in (Figure 88).

More important, the undercoat of oil paint contributes a new dimension to marker paintings: the creation of textured surfaces. Up to this point, all impermeable surfaces that allow markers to be handled to advantage have been comparatively smooth, with the exception of canvaslike paper (and primed canvas, as listed in Chapter 2). With the oil-paint impasto technique, however, a broad range of possibilities is unveiled. For not only can the paint be applied merely to create a nonabsorbent surface, but also to emphasize selected parts of the finished painting by means of changes in the impasto's surface texture and/or its thickness. A portrait such as the one started in Figure 87 and completed in Figure 88, for example, might be effective if the impasto in the facial area (or parts thereof) were smooth, while the backdrop remained rough, betraying the use of a palette knife and offering a visually interesting contrast. You can see the effect this approach

produces in a study of Sir Winston Churchill (p. 122) by Mr Troisé. The reverse of this procedure — that is, a smooth surface around a roughly textured facial region — is shown in a characterization of Louis Armstrong (p. 122), also by Mr. Troisé. In the original of this painting, a slight elevation of the face is discernible. In other words, the impasto is utilized to dimensionally model the face. There's no reason why you can't take that a step further and employ a sculptured bas-relief impasto. Using the impasto as a binder for sand or bits of cloth are among the other potentials waiting exploration by imaginative artists. Bernie Cohen, an amateur artist in New York City, has been experimenting with markers on foil and other mixed, often improvisational surfaces. Still more inventive approaches are yet to be conceived.

Fluxed Markers in Studies of Musicians

In addition to a mutual regard for markers, Mr. Troisé and Mr. Baker also share a common attachment to musicians as subjects for paintings. Mr. Troisé was once commissioned by *Playboy* to paint Louis Armstrong and has done several large canvases on other jazz musicians. Many of Mr. Baker's paintings are devoted to similar themes, and several of these are part of his personal collection. The fluxing technique that identifies Mr. Baker's highly individualistic style is also adaptable to character studies, as evident in the painting of jazz musician Chet Hawkins (p. 120).

Inspect the painting closely and you'll see that its development paralleled that discussed for *Snowscape With Skiers* (p. 117) in Project 7.

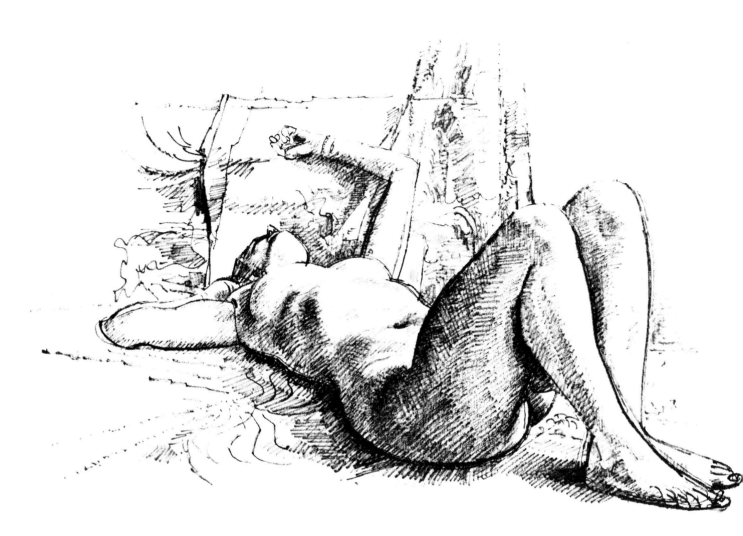

Reclining Nude by Robert Fawcett. The incomparable versatility of the Flo-Master fountain brush is well demonstrated in this illustration. Its pencil-like quality emerges when a fine felt tip is used on smooth paper. Note the range of ink intensities. This is achieved by regulating pressure on the felt tip: more pressure opens the spring-loaded valve, which lets more ink through to the tip. (From *On the Art of Drawing*)

THE FEMALE FIGURE

In the previous projects we introduced a new impasto technique for painting with markers. The textural possibilities inherent in the impasto are amply documented in the next study. We'll see this figure study develop step by step. In addition, the enormous latitude in individual style will be seen in nudes by David C. Baker and Robert Fawcett.

Materials Used in the Studies

In executing the figure paintings in this project, these materials were used:

1. Markers — flesh, blush, cadmium red, cadmium orange, magenta, ultramarine, olive, forest green, cadmium yellow, burnt sienna, umber, black, and violet

2. Flo-Master fountain brush with black ink

3. Black water-soluble marker

4. Illustration board

5. Marlite panels

6. Vellum pad, large (suggested size: 11″ x 14″)

7. Sketchpad, large, medium-toothed paper

8. Tube of white oil paint

9. Turpentine

10. Spray bottle

11. Paintbrush, 2″ wide

12. Watercolor brush

13. Paint roller, small

14. Rubber roller, small

15. Q-Tips

Live Models Are Better

The first step for painting any nude should always be a session with a live model. There's really no substitute for this. Your purpose is not to produce a finished art, necessarily, but to capture the essence of living flesh. In Figures 89 and 90, Mr. Troisé kept everything as simple as possible, and work was done rapidly with a water-soluble black marker on a large vellum pad (large so that two, three, four, or more sketches and studies can be drawn on each sheet). From these simple line drawings one was selected for development on the easel.

From Figure 91 we find the line sketch transposed to the painting surface, previously prepared by applying white oil paint with a palette knife on illustration board (Figure 92). At first the transferred line drawing was quite literal. As we can see, the model's left arm is at her side. The arm was bent at the elbow when a last-minute change was made. Colors at this early phase include an over-all flesh tone on the body, with shadows hinted with blush and burnt sienna. The model's hair is cadmium yellow and orange (she's Irish, with flaming red hair). And the towel is cadmium red.

In Figure 93, the general flesh tone was washed lightly with cotton containing a minute amount of turpentine, thus accenting the shadows, which have been intensified with additions of flesh, blush, and burnt sienna marker colors. Also, cadmium red and magenta have been used to develop the breast and groin areas. These two colors, plus some sienna, also show up in the hair, eyebrows, mouth, and facial shadows. In the towel, the dark tones on the left were produced with magenta and ultramarine, blended with cadmium red, which was also used to fill in more of the towel below the model's right arm. Above her right arm, cadmium orange was blended into the red and then carried upward to enlarge the towel. On the right, the dark strokes blocking out the towel are ultramarine.

The model's body is essentially complete in Figure 94. Actually, the figure is but slightly refined from that in Figure 93. The major differences: darker shadows along the model's left side and more detail (with magenta) in the hair. The towel is obviously better developed, with magenta and red folds under the model's right arm, plus a blended ultramarine shadow. Cadmium red folds from the model's right shoulder to her right hand. A new magenta-and-red drape on the right of the painting, with a narrow cadmium orange drape along the towel's extreme right. Finally, the background is no longer stark white. A cadmium red wash — thinned with turpentine to a pale pink — has been brushed on, and the texture of the oil-paint impasto is beginning to appear, giving a sense of depth to the area behind the model.

In Figure 95 a rewashing was done of the entire backdrop with thinned ultramarine, blending in touches of magenta, then using virtually pure ultramarine to stroke in a dense outline shadow, with a finishing touch of olive blended into the outline shadow along the left side of the towel and at the left and top right of the model's head. Notice that the final painting is based on one of the model's more static poses from the preliminary line sketches and how this pose was transformed into something vital and interesting by the mere addition of a draped towel.

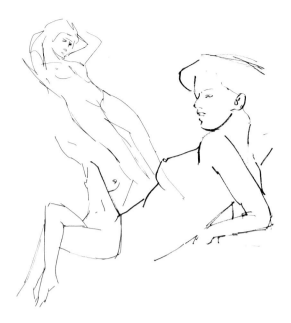

Figure 89. A live model was used in sketches rendered in water-soluble black markers on an 11″ x 14″ vellum pad. Preliminary poses are shown here.

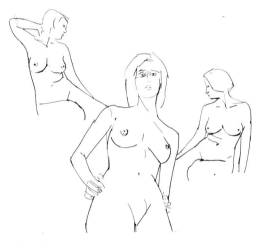

Figure 90. More sketches: here figures are fuller and more defined.

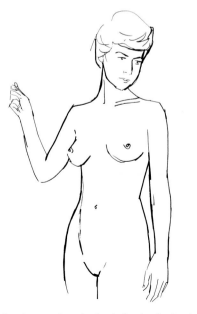

Figure 91. This sketch served as the basis for the final painting, but it was modified so that the pose was less static.

Lady Luck and a Live Model

Model Resting (p. 133, see also the color plate on p. 109), by David Baker, depicts another advantage of working with a live model. During one long afternoon session, the model was obviously tiring and was told to take a break. The pose she struck was quickly sketched by Mr. Baker. Unsatisfied with just the pencil rendering, he seized a Marlite panel that had been cut from a previous large painting. This discarded panel had several marker ink flows which had earlier been deemed unsuccessful.

With the aid of the pencil sketch and the still resting model, Mr. Baker superimposed the figure study, employing a watercolor brush and turpentine-thinned marker colors — burnt sienna for the model's hair, Prussian blue for her jeans, and a combination of these two colors for flesh. All of these colors, however, were noticeably modified by the rewetted existing colors. These previous ink flows, visible in the background as amorphously vertical bands, are (from left to right) cadmium yellow and umber, quite thinned; umber with some cadmium yellow; burnt sienna thinned to almost white; a narrow strip of black, spotted, and thinned with turpentine, then returning to black; burnt sienna with touches of gray; and the final right-hand third is a variegation of black, spotted gray and yellow, black, sienna, umber, and Prussian blue. The two horizontal bands are pale Prussian blue blended with the vertical flows, with some delicate yellow brushmarks near the right border; under this is an umber-darkened cadmium red flow that runs through the model's upper abdominal area.

Nude in Woods (p. 132, see also the color plate on p. 111), another of David Baker's distinctive efforts, is a moody study in yellow (figure and surroundings); forest green — enclosing the yellow area from near the figure's right leg, up and around to a point approximately on a diagonal drawn from the figure's head to the upper right corner of the painting — this green blending into a mixture of umber with touches of blue and yellow along the left edge and blending to a pale blue along the top edge; ultramarine (the leaves on the right, with burnt sienna under these leaves); and a predominantly violet area in the lower right.

The extremely realistic impressions of leaves — most noticeable at upper right — are exactly that. Mr. Baker plucked a maple leaf from a tree, painted it with ultramarine marker, sprayed this with turpentine, then rolled the leaf down with a small rubber roller. The less distinct leaf impressions in other parts of the painting were created in the same manner (though with different color inks), but then rerolled with a paint roller after removing the leaf. The paint roller, being absorbent, picked up and diffused the marker inks. After these leaf impressions were produced, the figure was modeled by manipulating the existing color with a watercolor brush holding turpentine (wiped almost dry). A few additions of very pale Prussian blue were also made for emphasis. The tree limbs were brushed in similarly.

Drawing With Flo-Master

For the ultimate in sketching virtuosity during sessions with a model, few instruments can compare with the Flo-Master

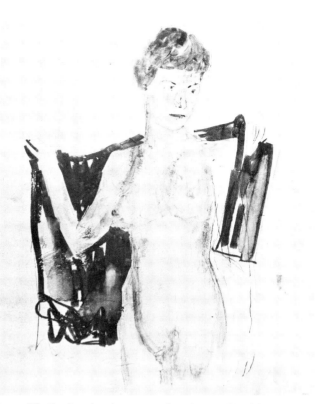

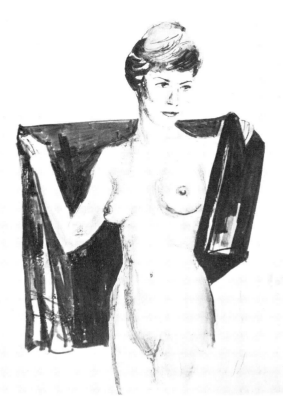

Figure 92. The line sketch was transferred to a 15" x 20" illustration board prepared with oil-paint impasto. Colors were blocked in — flesh for the body, cadmium yellow and orange for the hair, and shadows of burnt sienna and blush. The towel is cadmium red.

Figure 93. Over-all flesh tones have been gently washed with cotton and turpentine — the shadows intensified with more flesh, blush, and burnt sienna marker colors. Cadmium red and magenta are added to develop breasts, hair, and face, along with some touches of sienna. The towel is darkened with magenta and ultramarine blended with cadmium red.

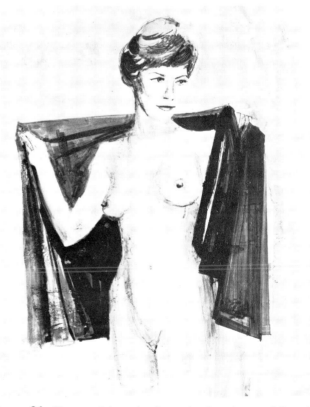

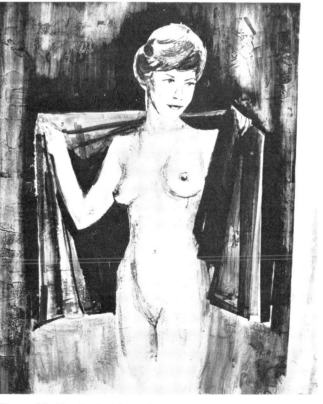

Figure 94. The towel has also been developed more fully, with magenta and red folds under the right arm and a new, longer drape in the same colors at the right side of the painting. At the extreme right is a narrow fold of cadmium orange. Shadows are produced by blending in ultramarine. The background has been washed with cadmium red to bring out the impasto texture.

Figure 95. The finished figure here shows the rich texture achieved with the impasto technique and hints at an extraordinary latitude of the mixed-media technique.

fountain brush — one of Robert Fawcett's mainstays. By judiciously selecting the felt tip and drawing surface, one Flo-Master can effect an amazing range of textural qualities. And there's no reason why you can't use two or more Flo-Master pens, each filled with a different color ink, and perhaps one filled with turpentine.

The potentials are demonstrated in three nude studies by Mr. Fawcett. In *Reclining Nude* (p. 126) an almost pencil-like quality emerges when a fine felt point is used on smooth paper. The rendering pictured in *Sitting Nude* (p. 130) assumes a crayon flavor because of the paper's texture. And a fair semblance to oils is evident in *Standing Nude* (p. 131), executed on a square-toothed paper.

And while we're on the subject of quick sketches, let's see what markers can do for one of the most fleeting and elusive subjects: children. This is the topic of the next project.

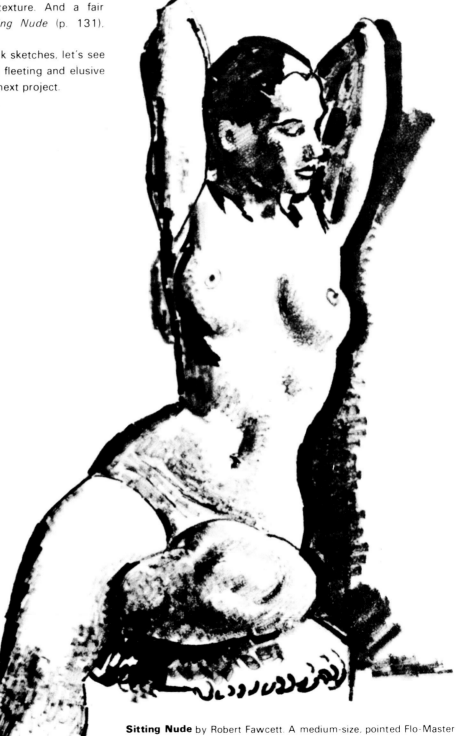

Sitting Nude by Robert Fawcett. A medium-size, pointed Flo-Master tip on coarser paper yields a crayon look. Flo-Master filled with special black-pigmented ink (nonfading) is one of this artist's mainstays. (From *On the Art of Drawing*)

Standing Nude by Robert Fawcett. With square-toothed paper, marker drawings such as this monochrome takes on the quality of oil painting. Were you to use a few Flo-Master instruments, each filled with different marker ink colors, the possibilities would be enormous. (From *On the Art of Drawing*)

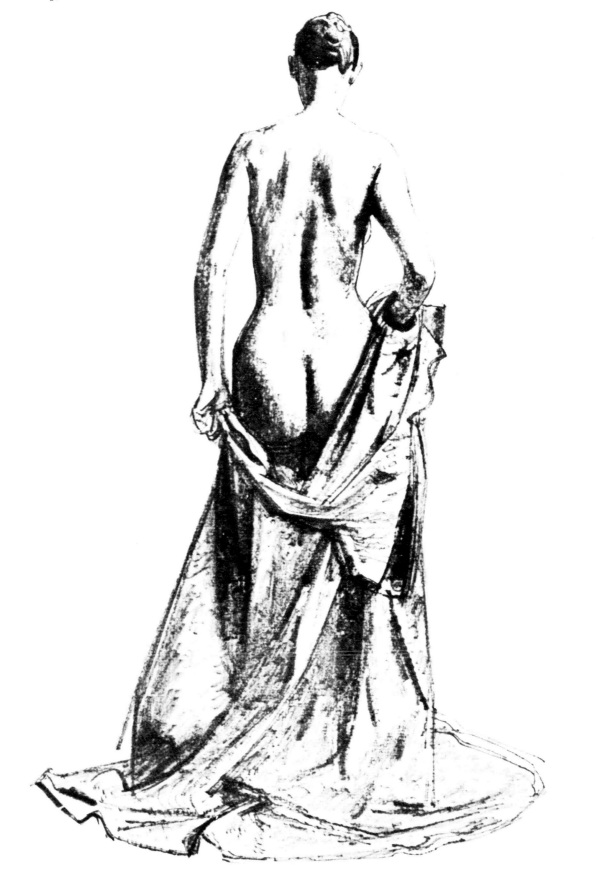

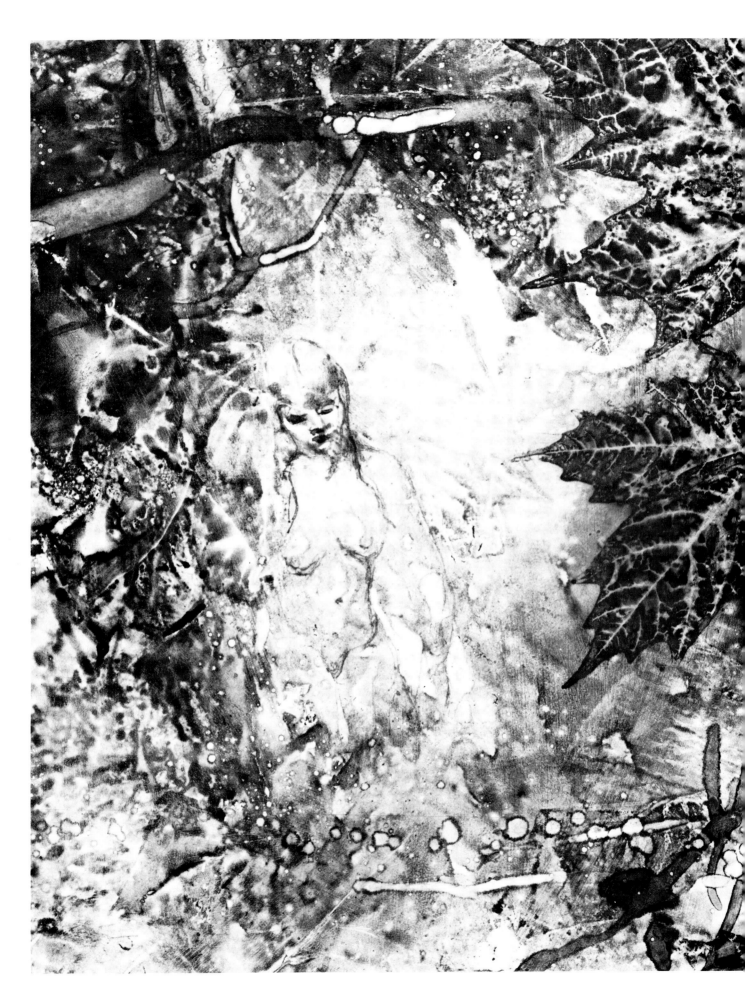

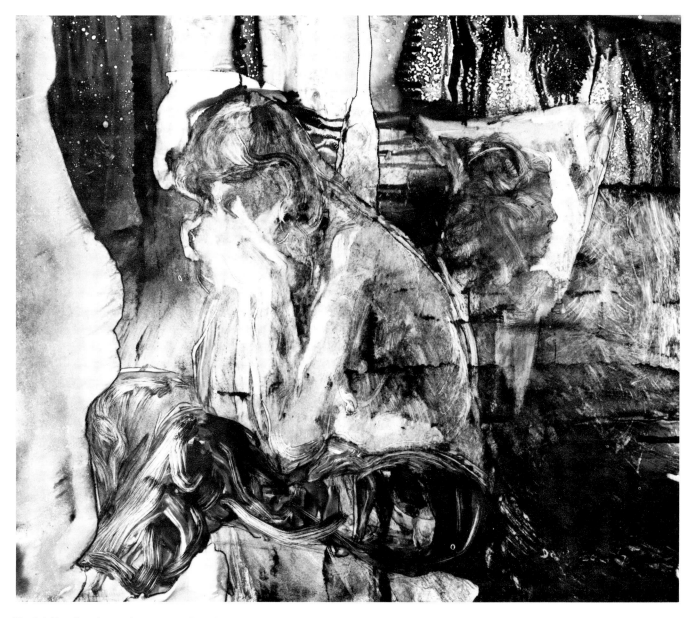

Model Resting (Above) by David C. Baker. This study of a tired model resting is one of Mr. Baker's most successful marker paintings. It was done in two colors on a 16" x 20" Marlite panel cut from an earlier painting. Although only two colors were used on the actual figure study — burnt sienna for the hair, Prussian blue for the jeans, and a combination of these two for the flesh — the finished painting is much more varied because colors in the amorphous, vertical bands (still visible in the background) were rewetted as new colors were brushed on and consequently blended with the sienna and blue.

Nude in Woods (Left) by David C. Baker. This study is rendered in yellow (figure and immediate surroundings), forest green (around yellow from right leg to upper right of head), umber blending into the green, with blue and yellow along the left edge of the painting and blending to pale blue at the top; ultramarine (leaves on right, with burnt sienna under the leaves), and a predominantly violet area (lower right).

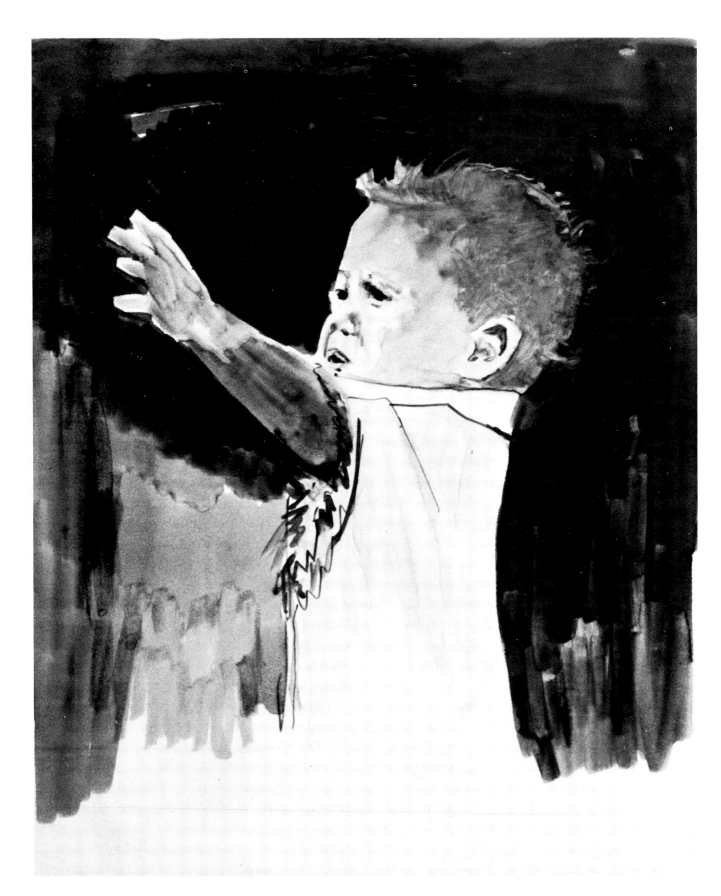

Groping Baby. This enchanting rendition of selfishness thwarted was done by "freezing" essential details — all too fleeting in the painting of children. Here, the general outline of the child's head and torso were defined with four or five sweeping strokes of red, a sixth stroke delineating the outstretched arm. Red areas were then washed with No. 1 gray to lighten and model the flesh. Extra pressure was exerted in the garment to produce a still lighter pink. For the child's hair, umber and yellow were painted over the gray-on-red pink.

The fleeting, often tumultuous changes in mood typical of children are well known to every parent. To artists, and particularly to artist-parents, this unrestrained spontaneity is at once a painter's delight and dilemma.

Let's get down to some specifics. It's possible to carry with you a small selection of markers which, working on vellum or matte-finish acetate — either of which can be purchased in small tablets, 8″ x 10″ or smaller — will produce a surprising range of colors and effects. The list of materials, therefore, is also a recommendation for the contents of a field kit that will fit (except for the tablet) into pocket or purse.

Materials Used in the Studies

1. Chisel-tip markers: ultramarine, cadmium red, cadmium yellow, olive green, umber, and No. 1 cool gray

2. No. 5 warm gray fine-tip marker

3. Vellum or matte-acetate tablet

These seven markers are all that you'll really need for sketching children, and if you want to be Spartan, the olive and fine-tip gray markers could be eliminated. All of the sketches illustrated on these pages were done by Emile Troisé with these seven markers. The scope of the colors involved aren't manifest in the black and white reproductions, but you'll get an indication from the discussions that follow.

Capturing or "Freezing" the Figure

The Groping Baby (p. 134) study is an enchanting rendition of selfishness thwarted. Here's how it was executed. Four or five arcing strokes of red defined the shape of the child's head and torso, with another stroke delineating the outstretched arm. The red was then "washed" over with No. 1 gray to lighten it to pink, with more pressure exerted in the garment to create the sense of draped folds. Umber and yellow were used for the hair (over the pink), then the No. 1 gray lightly dragged from the edge of the hairline, which was predominantly umber, toward the eyes and nose, simultaneously modeling the facial contours and marking the edge of the garment. Before the gray tip was wiped clean other shadows around the nose and eyes were filled in. Umber together with touches of yellow and more red were similarly employed in the arm, and a quick pair of dabs with the red marker shaded the lips. Two more dots with ultramarine took care of the eyes, and the essentials were completed. Details such as the lace at the gown's armhole (green), a few No. 5 gray lines and a background of ultramarine shading into green were the finishing touches. Note that the

ultramarine strokes in the background were also used to create the shape of the hand and to modify the other contours: face, hair, and back.

Basically the same approach led to *Boy on a Swing* (p. 136) and all of the remaining examples — that is, the figure's aspect was first rendered entirely in red. This affords the fastest way of "freezing" the figure. The red is washed with No. 1 gray to reduce it to a fleshlike pink and other colors superimposed. The boy's sweater is rather orange (the red wasn't thinned as much in this region, then blended with yellow) and his trousers are olive (worked over several times, lightly, so that layered green on green gave the feeling of worn Levis). Highlights were produced with the corner of the No. 1 gray marker's tip, which was also used to wash down the lighter areas in the boy's umber hair. The socks are yellow, the shoes a near black blend of ultramarine and No. 5 gray — also used for the swing, with some olive added. The rope was ruled in upon returning to the studio.

Making Use of Later Changes in Details or Color

In *Girl Skipping* (p. 136) we find the same sequence of development, with one slight variation: the shoes weren't part of the original laying in of red, nor were the hands. These parts were saved until last, the hands being executed according to custom (red overworked with No. 1 gray), the shoes simply sketched in with a corner of the umber tip, but picking up a small amount of pink. The hair is umber heavily overpainted with yellow. Slight touches of ultramarine were used in the girl's otherwise pure red jacket, and her slacks are umber with ultramarine over.

Two paintings depart from these guidelines only in choice of colors. For instance, the boy's trousers in *Climbing Boy* (p. 136) contain virtually no hint of the prior existence of red, as the No. 1 gray marker was used under considerable pressure and its tip wiped clean frequently to wash away the red. His shirt is red with a touch of blue shadow, his hair mostly yellow, and the railings he's climbing are blue painted over with No. 1 gray and No. 5 gray. *Girl on a Slide* (p. 136) is noteworthy because *everything* started out red. Before the slide was washed, umber was blended with the red. After washing, the darker areas were attained with ultramarine, then lightly overpainted with No. 1 gray and umber edges added. The girl's jacket is a lavender/purple blend of red and ultramarine.

And the black and white sketch pictured in *Baby and Sheepdog* (p. 137) is by way of acknowledging that where children are found, normally animals are there too. And so we'll take up the subject of animals in the next project.

Girl on a Slide. This study is noteworthy because everything — not just the girl — was blocked in with red. Before being washed with No. 1 gray, the slide was further developed by blending umber with the red; after the washing, darker areas were attained with ultramarine, followed by another overpainting with No. 1 gray — this one very gentle — plus umber edging. The girl's jacket is a lavender/purple blend of red and ultramarine.

Boy on a Swing. The figure was first sketched in with red; then the red was lightened to a fleshlike pink with No. 1 gray. The boy's sweater is orange, achieved by lightly modifying the red base with gray, blending in yellow. The trousers are olive, worked over several times to give the impression of worn, patched Levis.

Girl Skipping. This study followed the same sequence of development as the preceding figures, except that the girl's hands and shoes were added separately (they weren't included in the initial lay-in of red). Her hair is umber, heavily overpainted with yellow.

Climbing Boy. Distinguishing this quick-sketch rendition is the exceedingly harsh "erasure" of red in the boy's trousers. A No. 1 gray marker was used to erase so that virtually no trace of the red base remained. This was done with considerable pressure on the marker.

Baby and Sheepdog. This simple black and white sketch captures a portion of the close kinship between children and animals.

Chimpanzees. This painting was executed on Canvasette paper. The chimps were first rendered in oil-based, fine-tip markers. Then chisel-tip markers were used for shadows and blending by overpainting.

Before delving into the final few painting projects, where your new skills with markers will encounter some stiff challenges, let's review the techniques studied so far. For such a recapitulation, we couldn't wish for a better topic than birds and animals.

Materials Needed

In addition to a set of markers, these materials were used for the paintings that follow:

1. Fine-tip, water-soluble markers, including black, red, brown

2. Acetate overlay sheets, 19″ x 24″ and 14″ x 17″

3. Shading film sheet, 30% black, 19″ x 24″ or larger

4. Heavyweight vellum

5. Coated cover stock

6. Coated cover stock with pronounced surface texture

7. Canvasette paper

8. Sketch paper

9. Illustration board

10. Tube of white oil paint

11. Palette knife

12. Turpentine

13. Razor blade

14. Q-Tips

15. Watercolor brush, small

Large, Tight Renderings

Emile Troisé's studies of Parrot (p. 143, see also the color plate on p. 107) and Eagle (p. 143) are typical of the tight control you can exert with markers if you work with a fairly large format. Both of these paintings were executed on impermeable surfaces — the very colorful parrot on acetate and the eagle on vellum. Fundamentally, the parrot painting was achieved in the same manner as the Chianti Rose still life back in Project 3. First, a rough sketch was placed under the acetate overlay and the main colors were blocked in: crimson for the head and shoulders (with the area around the eye originally left untouched), then yellow, ultramarine, and Prussian blue in the wings and short tail feathers, with more crimson in the long tail feathers. Once the basic colors were laid in, the same markers were employed to rework the flat colors into feather shapes. Sometimes this reworking was done with heavy pressure on the marker tip, in which case the ink remained relatively pure. At other times, light pressure was used to avoid displacing the previous ink layer, and the result is tone-on-tone.

Shadows were added with other marker colors (for example, touches of ultramarine in the crimson, especially along the edges of the head, neck, and wing beneath the parrot's beak). Colors were modified, too, by stroking one color into an adjacent color. The crimson feathers extend into the yellow, producing various shades of orange along the interface. In turn, the yellow feathers project into the blues, so that the return marker stroke dragged some of the blue back into the yellow, where it blends. And here and there a Q-Tip containing a trace of turpentine was used to wash out a highlight.

Afterward, various finishing touches were added — a flesh-colored marker for the upper beak, Prussian blue over ultramarine for the bottom; dabs of flesh color and Prussian blue around the eye, and a tree limb painted the same way as the tree in Figure 39 (p. 51). Shading film was adhered over the marker inks and selectively scratched away with a razor blade. Most obvious in the background around the bird, the shading film's effects also augment the modeling of the parrot's body. Not scratched away is an area beginning near the beak and extending down and across the back and wing, through the tail feathers. Part of the yellow area is shaded with the 30% black film, but the difference it makes is particularly noticeable in the short tail feather that projects downward at right. Half of this turpentine-washed ultramarine feather is shaded; on the right-hand side, the shading film is scratched away.

Another Approach to Film Shading

A different approach to through-the-paper shading is evident in Eagle I. Here, the eagle's body as well as the entire background is shaded by means of marker strokes on the obverse side of the vellum. In Eagle II (p. 143) this technique is explicit.

On the other hand, a more casual shading of flamingos was done with pink, magenta, and cadmium red — the latter two colors considerably lightened with turpentine on a Q-Tip (Figure 96). The result is a delicate, dominantly pink painting (Figure 97). Coated cover stock, or a similar impermeable surface, was the material used for this rendition — and for the humorous study of the Black and White Owl (p. 143). Here, the unique eyes and the scratched-out lines delineating feathers and feet are the outstanding features.

In the painting Cardinal (p. 144), by Mr. Troisé, we find an interesting juxtaposition of looseness in the background, as a foil for the comparatively tight handling of the bird's red body. Actually, the painting initially was rendered still tighter. Then, to

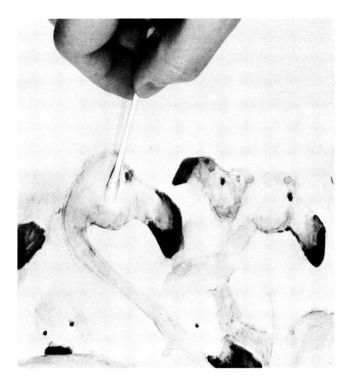

Figure 96. (Left) One of the birds' heads is modeled by thinning the color with a turpentine-moistened Q-Tip.

Figure 97. (Below) The combination of pink, magenta, and red is thinned and highlighted with turpentine. The result is a painting of flamingos done in the most delicate hues possible.

obtain the softness of feathers, the marker strokes were lightly blended with a moist brush. In this painting — because the cardinal was drawn with a water-soluble, fine-tip marker — the brush was moistened with water. Note how a succession of light strokes with the brush, which produced fine yet soft lines, were modeled into a realistic impression. The background was subsequently added with a dark gray, oil-based marker. Since oil markers easily cover water-based inks, the gray was used in places to create an opaqueness and redefine the outline of the bird.

Animals: Whimsical and Realistic

The flexibility and convenience of markers are a sheer physical joy, especially when you're painting certain animals that lend themselves naturally to oversimplification or even cartoonlike treatments. Markers are one of the few media handy enough for doodling or sketching, yet also capable of producing quality finished art. The *Koala* (p. 142), for example, has been executed very simply, each stroke packed with an abundance of information. And you can readily infer from the drawing that Mr. Troisé had fun doing it.

Totally different in style is Mr. Troisé's sketch of the *Pig* (p. 142). However, not much more actual work was involved in executing this study, which in its own way is just as amusing as the *Koala*. Pay special attention to the very real sense of pig skin. This was achieved by first selecting a painting surface with a marked texture not unlike a pig's skin — a textured, coated cover stock. Next, the entire form was painted in with a new, wet burnt umber marker (new so that maximum wetting and penetration would occur). Finally, a barely moist cotton ball was lightly and repeatedly rubbed over the pig's shape until the desired effect was realized. Details were picked out with a moist Q-Tip and with the corner of a No. 1 gray marker.

For still more draftsmanlike detail, fine-tip markers can be called upon for renderings like *Pekingese* (p. 145) by Meredith Hupalo. In this drawing, absorbent sketch paper was used with water-soluble markers in order that successive colors could be superimposed without removing any of the underlying ink. The dog was built color on color.

The horse's head was done in the same fashion although nonabsorbent canvaslike paper was used. In the first step (Figure 98), the subject was outlined and blocked in with tan and touches of sienna. Umber shadows were added (Figure 99), and then the study was reworked with all four colors — plus highlights of ochre and cream (Figure 100). Also executed on canvaslike paper are *Chimpanzees* and *Beagle Hound* (p. 138 and p. 142) by Mr. Troisé have another thing in common: the use of fine-tip markers for details, particularly the hair.

Finally, in *Cat's Face* (p. 142), you'll notice the same oil-paint impasto on illustration board used in Project 8. But here the technique's "scratchboard" capabilities are put to maximum use. All the white hairs were etched out with the corner of a razor blade. What isn't evident but is nevertheless noteworthy is that, on several occasions, Mr. Troisé felt inclined to make changes and corrections — which, unlike conventional scratchboard, is quite easy to do.

Figure 98. The main elements of the horse's head are blocked in with tan and sienna on canvaslike paper.

Figure 99. Umber and burnt umber shadows are added. Hard outlines are softened by overpainting.

Figure 100. The four colors are reworked, and cream and ochre highlights are added.

Pig. Another very simple rendering in which the startlingly real effect of the pig's skin was obtained by painting on a leather-textured, coated cover stock.

Koala. This lighthearted drawing of a koala is a somewhat refined doodle. A sense of humor in the artist can be valuable in maintaining perspective.

Beagle Hound. In this painting, fine-tip markers were added over blocks of color, creating the hairlike texture.

Cat's Face. The "marker scratchboard" effect was produced by painting on oil-paint impasto, then scratching through marker colors with a razor blade. One advantage of this technique over conventional scratchboard is that changes and corrections are more simple.

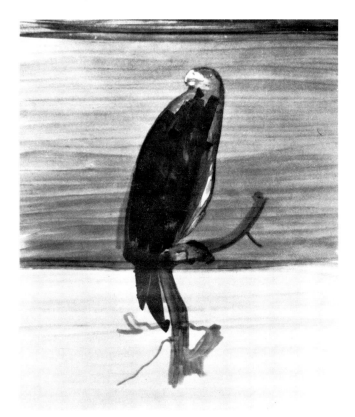

Eagle I. Making use of both sides of the paper permits styling of the background area without disrupting previously painted foreground subjects. Here, the sky was painted on the back side of a 19'' x 24'' sheet of vellum.

Eagle II. Compare the sky's tone in this illustration with that in Eagle I. The difference is due to the diffusing quality of the vellum.

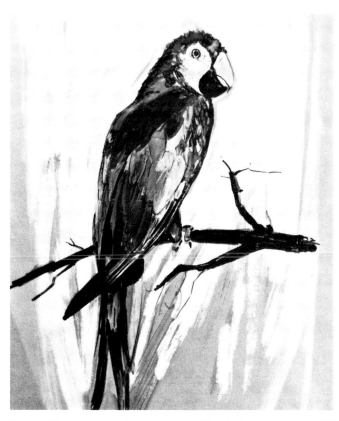

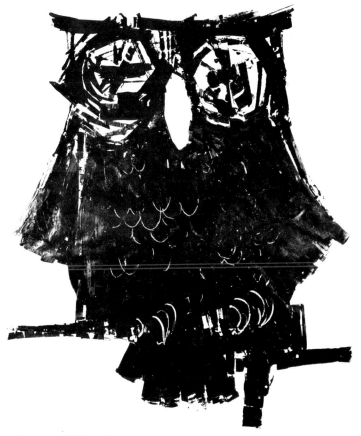

Parrot. Displaying very tight execution, this painting was done on 19'' x 24'' clear acetate, with the aid of a pencil sketch under the overlay sheet. Later, self-adhesive shading film was applied to the other side of the acetate and scraped with a razor.

Black and White Owl. A gum-water stencil was used on the owl's eyes, the scratchboard technique on the feather outlines, and "erasing" with a turpentine-moistened watercolor brush on the talons.

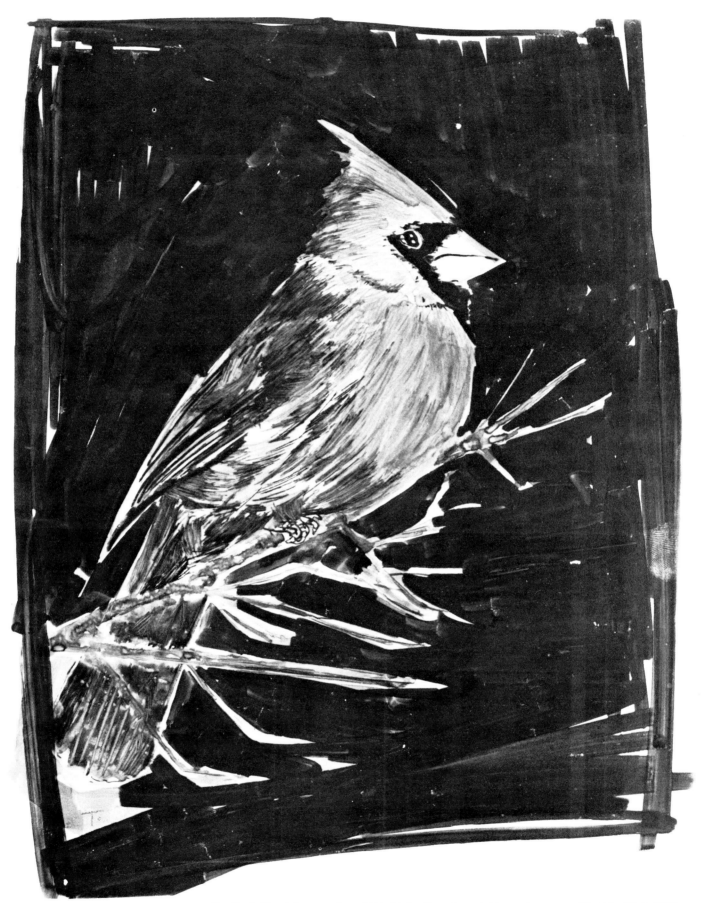

Cardinal. The tight execution of this bird with water-soluble markers was softened with a damp watercolor brush and water. Then the background was added with an oil-based marker. Since oil-based markers readily cover water-based colors, the background was used to make parts of the bird's outline opaque and to redefine other parts.

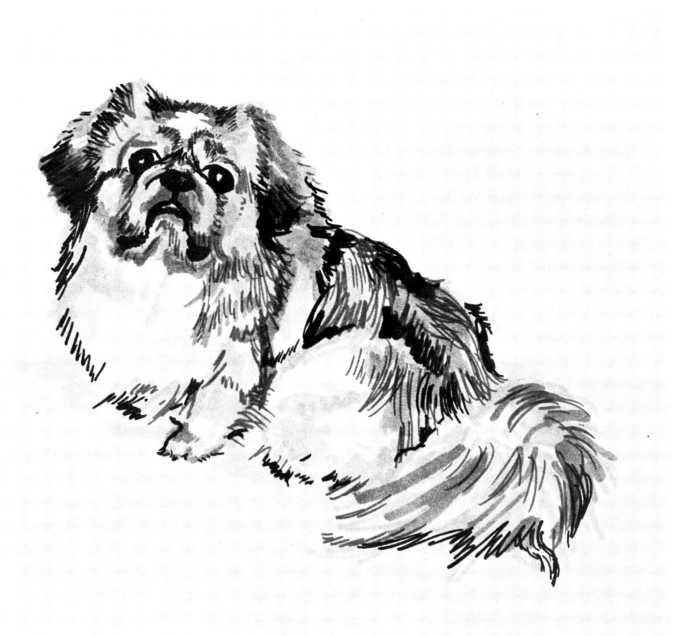

Pekingese by Meredith Hupalo. Fine-tip markers were used on absorbent paper to minimize blending and permit this study to be built color on color with draftsmanlike detail.

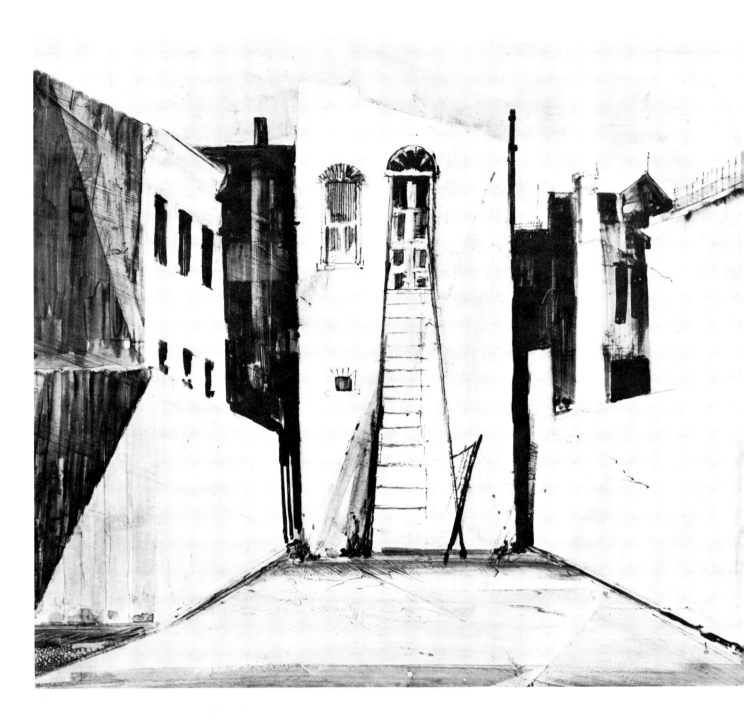

Buildings. Palette-knife tracks in oil impasto can be utilized, too, to define shapes of buildings and walls, as well as planes of light. The most obvious example is at the top of the central building.

If you've never really looked at the building you live in, those you pass on the way to work or shopping, and the other man-made shelters you encounter every day, you're missing a wealth of exciting, satisfying material. In fact, if your home is in or near a major metropolitan area, particularly a city with its own architectural personality, you may be overlooking your life's work. For painting a city's ever-changing moods can easily become a lifelong task, as it has been for us.

Strangely enough, there are numerous parallels between painting the sea and the city. Both require an emotional empathy best nurtured by constant exposure to their elemental forces. Both assume a superficiality that can be quite different from their true essences. If you probe beneath the surface, stripping away the veneer reveals that both are teeming with life to a degree which is merely hinted at. Both are in a continual state of flux, though the rate of change is considerably more rapid along the seashore. And both are remarkably pliant — exceptionally receptive to the stamp of an artist's individualistic style.

In this project and the next, we'll examine various ways of handling simple and complex subjects. To begin with, work at training your eye and a painting like *Demolition* will be right up your alley by the end of this chapter. Afterward, you can do some paintings that are more comprehensive.

Materials Used in the Studies

Here are the papers and other materials used in this project:

1. A broad selection of markers, including fine-tip black

2. Vellum

3. Coated cover stock

4. Illustration board

5. Tube of white oil paint

6. Palette knife

7. Turpentine

8. Cotton balls and Q-Tips

Wall Geometry

In the painting of *An Old Woman* (p. 150) by Emile Troisé, you see an example of how the oil-paint impasto technique can be used for dual purposes. Not only does the impasto seal the surface of the illustration board to create a nonabsorbent "skin" but it also produces texture and form on what would otherwise be blank walls. Two layers of white oil paint were applied. The first was put on with palette knife strokes from right to left. When dry, this layer was overpainted — but not totally — with knife strokes ranging from vertical to a slight angle off vertical.

The sense of angularity in the wall at left and in the wall at far right was heightened in the following manner. First, the rear vertical wall was painted with Prussian blue, then washed with a turpentine-moistened cotton ball to a pastel shade. Next, a sheet of sketch paper was laid on the painting, slanting sharply down from the top left corner. A Q-Tip containing a trace of turpentine was dragged over the edge of this paper mask and upward along the palette knife lines for a short distance. This picked up most of the remaining blue along the edge of the paper mask and produced a crisp edge where the mask's edge was. Note how this edge terminates at a deep, prominent line left by the palette knife. The triangle thus formed is read by your eye as a plane of light.

Directly behind the old woman is a trapezoidal shape produced in the same way (one sheet of paper was used and successively worked each of the three sides, but you could just as easily cut the shape from a sheet of paper and use the remaining part as a stencil). The triangle coming in from the painting's top right edge was created similarly, after the right-hand wall had been painted olive and washed down to a pastel shade. However, the adjacent triangle descending from the top border calls for a small modification. Here, the color was stenciled in with the aid of a cut-paper mask. More blue, plus some red, was stroked in with a chisel-tip marker, and then, with the mask still in place, a Q-Tip moistened with turpentine was utilized to wash down and blend the colors (Along the right side of the triangle you can see where the still wet wash was slightly smeared as the mask was lifted away. The smears on the triangle's left side were done with the Q-Tip after removing the mask.) Had the final colors been washed to an even lighter pastel, the edges of the plane would have resembled the corner between the rear wall and the pavement.

Another approach to this technique — more effective visually, but more demanding as well, since it requires that the main compositional elements of a painting be firmly fixed in your mind's eye — is depicted in *Buildings* (p. 146), also done by Mr. Troisé. Here, the palette knife tracks are employed to define physical edges as well as planes of light. The most obvious example is the top of the central building. Depending upon how thoroughly you can "freeze" the compositional details in your mind, since the oil-paint impasto will take several days to dry, you can experiment with still more extensive use of defining forms with the impasto — a sort of white-on-white painting technique.

Study of Buildings by Richard Downer. This in-the-field marker drawing was done with a Flo-Master fountain brush. Because the black ink flow is regulated by pressure on a spring-loaded valve, one felt-nibbed pen filled will produce tones varying from light gray to dense black. (From *Drawing Buildings*)

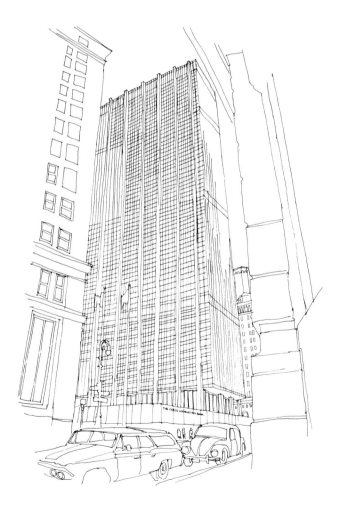

Chase Manhattan Bank by Richard Welling. Line drawings such as this, done with a fine-tip black marker, can be executed on the spot and later developed into a painting in the studio. (From *American Artist*, October 1969)

Careful Use of Planes and Color

Study *Buildings* for a moment and recall the early emphasis given to stenciling and other mechanisms for attaining crisp, sharp edges. In this painting you begin to understand the rationale. Study the painting a little more and you'll realize that the geometric planes of light, which perhaps appeared rather haphazard initially, are carefully constructed to unify the painting. The diagonal coming down from near the top right corner, for example, ends at the top of the courtyard wall — but then picks up again in the lower portion of that wall. And the extension of this diagonal further relates to several more diagonals on both sides that are parallel to it (or nearly so), including the railing at the bottom of the steps.

To appreciate this painting fully, you need to know the color scheme. At far left, the building is painted a cadmium orange over a washed-down Prussian blue. This wash underlies the entire painting, save for the sky (washed ultramarine) and the side of the building at left that faces the courtyard (washed yellow-green). In some light planes, the Prussian blue has been completely erased with turpentine, and in most other areas touches of another color, usually red, have been added and then washed. Some of the orange from the left-hand building carries down into the board fence, where darker Prussian blue and shadings of ultramarine are also employed. To the left of the central building, the background structure is dense Prussian blue over burnt umber. The central building is partly pure white. Its windows are orange with dabs of red, and the door is washed olive with forest green panels and a stroke, here and there, of orange and red plus ultramarine shadows. Behind at the right is a peacock blue and Prussian blue building with an overpainted, blended ochre window. The chimneyed building is burnt umber over a red wash.

Architectural Study (p. 151), done by Mr. Troisé on coated cover stock without impasto, is another resplendent example of what the introduction of geometric planes of light can do for predominantly architectural themes. This painting also uses bright color to key the focal points. Most of the walls are washed browns, with grays, blues, and ochre touches for interest. But when you come to the steps, they're almost pure sepia and ochre, with red and magenta used for the side at the right of the steps. The arched doorway is Prussian blue, ultramarine and a thin strip of peacock blue, all essentially pure colors. The large door is a mixture of Prussian blue and ultramarine, outlined in peacock blue and cadmium yellow.

If you think that this painting style — planes of light introduced into oversimplified structural planes — is appropriate only for crowded city scenes, turn back to Project 6 and examine the buildings in *Lake, Boats, and Barn* (p. 90). And another, less obtrusive approach — more suitable, perhaps — is illustrated in *Ramshackle Country Buildings* (p. 150) done by Mr. Troisé. Here, the light planes aren't as severely delineated. Yet this painting — on absorbent, smooth illustration board — sparkles with color, despite intensive use of grays in the ground and sky and near black in the building shadows. Over the yellow, ochre, and sienna building at left is an olive roof, while the sides of the right-hand building are red, orange, yellow, and Nile green.

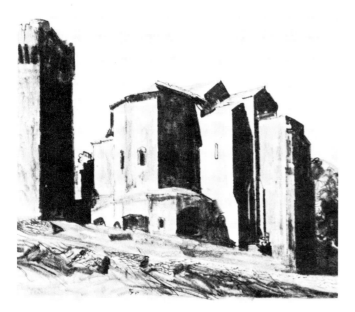

Deserted Abbey (Left) by Robert Fawcett. The scope of the Flo-Master pen is quite apparent in this drawing, dated 1947. Note the wide range of tonal effects and stroke widths. A half dozen Flo-Master pens, each filled with a different color of ink, is a strong painting arsenal for use in the field or studio. (From *On the Art of Drawing*)

Sunlight, San Gimignano (Below) by Robert Fawcett. Here, another Flo-Master drawing shows how imaginative views of wall geometry add interest to city scenes. (From *On the Art of Drawing*)

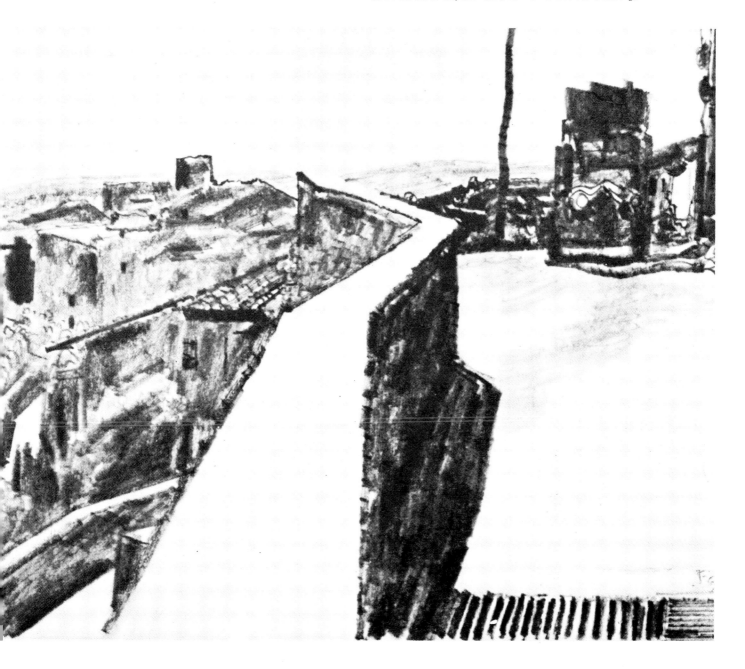

Ramshackle Country Buildings. This quick sketch on smooth illustration board illustrates a less obvious use of light planes. Here, the light planes are bright colors — red, orange, yellow, and Nile green — in an otherwise gray and near-black rendering. The more amorphous light planes effectively "dress up" the ramshackle buildings.

An Old Woman. Oil-paint impasto was used to seal ordinary illustration board, producing a nonabsorbent painting surface. Applied with a palette knife, the impasto also produced some interesting textures that were incorporated into the painting. Here, impasto textures relieve the large expanse of wall at left of any possible monotony. Look closely and you'll see evidence of the impasto applied in two steps and two directions. The angular planes of light were created with the aid of straight-edge stencils. Note how these planes are integrated with palette knife marks in impasto.

Abstracting With Color

By now, you'll have intuitively realized what Mr. Troisé was doing. He grossly oversimplified the primary compositional shapes and forms, usually with blocks of color (thus avoiding preoccupation with the complicated details that can inundate an artist working with urban scenes) — and then, to embody the sense of intricate entanglement that is characteristic of the urban complex, he broke down these fundamental forms into planes of light and color that caused the separate physical planes to interact. To do this effectively requires much practice and patience. Expect to discard many false starts and many weak finished paintings. But when your eye is trained, when your hand cooperates with your eye, the results will be worth the effort.

When you reach this stage, you're ready to progress to the next phase: imposing structural details over the abstracted primary forms, these details themselves abstracted blocks of color. In other words, the details are not just a kind of embellishment, but an integrated refinement of the over-all style.

Look at Mr. Troisé's *Demolition* (p. 151) and you'll see an example. Study this black and white illustration for a time, until you have a grasp of the main compositional scheme. (Then turn to the color plate on page 102.) Here, you'll perceive exactly how effective is the use of color "building blocks." This painting was done on vellum and resembles a watercolor. (In the next project you'll find examples with more obvious integration of primary and detail abstracted forms with planes of light suggested by textures in an oil-paint impasto.)

Because proficiency will come hard, you should never miss the chance to paint a scene which attracts you. Make it a habit, therefore, to carry at least one marker with you at all times (say, a fine-tip black that you can use to record an interesting subject). Even better, carry the more versatile Flo-Master fountain brush. In either case, you'll then be in a position to execute at least a line drawing — such as the study (on p. 148) by Richard Welling of *Chase Manhattan Bank* (one of several drawings that appeared in *American Artist*, October 1969) — or line and tone drawings from Richard Downer's book *Drawing Buildings* (p. 148), or those works of Robert Fawcett such as *Deserted Abbey* and *Sunlight, San Gimignano* (p. 149).

When you've done similar studies, you can return to your studio and produce a painting in full color.

Demolition. This marker painting is a partly abstracted view of a New York apartment building being razed. It was painted on an 11" x 14" heavyweight vellum sheet. Training your eye to distill such concentrated design elements from the busy urban environment requires considerable practice.

Architectural Study. Planes of light are also superimposed over textured impasto in this architectural study. The walls are turpentine-washed browns plus touches of gray, blue, and ochre. The steps, however, are emphasized with pure sepia and ochre, with red and magenta along the right. The arched doorway is Prussian blue, ultramarine, and some peacock blue.

View of the Brooklyn Bridge. A multicolored vista, looking from Brooklyn across the East River toward Manhattan, with Brooklyn Bridge at right, is painted on 14″ x 17″ oil-paint impasto. Distant buildings are done in heavily washed Prussian and peacock blues. The lighthouse used by old Fulton ferry boats is painted with No. 9 gray over ultramarine, bounded by peacock blue water and olive over a peacock blue building in front. The street is umber and Prussian blue, washed with turpentine. These colors also underlie bridge towers and buildings. Ultramarine, forest green, magenta, and sienna also appear in buildings at left. The façades at right are a patchwork of orange and red, Prussian and ultramarine, umber, sepia, olive, and forest green.

New York City is unique. There's an indefinable presence about the place unlike any other metropolis in all the world. The feeling goes beyond the sense of being at the hub of world finance and politics, at the center of the arts and communications. Although these attractions alone are sufficient to draw thousands of new and aspiring residents to the city each year, New York City casts a spell that can last a lifetime. It may take that long to get even a glimpse of its real nature. For only after many years, during which time much of the architecture that's become familiar will have been removed and replaced, do you begin to realize that the city's *élan* doesn't rely upon imposing canyons nor sky-high walls of glass nor thronged sidewalks nor the sound of 3 A.M. traffic jams nor any of the other signs bearing the unmistakable stamp of New York's bustling atmosphere. Neither singly nor collectively can these impressions convey the true flavor of New York, although they do contribute to the magic that makes Times Square and Fifth Avenue and Central Park more than just locations on a map.

New York as Experience

New York has one thing in common with love: you must experience it to know it. There's no halfway or in-between refuge. And that may explain why you either love the place or hate it.

Emile Troisé loves it and has devoted his life — and a major share of his artistic energies — to it. An opportunity to experience something new, to steep himself in its lore, to absorb the substance of some remote neighborhood, to explore an overlooked corner — none of these is ever missed.

This background is presented for two reasons. First, it sets the tone for the following paintings, most of them done by Mr. Troisé, all of which are highly personal interpretations. Second, and perhaps the more significant, it reveals something of the intensity with which markers can be employed. Markers would never have been considered if they couldn't at least equal the depth of expression possible with another medium.

Materials Used in the Studies

These materials were used in the studies presented in this project in addition to markers:

1. Coated cover stock
2. Illustration board
3. Watercolor board
4. Linen-finish board (or linen-mounted paper)
5. Sketchpad, large
6. Tube of white oil paint
7. Palette knife
8. Gum water
9. Turpentine
10. Watercolor brush
11. Razor blade
12. Spray bottle

Foundation in Linearity

When you study the physical structure of New York — or any other large city — the most powerful impression is of linearity. Verticals and horizontals threaten to overwhelm the eye. The best way to counter this threat is to subdue it with line. (In other words, fight line with line.) Take your sketchpad for a shield and a fine-line marker for a sword and wade into battle, as Richard Welling has done in *The Towers of Park Avenue* (p. 154). It may at first glance seem to be complicated enough, but really it's been quite simplified. The secret of success in such drawings, however, is in learning what to sacrifice. And that's probably best taught by practice. So practice well, for the ability to reject the superfluous is not only a prerequisite for concentrating on important features, but also is a necessary first step to including those details never captured by a camera. The abstracted planes of light discussed in the preceding project, for instance, are partly conditioned by and dependent upon an underlying simplicity.

Studying the City

Address the city from as many different vantage points as you can. Study its structure from the ground and from the tops of buildings, from a distance and from close at hand. For example, *The Pan Am Building* (p. 155) is another angle distantly visible in the center of *The Towers of Park Avenue* (p. 154). (Along with several others, these drawings by Richard Welling appeared in the October 1969 issue of *American Artist*. If you have a copy, you should read Mr. Welling's remarks on drawing New York City scenes.) Inspect *The Pan Am Building* meticulously and you'll notice that the rules or perspective aren't permitted to interfere with good artistic effects. So it should be

The Towers of Park Avenue by Richard Welling. One of the most important secrets to capturing city scenes on paper is learning to omit the maximum amount of detail yet sacrifice the minimum amount of effect. For instance, this marker drawing on 16¾" x 23½" sketch paper may at first appear complicated. In reality, it is simplified. (From *The Technique of Drawing Buildings*)

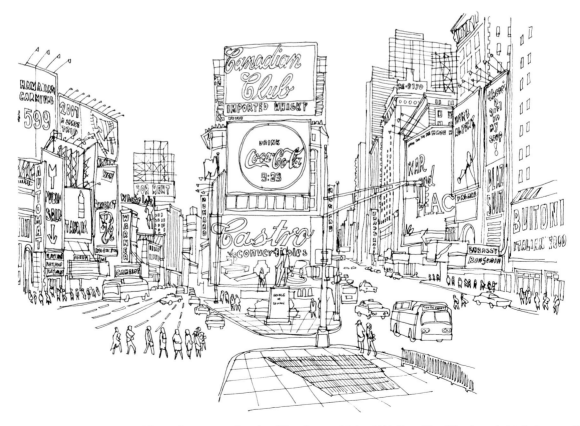

Times Square on Sunday Morning by Richard Welling. Simplification of details is essential in a drawing like this one. This 16½" x 23½" drawing can always be brought back to the studio to be transformed into a painting. (From *American Artist*, October 1969)

always in cityscapes. But again, this is something you'll be able best to evaluate after much practice — and patience.

Sooner or later, though, you may want to develop a drawing such as Richard Welling's *Times Square on Sunday Morning* (p. 154) into a painting. Obviously, if the eye is vulnerable to the city's majestic presence when a line drawing is the objective, an artist is considerably more susceptible when an interpretative painting is in his mind. For one thing, the genre of Emile Troise's painting *A Rainy Night in Times Square* (p. 160 and also the color plate on p. 98) demands a much more intimate rapport with the city, which puts an artist in a position not unlike that of the psychiatric researcher who decides to write a treatise on marijuana while under its influence in order to strike a note of authenticity. It's exceedingly difficult to retain objectivity. More than likely, the critique will not be written until the period of altered consciousness is past. This danger of being seduced by the city cannot be stressed too strongly.

A few points about this painting, although perhaps obvious, warrant special mention. Note the up-and-down strokes portraying the sky. Not only do they communicate a sense of rainfall — impending if not actual — but in a way also hint of the solid buildings just beyond perception in the gloom of night. The appearance of a wet street is heightened by "running" colors in the pavement that are reflections of the sky and the surrounding lighted buildings. Both the street and the lower part of the sky are "triangulated" by planes of light, created or superimposed by means of paper stencils or masks — and the use of this technique could hardly find a more appropriate context.

Also note the painting's subtle impressionistic simplifications. Perspective is subordinated to effect; isolate the sidewalk throngs at the extreme left and you'll find a group of people "floating" under a marquee. Very few of the lighted signs are illustrated as such; instead, the letters seem to be suspended in air. This too is appropriate. For when you come away from a locale as visually congested as Times Square at night, the physical fact of signs is often remembered just as size and color of the words while other details are quickly forgotten.

Step-by-Step to Cityscape

Before presenting the rest of our tour of New York, let's take a step-by-step look at how a cityscape painting develops. The scene is Third Avenue of years ago, before the elevated subway was removed, and the artist could well be one of the pedestrians. In this case, the painter was Emile Troisé and the actual size of the painting is 13" x 14 ½" although a 16" x 20" illustration board was used. After the main composition was blocked in, the general color scheme was established (Figure 101). As the painting is effectively bisected by the open space down the center of the sidewalk, a split was made with cool colors on the left and warm colors predominating on the right. From left to right, the colors applied are Prussian blue over umber (steel superstructure of the el), forest and olive green (light portions of the el, including the shelter over the sidewalk), brick red, wine red, lilac, and magenta (buildings at right), and light blue for the seafood sign. Before the blue was laid in, however, a small watercolor brush moistened with gum water

The Pan Am Building by Richard Welling. The city deserves exploration from all possible angles. It may tax your abilities to handle perspectives, but the rewards are more than ample. However, don't allow rigid rules of perspective to interfere with good artistic effect as in this drawing done on 23 ½" x 16 ½" sketch paper. (From *American Artist*, October 1969)

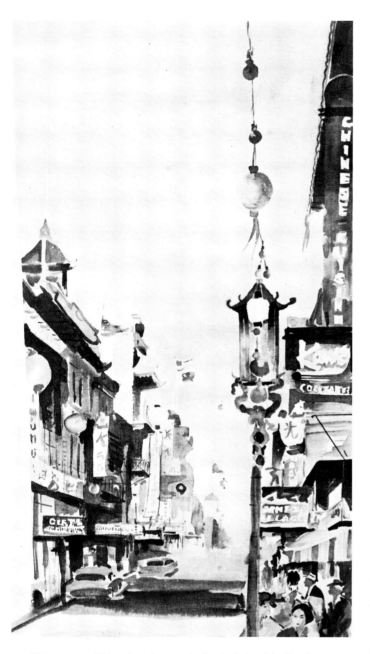

Chinatown. This vista is practically indistinguishable from conventional watercolor, which points to the importance of selecting your painting surface with care so you can achieve a good effect. This painting was done on paper-mounted linen. The fabric's beige tone and partial absorbency tend to mute and diffuse the vitality of marker inks, producing a most attractive finish.

was used to letter "sheepshead" and "seafood." Later, this gum-water mask was rubbed off to reveal the white impasto. The same procedure was followed before painting the "restaurant bar grill" sign (magenta) and the "antiques" sign (brick red).

In Figure 102 more gum water was applied to stencil the el's crisscrossing siderails, the "871" on the garbage can at bottom right, and the crisscrossing steel railing just behind the can. Light blue was then stroked over the gum-water mask delineating the el's siderail, with a peacock blue strip immediately above this. Several shadows were added: emerald green eave in the el shelter, umber eave on the building to its right. Umber was also employed for the triangular planes at far right and adjacent to the "restaurant" sign. The "antiques" sign was triangulated with magenta. Prussian blue and violet were blended for the refuse cans, and a brick red triangle has appeared in the sidewalk.

In Figure 103, part of the gum-water mask was removed and peacock blue and ultramarine were used to darken the el. The green overhead shelter was washed down with a turpentine-moistened Q-Tip; subsequently, an emerald green scalloped shadow and an oil diagonal were added. Peacock blue, with a touch of ultramarine, strengthened the "seafood" sign's borders. These two colors, reversed in prominence, were also used for the area around the garbage cans.

More planes of olive and forest green were added to the el's overhead shelter. Hints of aqua were also daubed on (Figure 104). Brick red and umber triangles were laid in the buildings at right. Two Prussian blue planes were added to the sidewalk.

All the gum-water masks were removed (Figure 105). Existing color schemes were developed more fully — and some new twists crop up. In the upper right corner, a plane of ultramarine helps balance the two sides of the painting. An ultramarine triangle in the corner of a Prussian blue polyhedron just above the garbage cans also helps to balance the composition, as does a washed-down forest green triangle in the store window about the "antiques" sign.

Manhattan Island

As everyone knows, Manhattan is a relatively small island crammed with buildings that comb the sky. A semblance of what immigrants to America must have felt can still be experienced from the deck of a Staten Island ferry or an excursion boat to the Statue of Liberty. *Manhattan Skyline* (p. 157) by Mr. Troisê is the view. This scene is undeniably awe-inspiring and has been studied by countless photographers and painters. This interpretation contrasts the liquid turbulence of the sea greens and blues of the river — with the engineered turbulence of the city — executed in blues and greens also, with contrasting warm hues of umber, yellow-green, violet; and various shades of washed cadmium red. Reflections in the water and light-plane edges both in the water and in the buildings are achieved by gently washing along the edge of a paper mask with a turpentine-moistened Q-Tip.

Because Manhattan is surrounded by water, vehicular access to Manhattan is limited to bridges and tunnels, with the bridges affording especially attractive backdrops. *View of the Brooklyn*

Manhattan Skyline. Over a 15″ x 22″ oil-paint impasto that's responsible for interesting textural effects, the fluid turbulence of the sea was painted to contrast with the structural turbulence of lower Manhattan. Greens and blues are the predominant colors for both water and buildings. Umber, violet, and·tints of red are also used in the buildings. Reflections in the water and light-plane borders are achieved by gently washing along the edge of a paper mask with a turpentine-moistened Q-Tip.

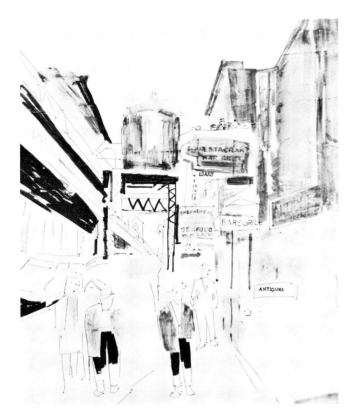

Figure 101. After the composition was blocked in, the color scheme was established. The superstructure of the elevated railway is Prussian blue over umber. Forest and olive greens in the overhead shelter bridge the vertical split of cool and warm colors. Brick red, wine, lilac, and magenta are present in the buildings at right. The lettering in several signs has been masked out with gum water.

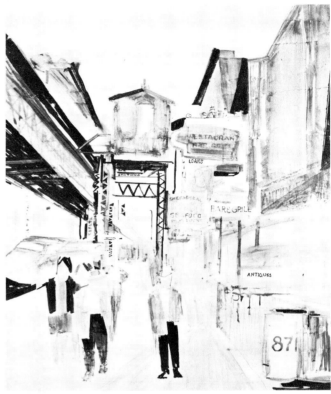

Figure 102. More gum water has been applied to stencil the elevated's crisscrossing siderails, the "871" on the garbage can, and the steel railing just behind the garbage can. Light blue has been stroked over the gum water mask on the side of the el, with a peacock blue strip immediately above, next to the Prussian blue. Umber shadows have been added to the buildings.

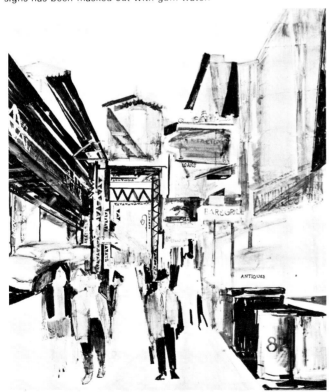

Figure 103. The el has been darkened with peacock blue and ultramarine; part of the gum-water stencil is removed. The overhead shelter has been washed down with turpentine before adding an olive diagonal and an emerald green scalloped shadow.

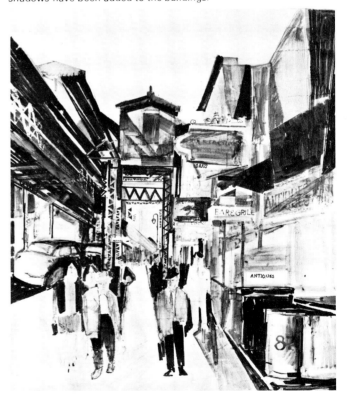

Figure 104. More planes of olive and forest green are superimposed on the overhead shelter, along with a trace of aqua. Brick-red and umber triangular planes of light proliferate on the buildings.

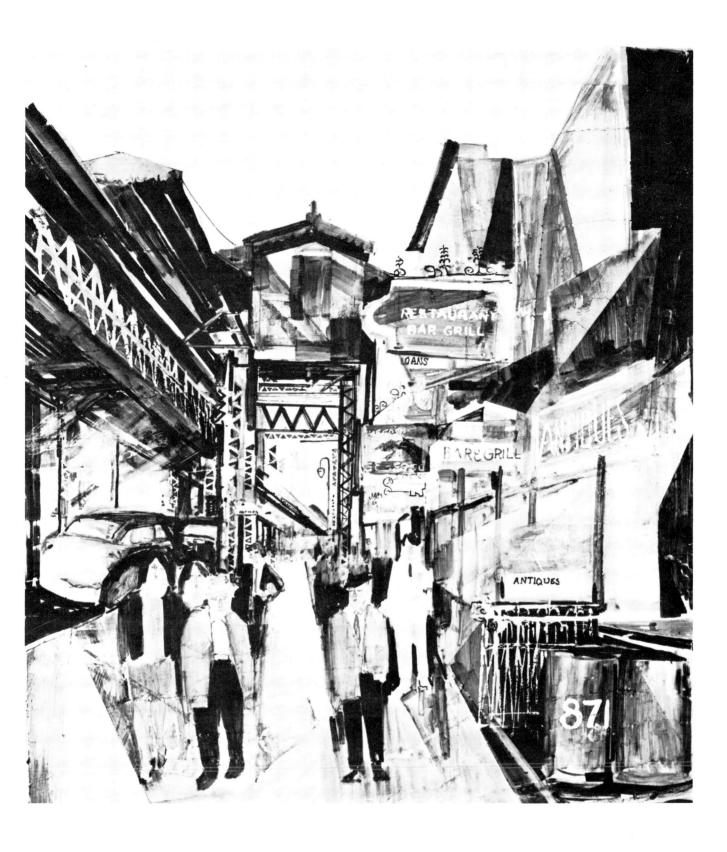

Figure 105. All gum-water masks have been removed. Existing color schemes have been developed more fully and intensified. For balance, a large umber plane at upper right has been washed with turpentine and ultramarine painted over. Also, an ultramarine triangle in a Prussian blue polyhedron just over the refuse cans has been added along the right border. A further note of color balance is the washed-down forest green triangle in the storm window above the "antiques" sign.

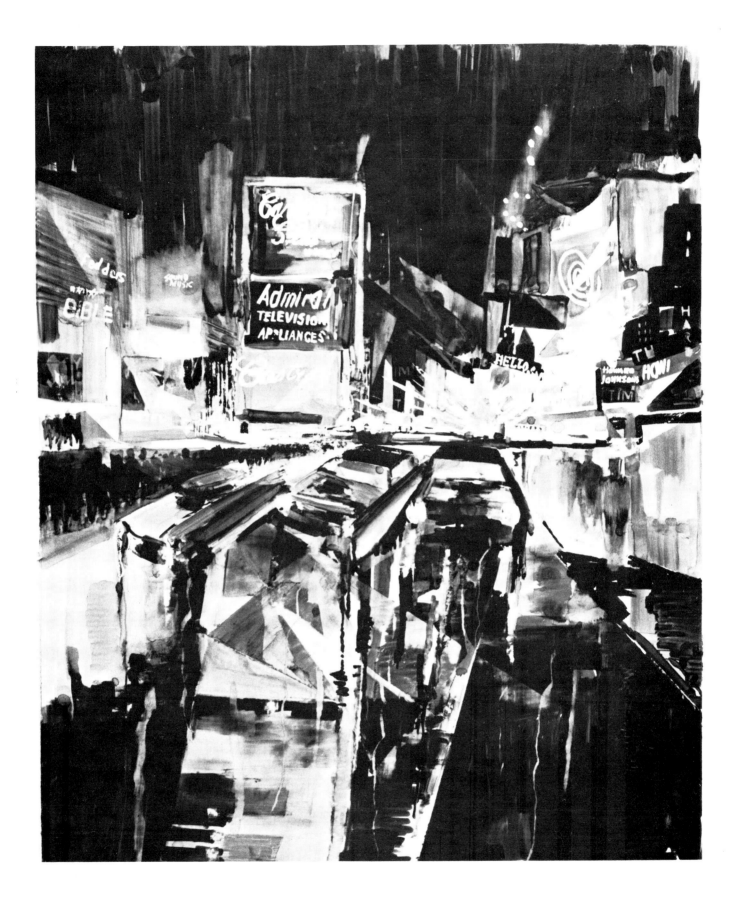

A Rainy Night in Times Square. Triangulating planes of light are utilized here to full advantage.

Bridge (p. 152, see also the color plate on p. 108) by Mr. Troisé is typical. In the background is the Brooklyn Bridge, considered by many to be the handsomest bridge in the world. Farther in the distance, over the lighthouse originally used by Robert Fulton's ferryboats connecting Fulton Street, Brooklyn, with Fulton Street, Manhattan (before the bridge was constructed), are the concrete, steel, and glass towers of New York. These are painted in heavily washed Prussian and peacock blues. The lighthouse is No. 9 gray over ultramarine, offset by the peacock blue East River and the olive over peacock blue building in front. Directing the eye to the lighthouse is the broad umber-and-Prussian blue street, washed to a light pastel. These colors are also used in the bridge towers and are the foundation of the buildings at left and right. Ultramarine facades with traces of forest green, magenta, and sienna are employed generously to darken the buildings on the left. Those on the right are a patchwork of cadmium orange and red, Prussian and ultramarine blues, umber, sepia, olive, and forest green.

Another link between Manhattan and the outside world is the Queensboro Bridge. Mr. Troisé's work (p. 161, and also the color plate on p. 105) shows the underlying impasto is applied with pronounced textural roughness which comes through the marker strokes to emulate the rather grimy surroundings. Note the boy playing stickball. It was this scene that initially appealed to the artist. In keeping with this grim neighborhood, drenched in automobile exhaust fumes and soot from a nearby powerplant, the painting is largely gray and somber. Prussian blue, violet, and lilac reinforce the general color scheme, which is relieved only by the cadmium red ball, a peacock blue shirt, and a magenta jacket (worn by the women in the foreground), the orange "Gulf" sign, and a few spots of red, magenta, and orange in the buildings above the "Gulf" sign. But even these colors are, for the artist's usual palette, uncommonly subdued to mirror the pathos he felt when he chanced upon this scene. The boy's clothes were dingy rags, his face and hands smeared with dirt. The irony of such a picture in the shadow of such a monument to affluent technocracy as the Queensboro Bridge was too much of a challenge, too touching a vignette to pass by without reflection.

Other Districts

Within Manhattan Island are numerous enclaves and districts that are practically separate islands unto themselves. One of the more famous is Chinatown. *Chinatown* (p. 156, see also color plate on p. 107) is one of Emile Troisé's most unusual marker paintings. It's almost indistinguishable from a conventional watercolor, which points up once again the importance of choosing your painting surface with care. He used an old sheet of linen-laminated paper. Nothing comparable has been found in New York art stores, and it's believed to have been originally a wallpaper material. The beige tone of the fabric and its partial absorbency tended to mute and diffuse the vitality of marker inks, producing a most appropriate result.

And now, before you set out to write new chapters for this book, let's create an adventuresome mood and do some experimentation in the next and final project.

The Queensboro Bridge. The oil impasto on this 20″ x 27″ painting was purposely applied to produce the rough surface that emerges to convey a sense of griminess of the neighborhood near the Queensboro Bridge. This quality is further stressed by gray, somber colors, which are in keeping with the auto exhaust fumes from the heavily traveled bridge and the soot from the nearby powerplant. Prussian blue, violet, and lilac reinforce the over-all color mood, relieved only by the red ball, the peacock blue skirt, the magenta jacket on the woman in front, the orange "Gulf" sign, and the highlights of red, magenta, and orange in the buildings.

Icarus by David C. Baker. A feather was wetted with marker ink and rolled down on the Marlite panel. The black and white circular ink flow which radiates outward from the sun at right was achieved by rotating the painting on a potter's wheel.

EXPERIMENT IN CREATIVITY

Several examples of David C. Baker's distinctive work have appeared in various chapters. It's next to impossible to talk about how one of his paintings evolves; you have to see it to believe it. It's a process of continuous development, of controlled creativity, of capitalizing upon accidents, of creating "accidents" through imagination.

One other preliminary note: to attempt to simulate precisely the step-by-step evolution of this painting is hopeless. Don't even consider it. What you can do is to use the same tools at approximately the same points, but adapting them to your own painting's needs. This, after all, is as it should be.

Suggested Materials

Here are the materials Mr. Baker used in executing his painting, which you can use as well in this step-by-step demonstration.

1. Marker inks — cans (for refillable markers) of red, yellow, blue, and black

2. Marlite panel, approximately 24" x 36"

3. Turpentine

4. Spray bottle

5. Rubber roller, small

6. Paint roller

7. Paintbrush, 2"

8. Watercolor brush, small

9. Watercolor brush, medium

10. Boughs of various leaves

11. Scraps of paper and miscellaneous items

Place the Marlite panel on a horizontal surface and squirt colors directly from the cans onto the panel (Figure 106). Use all four colors — red, yellow, blue, and black — but a sparing amount of black. Tilt the panel until the colors begin to run, then reverse the angle of tilt and let the colors run in the opposite direction (or nearly so). A third angle can also be used. Dip a 2" paintbrush in turpentine and stroke over the ink flows, blending the colors and applying a fairly liberal amount of turpentine to the panel (Figure 107). Tilt the panel again and let the colors flow and intermingle (Figure 108).

Place the panel on the floor and, while the inks are still wet, lay another Marlite panel on top (Figure 109). Step on the top panel with your full weight in two or three places. Working quickly, before the colors dry, take a bough of leaves, paint them on one side with a medium-size watercolor brush (and red ink), then roll the painted side down over a blue ink flow, or paint the leaves blue and roll them over a red ink flow (Figure 110). This is roughly what your leaf impression should look like (Figure 111).

Repeat the step in Figure 110 to obtain additional leaf impressions. In Figure 113, you can see the over-all view of the painting at this stage in its development.

Tear a piece of cardboard and use the ragged edge to mask the painting while you spray turpentine in a selected spot. Three or four squirts from a spray bottle will be sufficient (Figure 114). Hold the panel upright and let the turpentine flow (Figure 115). When you're satisfied with the effect, return the panel to a horizontal position — to "freeze" the flow — and run a paint roller over the painting (Figure 116). This will both contribute some blending of colors and reduce color intensity.

Repeat the step of rolling painted leaves in another place on the panel (Figure 117).

Squirt on more ink (Figure 118). Spread out the new ink with a paint roller (Figure 119). Give the fresh ink time to dry, then put the panel on the floor (Figure 120). Scatter, rather haphazardly, random sizes of paper over the region worked on in Figures 118 and 119. Then spray the area with turpentine. Wait until it's dry and remove the paper masks. At this point, begin to develop specific themes. The panel is returned to the easel, upside down, and a medium watercolor brush employed to stroke on turpentine over part of what will be the sky (Figure 121). With the panel restored to rightside up, a small watercolor brush and turpentine are used to paint in a somewhat macabre tree (Figure 122).

Repeat the step in Figure 110 with a different type of leaf (Figure 123).

From here to Figure 124 is just a matter of a few details. A lobster trap at the rowboat's bow, a post near the boat's stern, a house on the cliffs in the distance, and a few branches at the far right — all of these were painted in with a small watercolor brush. You can add your own details — whatever suits your imagination.

Look at Mr. Baker's painting *Icarus,* the final work in this book and a good example of creative painting demonstrated in this project. As you can plainly see, instead of leaves, Mr. Baker rolled down a feather and achieved a most appropriate effect. Observe the circular ink flow at the right which radiates outward from the sun. This was accomplished by rotating the Marlite panel on a potter's wheel. This painting was done in black and white.

The End of This Beginning

And so we reach the ending of our joint efforts and the beginning of your independent work. In less than 200 pages, we've conveyed the essential findings of more than two years of systematic exploration of markers as a painting medium, plus several more years of intuitive feeling around and formative painting by Emile Troise. All that time and effort come together here, focused and concentrated in an easy-to-follow, step-by-step study course. With less preparation than you now have, a New England artist is regularly selling marker paintings and a New York artist has won in a competition with her marker painting.

Your future achievements are limited only by your innate talent and perseverance. Markers are an extremely malleable medium, as you've seen in the wide diversity of styles illustrated in this book. They can be handled loosely and fluidly, or tightly and rigidly; they can be used like oils or watercolors or pen and ink or pencil. You can obtain attractive results on virtually any art surface known in the fine or graphic arts. Confidence in this easy-to-master medium should now be within your grasp.

We would be less than candid, however, if we didn't acknowledge that much more work remains to be done and many discoveries remain to be made. Perhaps among our readers are authors of sequels to this initial study. Certainly there are many to whom markers will bring artistic fulfillment. And that's what will make our efforts worthwhile.

Figure 106. Tilt the Marlite panel after spraying it with colors.

Figure 107. Dip a paintbrush in turpentine and stroke it in the colors.

Figure 108. Tilt the panel again to let the colors flow.

Figure 109. Press another panel against the first with a full weight.

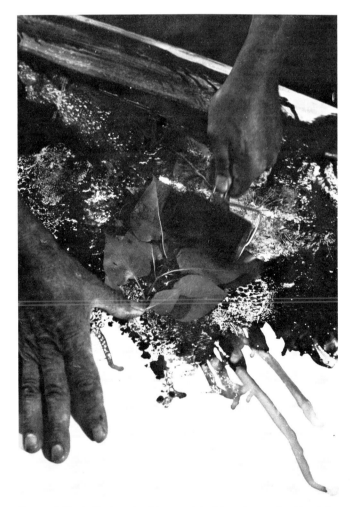

Figure 110. Roll a bough of leaves, inked in red, over the blue ink.

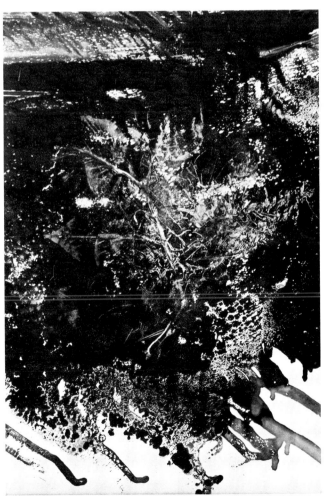

Figure 111. This is the result of the leaf impression.

Figure 112. Do more leaf impressions with the roller brush and leaves.

Figure 113. The additional impressions aid in the shaping of the painting.

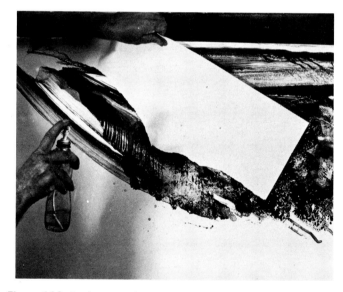 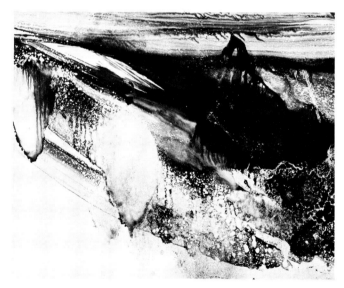

Figure 114. Squirt turpentine on the panel over the ragged edge of a cardboard.

Figure 115. Tilt the panel so the turpentine flows and blends with the colors.

Figure 116. Lay the panel flat again and run a paint roller over it.

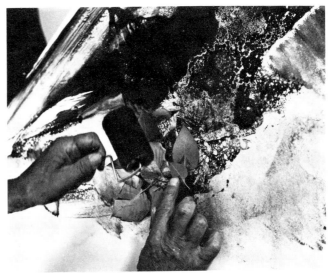

Figure 117. Make additional leaf impressions over the new layer of colors.

Figure 118. Spray on more ink in another color.

Figure 119. Use a roller to blend the ink.

Figure 120. Spray turpentine over paper masks and let dry.

Figure 121. Use a watercolor brush to work out details.

Figure 122. Paint in a treelike shape; add details at the bottom.

Figure 123. Add another type of leaf impressions.

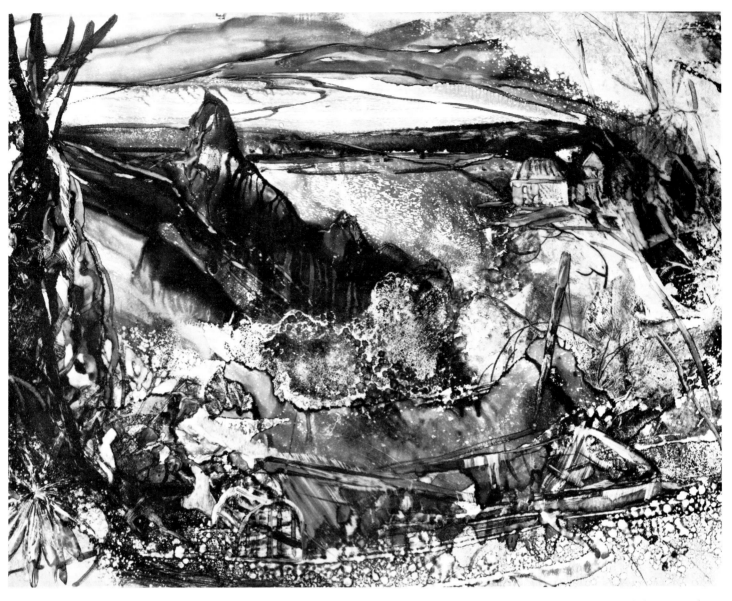

Figure 124. Your painting could look somewhat like this, an interesting abstract painting textured with leaf impressions.

Fixatives

Merix AST 1001 — approximately
$12 per quart, $30 per gallon

Merix Chemical Company
2234 East 75th Street
Chicago, Illinois 60649

Uvinul D-50

GAF Corporation
140 West 51st Street
New York, New York 10020

Crescent Matton & Koloron

Crescent Portrait & Frame Company
14068 Euclid Avenue
East Cleveland, Ohio 44112

Korad ACV

Rohm & Haas Company
350 Fifth Avenue
New York, New York 10001

Markers

The Carter's Ink Company
239 First Street
Cambridge, Massachusetts 02142

Dri Mark Products, Inc.
158 South 12th Avenue
Mount Vernon, New York 10550

Eagle Pencil Company
Eagle Road
Danbury, Connecticut 06810

Eberhard Faber Pen & Pencil
Crestwood
Wilkes-Barre, Pennsylvania 18703

Flash Manufacturing Company
98 Murray Street
Newark, New Jersey 07114

General Pencil Company
67 Fleet Street
Jersey City, New Jersey 07306

Magic Marker Corporation
84-00 73rd Avenue
Glendale, New York 11227

Marsh Stencil Machine Company
707 E. "B" Street
Belleville, Illinois 62222

Pentel of America, Ltd.
333 N. Michigan Avenue
Chicago, Illinois 60601

Sanford Ink Company
2740 Washington Boulevard
Bellwood, Illinois 60104

Venus Esterbrook Corporation
730 Fifth Avenue
New York, New York 10019

Yasutomo & Company
24 California Street
San Francisco, California 94111

Papers

Plastic Papers

Appleton Coated Papers
825 East Wisconsin Avenue
Appleton, Wisconsin 54911

Crown Zellerbach Corporation
One Bush Street
San Francisco, California 94119

Kimberly-Clark Corporation
North Lake Street
Neenah, Wisconsin 54956

Mead Paper Company
Talbot Tower
Dayton, Ohio 45402

Scott Paper Company
Scott Plaza
Philadelphia, Pennsylvania 19113

Sorg Paper Company
901 Manchester Avenue
Middletown, Ohio 45042

Zellerbach Paper Company
4000 East Union Pacific Avenue
Los Angeles, California 90023

Primed Canvases

Tara Materials, Inc.
1273 Chattahoochee Avenue, N.W.
Atlanta, Georgia 30325

Pyroxylin Coated Cover Stock

A. I. Friedman
25 West 45th Street
New York, New York 10036

Textured Papers

Uni-Mark, Inc.
169 "A" Street
Boston, Massachusetts 02210

5875 North Lincoln Avenue
Chicago, Illinois 60645

31 Union Square West
New York, New York 10003

Vellum and Acetate Overlay Sheets

Charles T. Bainbridge's Sons
20 Cumberland Street
Brooklyn, New York 11205

Bee Paper Company, Inc.
100 Eighth Street
Passaic, New Jersey 07055

Bienfang Paper Company, Inc.
Box 408
Metuchen, New Jersey 08840

Shading Film

Burgess Sonotone — Solid Ink

A. I. Friedman
25 West 45th Street
New York, New York 10036

Instant Lettering — Half Tone, Ink Dot

Letraset, Inc.
33 New Bridge Road
Bergenfield, New Jersey 07621

BIBLIOGRAPHY

Ballinger, Harry R., *Painting Landscapes*. New York: Watson-Guptill Publications, 1965.

Ballinger, Harry R., *Painting Sea and Shore*. New York: Watson-Guptill Publications, 1966.

Blake, Wendon, *Acrylic Watercolor Painting*. New York: Watson-Guptill Publications, 1970.

Carlson, John F., *Carlson's Guide to Landscape Painting*. New York: Sterling Publishing House, 1953.

Fawcett, Robert, *On the Art of Drawing*. New York: Watson-Guptill Publications, 1958.

Hogarth, Paul, *Creative Ink Drawing*. New York: Watson-Guptill Publications, 1968.

Kautzky, Ted, *Painting Trees and Landscapes in Watercolor*. New York: Van Nostrand Reinhold, 1952.

Kautzky, Ted, *Ways with Watercolor*. New York: Reinhold Publishing Company, 1949.

Pellew, John C., *Acrylic Landscape Painting*. New York: Watson-Guptill Publications, 1968.

Pike, John, *Watercolor*. New York: Watson-Guptill Publications, 1966.

Pitz, Henry C., *Drawing Trees*. New York: Watson-Guptill Publications, 1956.

Welling, Richard, *The Technique of Drawing Buildings*. New York: Watson-Guptill Publications, 1971.

Edited by Juliana W. Goidman
Designed by James Craig and Robert Fillie
Composed in 10 point Univers Medium by
Wellington-Attas Computer Composition, Inc.
Printed and bound in Japan by Toppan Printing Company, Ltd.

ZISe89

ZISe89